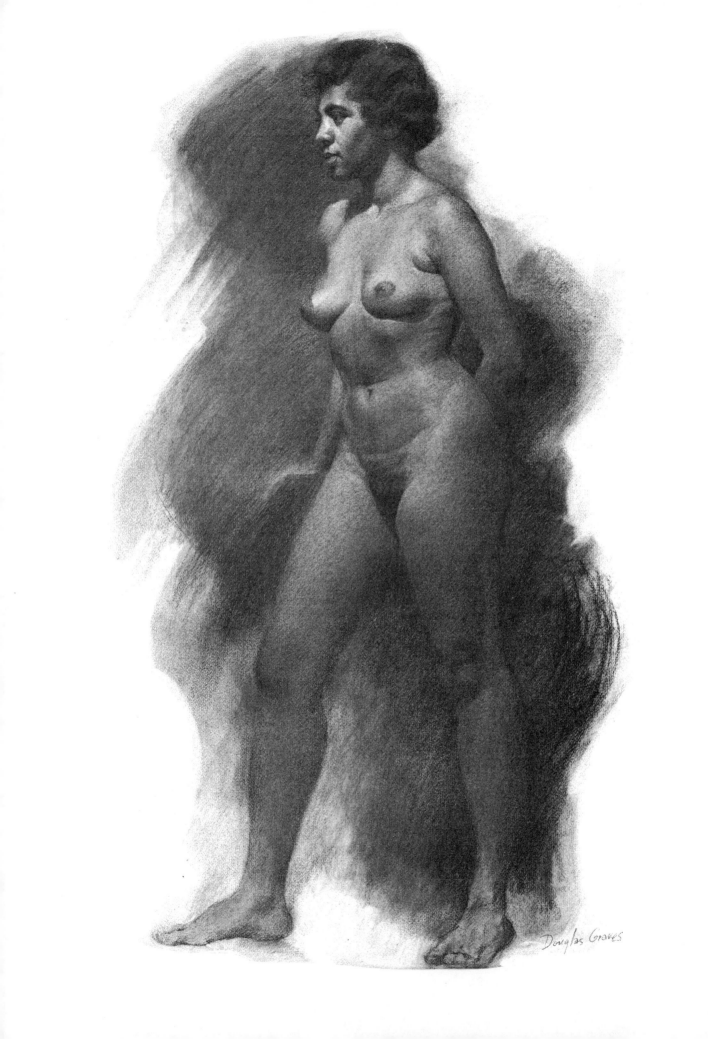

Douglas Graves

Life Drawing in Charcoal

BY DOUGLAS R. GRAVES

DOVER PUBLICATIONS, INC., New York

"For Man's most noble sense is sight."

— ALBRECHT DÜRER

Copyright

Bibliographical Note

This Dover edition, first published in 1994, is a revised and enlarged republication of the work originally published by Watson-Guptill Publications, New York, in 1971. Project 24 has been written specially for the Dover edition; Project 23 has been retitled and given new artwork; Project 25 has been newly created by reorganizing material previously in Project 23; Projects 26 and 27 were previously numbered 24 and 25. The acknowledgments have been revised. Various material has been shifted to new pages and the Index adjusted accordingly.

Library of Congress Cataloging-in-Publication Data

Graves, Douglas R.
 Life drawing in charcoal / Douglas R. Graves.
 p. cm.
 "Revised and enlarged republication of the work originally published by Watson-Guptill Publications, New York, in 1971"—T.p. verso.
 Includes index.
 ISBN 0-486-28268-6 (pbk.)
 1. Charcoal drawing. 2. Anatomy, Artistic. I. Title
NC850.G7 1994
743'.4—dc20 94-35240
 CIP

Manufactured in the United States of America
Dover Publications, Inc., 31 East 2nd Street, Mineola, N.Y. 11501

ACKNOWLEDGMENTS

My gratitude goes to John Grafton, Hayward Cirker, Bonnie Iris, and my wife Bea, who all believed there was more "life" in the book.

CONTENTS

INTRODUCTION

One of the exciting moments of an art career is finding a fresh concept, a new procedure, and having it work for you. When I discovered seeing and drawing by tonal masses, I realized I had a simple and direct means for organizing a picture. The mass approach was unique to me, because it was completely opposite from the procedure I'd always used. My drawing took a gigantic stride forward in both quality and length of completion time.

The process of assembling a picture with what amounted to threads and sticks now seemed unnatural and time-consuming. Why should a drawing be done so piecemeal when it can be executed with free, bold areas of tone put down in their correct juxtaposition? Instead of a slow, tedious building-up process (the transition from thin contour lines to a full tone or color) you should be able to strike in the image massively just as you see it — providing you can see your subject as masses of tone and color.

I hope to show you how subject matter can be seen impressionistically, how you can put down your total reaction to it. By arranging tone in large masses, you have a fast and facile way of drawing. This is the reverse of other drawing procedures that start with line. My method of drawing with masses of tone leads you in the direction of painting without sacrificing charcoal's graphic integrity. The saying, "drawing is painting and painting is drawing," becomes clear with my method. I'd like to change the definition of drawing from delineation to illumination — in the literal sense of rendering light and shade.

Think of this book as a life drawing classroom. There are some still lifes set up in the corners; you have the models (my drawings); you have my "kind words"; and you have the drawings which progress step-by-step in each project.

Better yet, if you attend an actual life class, this book can serve as a reference guide. But no book is a magic key to success in attaining any skill. The process of development is determined by dedication as well as ability which is usually the result of a disciplined drilling routine.

If you can pursue charcoal drawing until you understand it, you'll appreciate its inherent beauty, its suitability both for studying the figure and for thinking in terms of tone.

Figure drawing is the heartbeat of all artwork. Working from the figure performs two interdependent functions: it forces you to observe and render the most subtle of any tone gradations and shapes in nature; at the same time, you become knowledgeable about the human body.

I've heard it said that learning a craft stifles creative energy — that you should, without training, plunge immediately into the frantic production of your thing. I think this is floundering of the worst sort. To do an art project in this manner is to work with every handicap; only the most shallow form of novelty and trickery is produced. I think it's foolish to disregard the need for instruction in favor of an incompetent novelty, just so that your creative psyche won't be stained.

On the other hand, though I'm strong for training, you won't have to spend as long a time as you might fear using the method in this book. Working in a tonal or chiaroscuro way isn't unusual for an experienced illustrator or painter, but the beginner is rarely encouraged to start right off in this mode. In the long term apprenticeships of the old masters, drawing in tone was the reward that followed a long period of line drawing. I'm going to propose a switch and have line drawing as a graduate course!

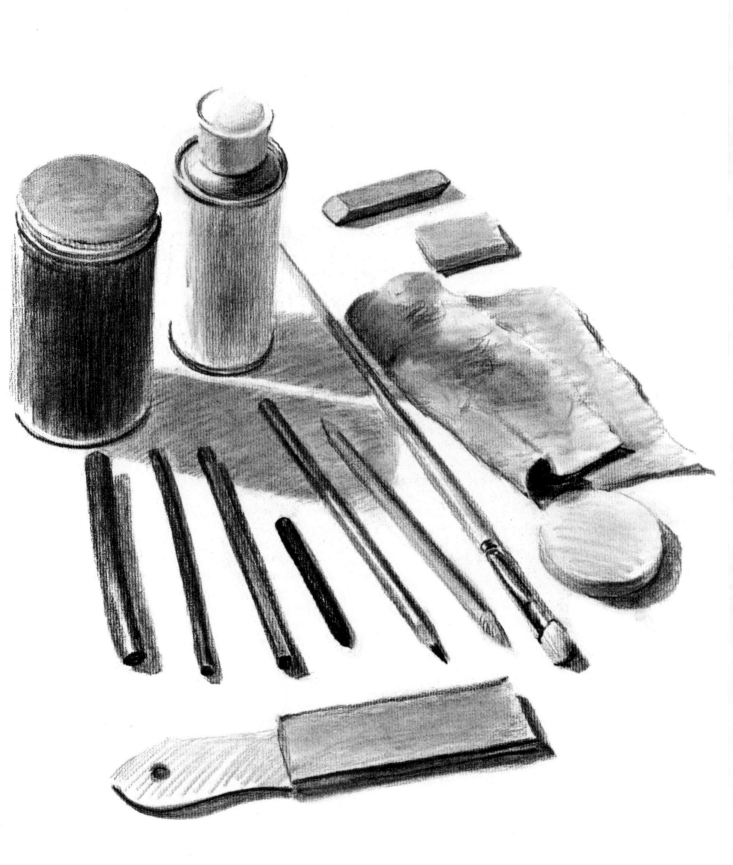

Figure A *Materials for charcoal drawing are few and inexpensive: charcoal sticks and pencils, a stump, a bristle brush, a couple of erasers, a powder puff, a chamois, a sandpaper pad, a spray can of fixative, and perhaps some powdered charcoal in a covered container.*

PROJECT 1

MATERIALS
AND
EXERCISES

The materials needed for working in charcoal (Figure A) are few and not too expensive. Usually they can be found in any art supply store. On the chance that you've never used the medium of charcoal, I'll describe briefly the items that should be in your kit, and I'll say something about their use. The list of what you'll need is the same kit that I've used in my drawings. It includes the following:

> Charcoal sticks (vine)
> Compressed charcoal
> Powdered charcoal
> Charcoal or carbon pencils
> Kneaded eraser
> Chamois
> Pink pearl eraser
> Stump
> Bristle brush
> Foam rubber powder puff
> Sander
> Paper
> Fixative

CHARCOAL

The charcoal sticks that I recommend for beginners are usually called vine charcoal. They're made from straight, fine grained woods like willow, beech, and bass. Sizes vary in thickness from 1/4" to 1/2". Grades are soft, medium, and hard. In an old book, *The Craftsman's Handbook* by Cennino D'Andrea Cennini, the author tells how you may make your own "coals," as he calls charcoal. "Bundle together nice, dry sticks of willow, about the length of your palm. Tie the bundles in three places, the middle and each end, with a fine copper wire. Take a brand new casserole and fill it with these bundles. Then get a lid for it (luting it with clay so nothing will evaporate). Then, go to the baker's in the evening, after he has quit work, and put this casserole in one of his ovens and let it stay there until morning!" Your baker would probably throw you out if

you tried such a thing, so I'd suggest you buy the ready-made charcoal.

A new brand on the market is made by F. Weber Co. called American Rouget willow. It comes in square sticks. I find that it works very well, behaving like the beautiful French charcoal we used to be able to get.

Compressed charcoal (Siberian charcoal) is potent stuff, too powerful for beginners. Since the value of charcoal is its easy removal with erasers and chamois, the tenacious adhesion of compressed charcoal is undesirable; it doesn't lend itself to the plastic method of drawing that I'm going to demonstrate at first. When you're more sure of yourself, then compressed charcoal will be useful. Its virtues, on the other hand, are its rich black color, smoother texture, and more permanent quality. Compressed charcoal is made by grinding charcoal and compressing it with binders such as clay, chalk, soap, tapioca, or other ingredients.

In the early phases of charcoal drawing, I'll advise you to cover your paper with a middle tone. You can do this by using a stick of soft charcoal; but as you zigzag over the page, you'll quickly use up the stick. An expedient way of covering your paper is with powdered charcoal sold in paper cans. A can of it will last a long time, because a little bit goes a long way. Lay your paper flat and sprinkle the powder on lightly. Brushing it out with the powder puff will give you a nice middle tone. The powder can also be used to render a complete drawing. By dipping a bristle brush into the powder, you can apply it directly to the drawing and brush it on as a tone. Experiment with it, but be careful or you'll wind up looking like a coal miner. (Caution: near an open flame or spark, powdered charcoal can be explosive.)

Charcoal and carbon pencils are about in the same class as compressed charcoal, except that they're made in the form of a pencil with a wooden sheath and smaller in diameter. They have the same advantages and disadvantages as the sticks of compressed charcoal. Further hindrances are the need to sharpen them constantly, and more importantly, the fact that they won't cover large areas quickly. The small point won't make broad, sweep-

ing passages. But later these smaller drawing tools can be used to accentuate small, pinpoint spots where a large stick of charcoal would be clumsy.

ERASERS

The next items might really be listed under charcoal, because I'd like you to think of them as tone makers for the lighter tones.

In charcoal drawing, the kneaded eraser and the chamois are the best tools for making lighter grays and whites on toned paper. (Oddly enough, the kneaded eraser is a modern version of soft, fresh bread, which was used once upon a time to clean off charcoal.) You'll get into the habit of kneading the eraser in your hand as you work to keep its clean surface on the outside. You can shape it to render anything: a wide sweep or a pinpoint highlight.

The chamois will make larger expanses of light tones. By wrapping it around your finger, you can remove more at once than you can with the eraser.

If the kneaded eraser doesn't remove enough charcoal, use the pink pearl eraser, which is firm rubber.

BLENDERS

The blenders are the stump, brush, and puff. I'm not *opposed* to using a stump, which is merely a tightly rolled paper formed into a pointed tool. I've seen some nice drawings done by using this tool throughout the whole process. However, I don't use a stump because it seems to destroy the patina of the paper. The tones go lifeless and lose that sparkle which the tiny valleys — skipped by the charcoal, but filled by the stump — give the drawing. The same holds true for the bristle brush. It's a favorite tool for many, and the advantage is the long handle that enables you to use it like a painter (with arm movement) and to keep a little more distance from your work.

For myself the perfect blender is my finger; but I'm lucky because my fingers are dry. If you've a tendency to perspire or have oily skin, don't touch the drawing with your fingers! The next best thing is the foam rubber puff. Its soft texture is perfect for blending tones. The puff makes the tones lighter — about a half step at first — but as you add more charcoal less will come off. Hold the puff tilted up so that just the edge glides, light as a feather, over the zone to be blended. If you want to get into a very tiny spot, double it over so that you have just a point. These puffs are available at cosmetic counters.

The sandpaper pad is a portable sharpener. The conventional pencil sharpener will also hone a round charcoal stick to a nice point. Once you've first sharpened the charcoal, you can keep it sharp by rotating it as you shade.

PAPER

As in all artwork, the right paper is important. You can't use just *any* kind successfully — at first, anyway. It should be especially prepared for the intended purpose. I prefer the French Canson Ingres #281 white. It's a 100% rag content paper, sized, and air dried. It has a texture called *laid*, which means that there are fine, parallel, watermarked lines running lengthwise on the sheet. This texture is heavier and more distinct on one side, making that side the best to work on. If it's difficult to determine this at first, the brand name is readable on the correct side.

I'll use this type of paper for most of my drawings in this book. Later, I'll try other kinds of paper to show you the various possible effects.

FIXATIVE

Fixing can be done in stages as you draw or at the finish of a drawing. A spray can is better than a mouth atomizer — which tends to drip. If you fix during the progress of the drawing, be sure you aren't going to make changes in the parts you've previously drawn.

Personally, I feel that fixing ruins the tones; it seems to dull the luster of the black tones in particular. Of course, my problem is to preserve the unfixed drawing. If it's possible to get the drawing behind glass, with a mat thick enough to keep the glass from touching, I probably won't use fixative at all.

EXERCISES

I can hear you groaning when that word *exercise* is uttered. It conjures up all sorts of frightful things like sore muscles, strained backs, and most of all, endless hours of boredom. I scrupulously avoid calisthenics of any kind, so I'm with you in my lack of enthusiasm about that word. But before you quickly turn the page, let me say that the exercises I suggest are more like *experiments*. Of course, if you've already used charcoal — 'bye, see you in the next chapter.

There are several different ways to hold charcoal to achieve various textures. You should at least try these ideas, so you'll be better equipped to solve your rendering problems.

In Figure B I've ruled off 2" squares and used several different techniques. Try these yourself. With these shading methods you can get a variety of effects, depending on the angle at which you hold the stick to the paper. With the stick at a steep angle working up on the point, you'll get noticeable lines and you'll have to sharpen the point often. If you hold the charcoal flatter to the paper on the side of the point, the tone will automatically sharpen it.

The first and most common method is holding the stick back as far as its length will permit, so that you can swing your arm instead of wiggling your fingers (Figure C). With a fairly rapid motion, move zigzag down and across the paper. A right-handed person usually leaves strokes that go from the upper right down to the lower left. As a matter of fact, when you use this technique your whole drawing will have a directional hatching appearance.

1. *Light shade, using rapid up and down movement.*

2. *Blended light to dark, using rapid up and down movement.*

3. *Rapid shading at an angle, the most natural movement.*

4. *Rapid shading.*

5. *Slow up and down movement.*

6. *Going over with slow up and down movement.*

7. *Pecking strokes.*

8. *Crosshatching.*

9. *Slow strokes, overlapping tones with square charcoal.*

10. *Clean lines over a smooth tone.*

11. *Smoothed with a stump.*

12. *Smoothed with the fingertip.*

13. *Smoothed with a bristle brush.*

14. *Smoothed with a puff.*

Figure B *Different techniques use various arm movements.*

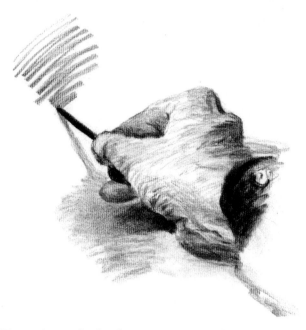

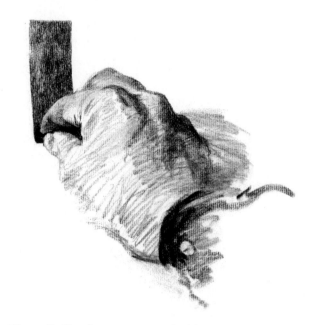

Figure C *Try this hand position for sketching with lots of arm movement — hold the stick back from the end.*

Figure D *Use the squeegee method for wide, flat passages.*

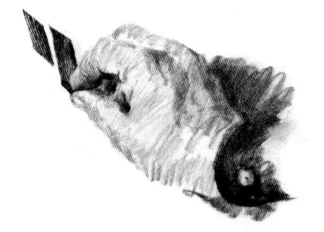

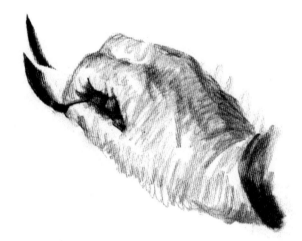

Figure E *Here's the squeegee method at an angle.*

Figure F *The squeegee method can be used to make curves.*

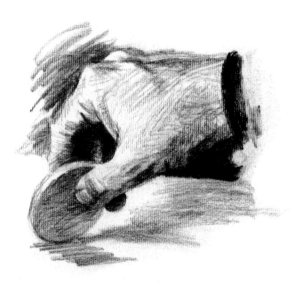

Figure G *Hold the puff this way for smoothing tones.*

Now, try some techniques that are achieved by holding a shorter piece of a charcoal stick, squeegee fashion, as shown in Figure D. First, draw the charcoal straight down the paper, making a broad tone the width of the stick. This should produce an even tone with a sharp edge on each side. The stick is a little harder to hold and may have a tendency to pop out of your hand, but learning to use this stroke will have many uses. For one it's a speedy way to lay down a tone. (See Figure D.) Now, still holding the stick the same way, make tones by varying the angle of the stick to the direction of the stroke (Figures E and F).

To obliterate the lines by shading take the puff, lightly holding it up so that only the edge touches, and rub it at right angles across the hatching (Figure G). This will blend them together into a smooth, velvet tone. If some of the tone has been lifted, repeat the shading and rub with the puff once again. Remember, be light with your touch.

As you gain control, you'll find that the zigzag stroke technique can be used to get any kind of effect. After a while you should be able to lay down a smooth tone without rubbing it with the puff. You might eventually like the notion of some kind of texture, exaggerating it or letting it become the "interest" of the drawing with the figure almost subordinate to it.

Beautiful drawings can be done with a multitude of scratchy, swirling lines representing tones (Figure H). Daumier used this technique somewhat. Other techniques are shown in the swatches. For example, you can rub the compressed charcoal very smooth with your finger on a smoother paper (Figure I). You can erase hatched lines into a darker tone (Figure J). Experiment with jabs of dark as in Figure K. A direct and powerful means of getting a rounded edge is to take a piece of compressed charcoal and press on one end only, sweeping *around* contours (Figure L).

Figure H *Here's a wiggly tone texture.*

Figure I *Compressed charcoal can be blended with the fingertip.*

Figure J *Lines here are erased from a tone.*

Figure K *Dark jabs are also possible.*

Figure L *Compressed charcoal contours produce a powerful rounded edge.*

PROJECT 2

SEEING
TONAL
QUALITY

In preparation for figure drawing, you must learn to see elementary light effects. At first, it's difficult to see the delicate tonal gradations and subtle shapes of lights and shadows on a figure. It's best to learn to see these effects on objects with simple shapes. Don't think that it's beneath your dignity to do the projects I'm going to give you; you may think they're easy, but they're not. At least I'll spare you the tedium of drawing cubes, cylinders, and other geometric objects. As a beginner you'll certainly need the practice of my basic approach to figure drawing; the more advanced students should find this method different enough to explore it from the outset.

SINGLE LIGHT EFFECT

Start with an egg, a simple colorless object. The choice isn't a whim. There are several reasons for it. Its shape will demonstrate the elements of a pure, single light effect upon a round object. Its shape compares to the basic shape of a human head. (See page 129.) Being almost pure white, the egg provides no color distraction at this point. Put the egg under a single light source. If possible, no other light should hit the egg at all. To keep all reflections of light away from it is almost impossible, but try using a dull black cloth for the background and for the base. This cloth will prevent light from bouncing onto the egg from the immediate area. Start at once. Disregard thinking about *what* the object is. Look for the light and dark shapes only.

TONES AND THEIR RELATIONSHIPS

Notice the simplicity of this light and dark arrangement in the demonstration steps. The elements are the main light, the spot of a highlight, the shadow side of the object, and the object's cast shadow. In the demonstration, the large, light shape is a very flat oval, floating above a longer and thinner black shape. The area between these two shapes

seems to be approximately the same middle tone as the background. These observations require no knowledge of the egg's inner construction, just a careful study of what you see. With very simple indications, we've portrayed a picture of an egg. It's an uncomplicated visual reaction. The only shading you might need is to delicately "true up" the shapes, as I've done. Have you noticed that I never use any contouring or outlining? I don't feel that it's necessary to use lines. No outlining and filling in!

LEARNING TO SEE THE TONAL WORLD

In this project, as in most of the early ones, you'll be covering the paper with a middle tone, coming as close to the tone of the background as possible. Even though the backdrop is black, it looks lighter. The egg might seem an easy thing to draw but it's not a project that should be passed up.

Drawing and seeing tone is — and should be — a constant concern. What you see in the world around you is an "effect of light." But what is tone? *Tone* is the amount of light reflected off an object. Objects reflect or absorb light according to their substance and shape, in addition to their position in the light. When the light and shade of an object varies in clearly defined areas it's said to have planes. If the light varies with no discernible boundaries, it's assumed that the object has a rounded shape. Therefore, form is obtained by some kind of tonal gradation — from light to dark. Color, on the other hand, is influenced by surface pigmentation as well as light. For black and white drawings you should learn to ignore color and see things lighter or darker — in varying shades of grays. At the beginning you may find it hard to separate tone from color. It will take a while for you to translate pale yellow, let's say, into off white or deep red into dark gray. And once you've acquired the ability to see the tone of things, you must learn to control these tones in a drawing.

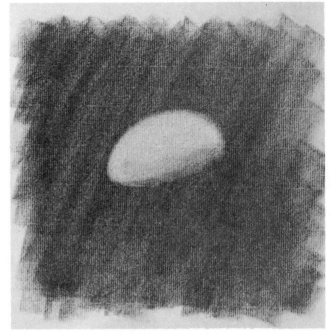

Step 1: *Most of the area in this picture is composed of the black backdrop. With the strong spotlight on it, the backdrop doesn't look 100% black. I take a fairly soft, square charcoal stick and spread a tone for the whole picture area. I call this the middle tone.*

Step 2: *I wipe out the large area of the light with a clean chamois wrapped around my finger. As I wipe, I take care to get the exact shape of the light. The chamois leaves just a small amount of tone which will help me in the last step.*

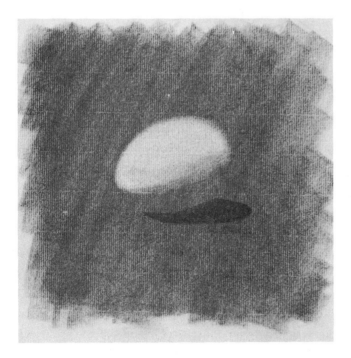

Step 3: *At about the same distance as the top of the egg from the edge of the shadow, I indicate the cast shadow below the egg. It's a flatter shape, pointed on the left and rounder on the right. I make it as black as I can. When this shape is very carefully done, it tells as much about what's above as the light on the object itself. It has to be positioned exactly right underneath also. The middle tone notches out a bit of this shadow and shows us that the egg is located over the top of the shadow.*

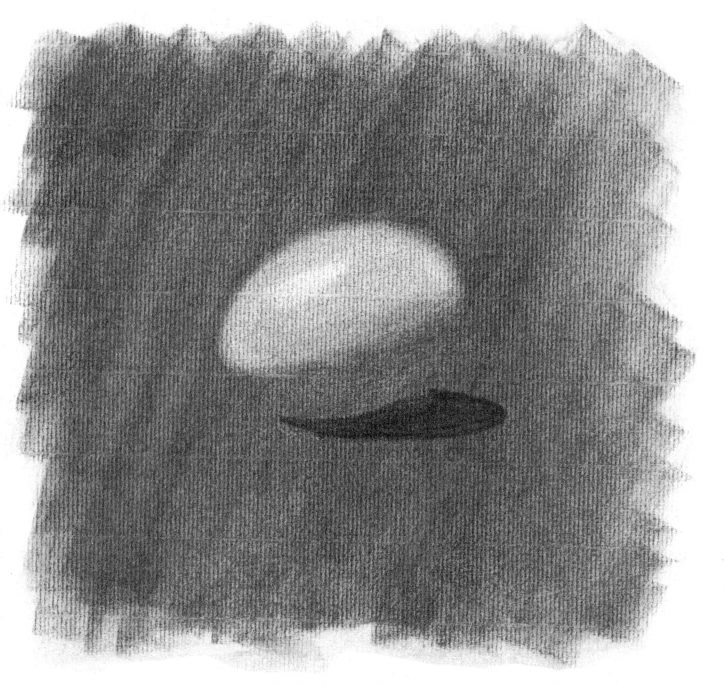

Step 4: *The last thing I do is to take an eraser and make the soft edge highlight. That, plus the shaded edge around the top of the egg (that the chamois leaves) shows the roundness of the object. There's nothing further to be done, because by now you should be able to see an egg sitting in a light. It isn't necessary to do anything about the shadow on the egg itself; it appears to be melted right into the background.*

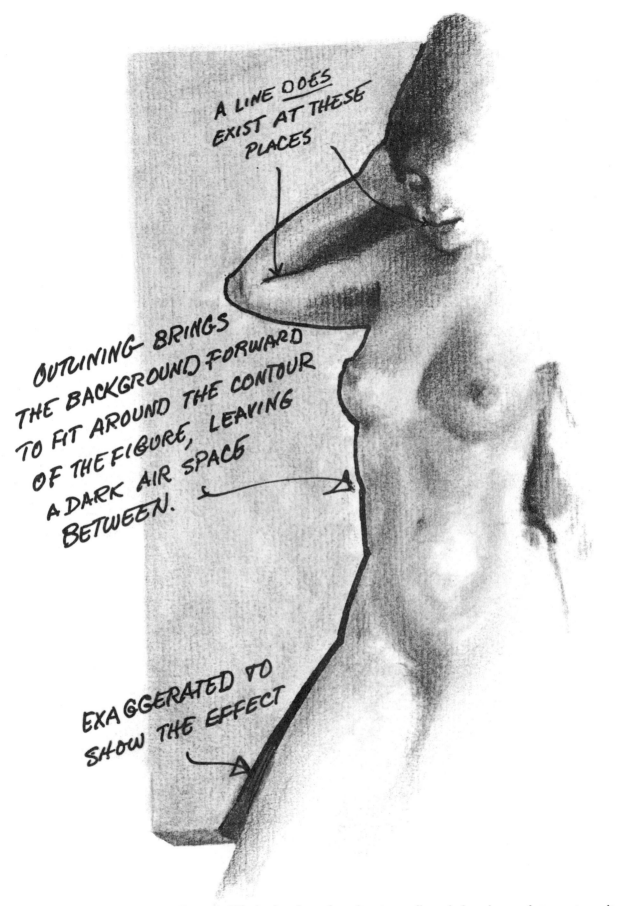

A LINE DOES EXIST AT THESE PLACES

OUTLINING BRINGS THE BACKGROUND FORWARD TO FIT AROUND THE CONTOUR OF THE FIGURE, LEAVING A DARK AIR SPACE BETWEEN.

EXAGGERATED TO SHOW THE EFFECT

Figure A *What's thought to be a line is usually a darkened space between two adjacent objects. When a line is put around a contour, you subconsciously bring the background forward, beside, and touching the foreground object.*

PROJECT 3

THE DIFFERENCE
BETWEEN LINES
AND EDGES

I'd like you to find an all white ceramic object for this project. The lighting will also be from one source for this drawing. It might seem that I'm placing too much stress on simple lights, no reflections, etc. But I want you to realize that the best means of seeing the form of the object is in a simple light. Since your vision is attuned to changes in the *light*, I think it's most important, at first, to play upon that idea. Make the changes of tone in the lightest areas. In the shadows, make no drastic change; keep them mysterious. Use only one tone there, if possible.

It's a good idea to have a place, a permanent corner in your home or studio, to set up still lifes, preferably away from other light influences. This eliminates complicated light patterns. An ideal setup would be one where the object is in an enclosed box with a black lining. There would be two openings, one for the single light source, and the other for the peephole.

A NEW WAY TO OBSERVE

The method of drawing in this book involves a new way of *observing* objects. It's based on the fact that there are no lines in nature. If you analyze what appears to be a line, you'll discover that it's merely a width of tone having a sharp edge on both sides. Therefore, you have a new phenomenon to deal with — edges. Learning the proper use of edges will have a growing importance in my story. The control of edges is the very heart of an in-depth rendering by a tonal method. Edge control is the golden key to giving a third dimension to a drawing.

The surest way to destroy and flatten the third dimension is to outline or contour with a line. Why is this true? When you observe what you might think is a line, it's only a darkened space between two adjacent objects, for example, between the door and the door stop, or cracks in a wall or on a sidewalk. On the human figure, some examples are found between the fingers when they're together, at the meeting of the arm and chest, or the line of the lips. In every case, the two like objects are side by side. You get so used to seeing this kind of an association

that when a line is put around a contour, you subconsciously bring the background (outside shape) forward, beside, and touching the foreground object. You could make a rule then that when you see a line, the objects on either side are touching. (See Figure A.) This truth has been put to use in murals where the scene is kept flat looking on the wall. Stained glass windows are also done in a linear manner to keep them flat.

DEFINING TERMS

I'll be using some terms that might not be familiar to you. I'll refer to *mass*, which means an area of tone. I'll sometimes say that a tone has a certain *value*. Value means lightness or darkness as you'll see in Project 6, Figures C to G, in which a series of value scales are reproduced. I want you to develop a value scale in your mind's eye, with a series of tones that run from black at one end, through a series of grays that get lighter and lighter, to white at the far end. With this value scale in mind, you'll know what I mean when I say "bring the value up" (meaning lighten it), or "bring the value down" or "knock it down" (meaning darken it).

When I use the word *shading*, I'm just talking about darkening an area. By *tinting*, a word I won't use too much, I mean just adding a small amount of tone; I'm thinking in terms of a white pigment that needs slight graying or coloring.

USING THE MIDDLE TONE

At this point I'll explain why I start with a tone covering the paper. A white piece of paper or canvas is stark and formidable. There's a lot of area to be covered. When you reproduce a scene, a still life, or a figure, it soon becomes evident that there's very little, if any, white in it. Eventually, you're going to have some kind of tone over almost the entire paper. So a middle tone is a better starting point. It should be an amalgamation of the entire tonal pattern.

In a sense, then, you're starting from the center and working both ways: middle tone to light, middle tone to black. It's just half as far, isn't it? Also, a middle tone enables you to use the eraser and chamois in a painterly fashion. A comparison of tones and their values becomes much easier.

The obvious query here is always: why don't you start with a paper that's toned? First, you want to be able to get lighter than middle tones by wiping or erasing — without having to introduce another pigment. Also, you want the little sparkle that the small white speckles of paper give the drawing. You can control the whole mood of the drawing by controlling the middle tone value. If it were generally a lighter mood, you could use a lighter middle tone, and for heavier moods, a darker middle tone.

This book is intentionally slanted toward people who want to paint. Learning to draw in a tonal or mass way is the best way to provide an easy transition to the painting class.

Step 1: *With a large 1/2" thick charcoal, I make a background with a dark middle tone about 9" square. I hold the tip of the charcoal stick on its side to make wide, overlapping strokes. I smooth the tone slightly by brushing across with the puff in the direction of the strokes. Using the chamois again, I carefully wipe out all of the general light areas. I've done a very simple step, but already you can see a suggestion of the pitcher. It even begins to look round.*

Step 2: *I add the black cast shadow which immediately sets the pitcher down on the surface. The shadow also shows some of the pitcher's shape underneath. This shadow becomes the darkest tone in the drawing.*

Step 3: *I take out the bright highlights on the pitcher's lip, handle, and bowl with a clean, pointed kneaded eraser. These will be the lightest areas.*

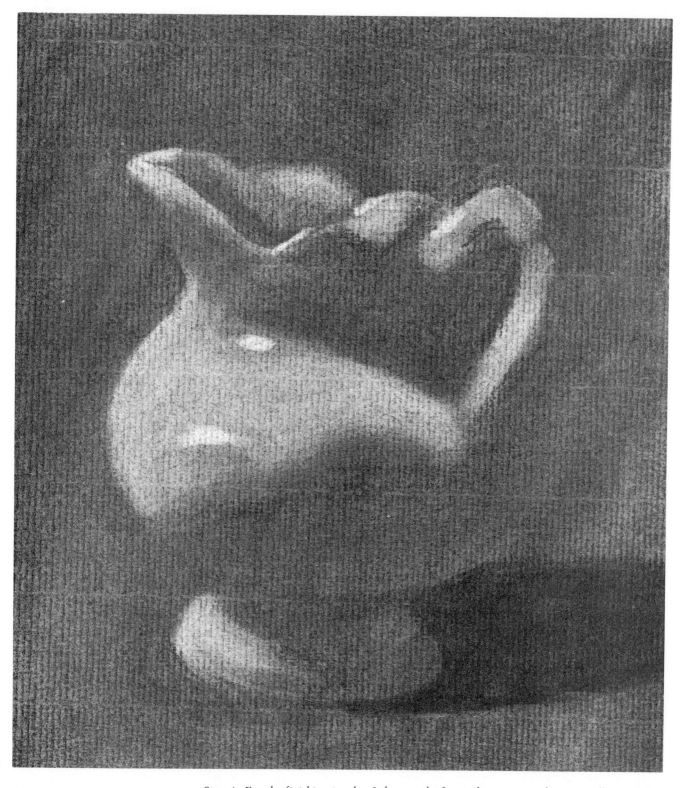

Step 4: *For the finishing touches I sharpen the front edges in some places, not all over. I align things better, and add a little darker tone along some of the locations where the shape turns into the light. This is slightly darker than the middle tone. I soften some edges. Don't be misled by the double highlights — the surface curves twice in the same manner to kick off a highlight.*

PROJECT 4

OBJECTS
AS THEY
ARE

It's a good idea to continue to work from an all white object. I urge every student of figure drawing to invest in one of the various types of plaster casts available. To introduce a part of the human figure, let's use a plaster cast of a human hand. Figure casts come in several sizes, including life size; however, the one about 24" high is sufficient. With this kind of a cast, you always have the correct proportions and muscle structure in a handy, three dimensional unit. It's much closer to the actual figure than anatomical studies in books or diagrams. Many students coat the cast with white shellac. (The shellac will yellow it somewhat.) This gives it a washable surface upon which to write the names of the muscles. If you can't swing the cost of a full figure, at least get a cast of a hand, a foot, or a mask. A cast like the one I've used in this project would be fine; then you could compare your drawing with mine.

LIFTING OUT LIGHTS

Using the same smudgy charcoal technique as in the last project, let yourself still be guided by tonal shapes. Working into a fairly dark middle tone, use only the chamois to lift out the lights. Wipe, as I've explained, with it wrapped around your index finger. You'll have to find a clean spot on the chamois quite often and also shake it out several times. The pressure of your finger will control the amount of charcoal you wipe off. Do this project as many times as necessary to get the feel for this kind of rendering. I repeat, you should do this project *without* outlines, lifting out and lightening to show shapes.

THINKING ABOUT WHAT YOU SEE

You'll find that shapes and their interrelationships in this project make it difficult to see lights and darks. To further complicate matters, you'll start thinking about "what" a hand consists of, and this will influence what you actually are seeing. For example, an ordinary piece of pipe or tubing has the property of being long and round, the same diameter from end to end. A cube has six sides — all exactly the same size and shape. But do they look that way? No matter from what vantage point you view these objects, they lose those intrinsic properties, or rather they *appear* to lose them. If you look at the pipe from an angle, it looks fatter at one end and its roundness becomes ovular. If you look at it end on, it no longer presents its dimension of length. The cube's sides aren't *visibly* equal in size and shape.

At this stage try to separate two thought processes: one being emotional knowledge of the object, the other the sight sense stimulus to light and dark shapes.

THE MIND'S INFLUENCE ON THE EYE

Let's discuss this influence in terms of the human hand, that is, what you know a hand consists of and what you actually see. Without the thumb the hand is divided into two flat, trapezoid shaped sections about equal in length with the dividing point at the knuckles. The tips of the fingers vary in length forming an arc; the joints form ever-flattening arcs. The fingers curve in toward the middle finger. On the back of the hand the separations of the fingers don't go all the way to the knuckles; there's about an inch from the finger openings to the knuckles. On the palm side, the finger openings go only to the mounds which hide the hinging line. The thumb fits on the side and underneath the main plane of the hand.

Now look at the plaster cast of the hand — really observe it. The hand you see doesn't fit the anatomical description exactly, does it? You're confronted with strange and irregular shapes. The back of the hand, for instance, instead of looking like the same trapezoid shape as the fingers, now looks very shallow, almost disappearing. It's impossible to tell how long the fingers are. You wouldn't know that the tips of the fingers form that graceful arc, because you can't see it. In addition to seeing these unusual shapes, you must also see how they meet each other; what parts come together. In other words the juxtaposition of the parts forms the structure of the whole object. You can soon learn to draw each piece as an isolated shape, but putting these pieces together in their correct relationship is the key to good draftsmanship.

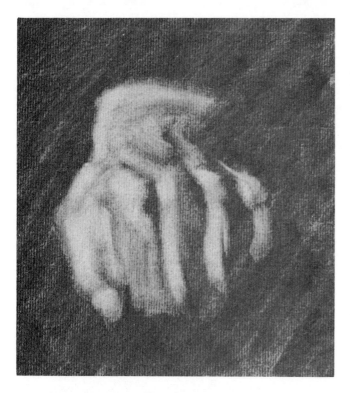

Step 1: *From an area of dark middle tone, I wipe out the light tones of the plaster cast hand. (This is a replica of a cast made from Abraham Lincoln's hand.) By varying the pressure, I can immediately suggest halftones.*

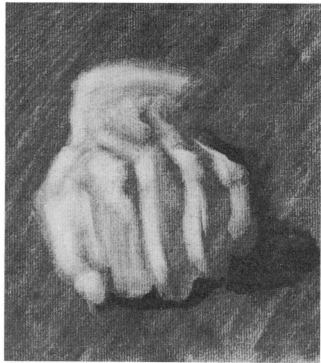

Step 2: *The cast shadow is added to define the contour on that side. It sets the hand down on something. It also gives me a comparison for the darks, because this cast shadow will be the darkest tone of the drawing.*

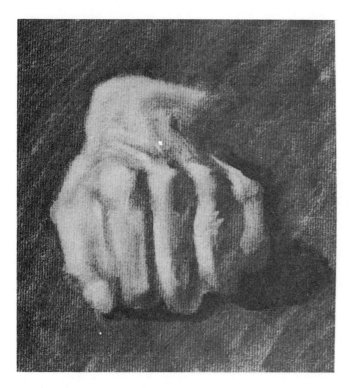

Step 3: *Some of the shadows of the fingers I establish a little more clearly. The contour around the top of the hand and coming down around the thumb I define more sharply. The light on the upper wrist has to be wiped a little more to make that half of the arm and hand turn up to the light. The highlight on the vein above the index finger I erase out. Also I can't resist the two little light clicks on the third finger.*

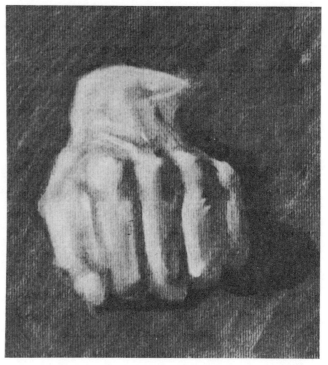

Step 4: *I discover that the light representing the small finger is the wrong shape; also the light on the small finger makes it come forward. I reshape it and soften the tone to push the small finger back. I make the light on the third finger a more definite shape at the bottom, but I've made it too bright. So you'll see in the next stage I knock that light down also. I do more reshaping on the contour of the hand at the top.*

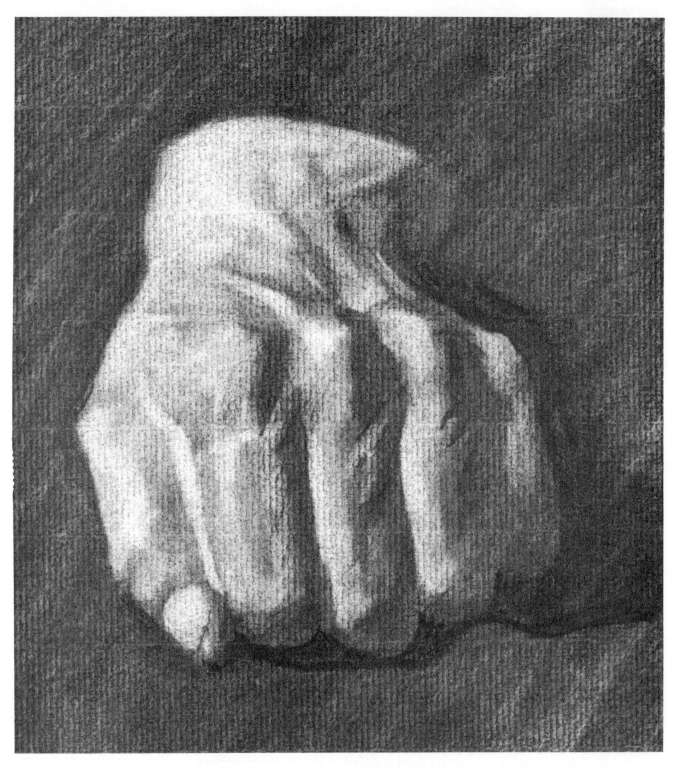

Step 5: *Now I work in the details. More highlights are added like the one separating the thumb and fingers, the knuckle of the thumb, the fingernail, and some on the top of the hand. With a sharp piece of charcoal I carefully shade in the nuances. I make the contour of the whole hand sharper in a few places, and add features like veins and stretched skin on the fingers.*

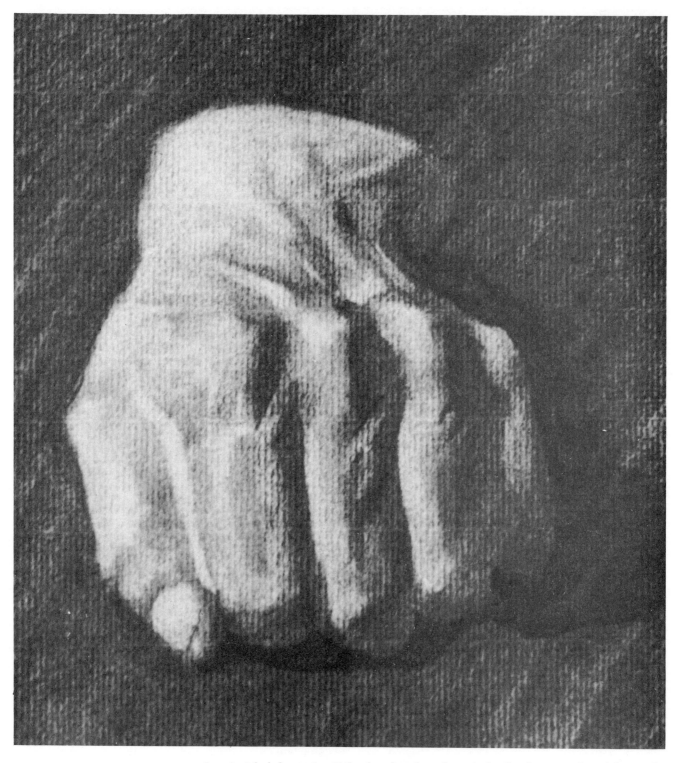

Step 6: *I feel that in Step 5 I've lost the white plaster look. There's too much modeling in the lights. So I take a clean spot on the chamois and carefully blot some of the halftones on the thumb side of the hand.*

PROJECT 5

THE TRADITIONAL USE OF PLASTER CAST FIGURES

Your initiation to the full figure should begin with the use of the plaster cast figure. I think that the European method of studying first from casts is the soundest and least confusing means of learning the figure. Here, as in the last project, you aren't bothered with doing anything about color. Another advantage of working from a figure cast is that it poses for you for hours on end without moving or tiring. If you have the same cast that I've used in this project, do a drawing from the same viewpoint as I have for comparison. Of course, you'll want to do many drawings of it from other positions. This cast, by the way, was originally sculptured by a French artist, Jean Antoine Houdon. This "Ecorché" was made (like many others by famous sculptors) for the purpose of anatomy study. One of my evening students, obviously after a hard day at the office, asked who had posed for this cast.

Charcoal as a Study Medium

Charcoal is the traditional, time-tested medium for studying and drawing because of its pliability and complete compliance to the artist's wishes. Being so flexible, charcoal will often defeat you at the outset and you may seek refuge with your old friend, the graphite pencil. Let me emphatically say that graphite is a master's medium. The graphite pencil must be used in a direct manner without manipulation or change. For studying purposes, you need the freedom of charcoal's flexibility. In case you're impatient with your lack of control with charcoal, don't forget that you've had a pencil in your hands for many more years. Charcoal can be used in many ways. It can create extreme contrasts or tones close in key. It can be strong, dark and bold, or soft with mystery in its play of lost and found edges. Charcoal can express whatever feeling you may have about what you see.

SQUINTING TO COMPARE TONES

One day when I was demonstrating drawing to a young student in class, as usual my eyes were wrinkled and crunched together as I peered at the model. The student's pretty face looked sympathetically in mine and she said, "Don't you think you really should see an eye doctor — you have to squint to see the model." I hadn't yet explained to the class the reason for this squinting. It may seem odd to do this, but the paradox is that you want to see *less*, not more.

Your eyes can betray you when you attempt to evaluate tone comparisons on a lighted subject. For example, stare at the part of the subject or model that's in a direct, strong light, and then quickly glance over to the shadow areas. At first, the shadows look very dark, and you aren't able to see many variations of change there. But the longer you focus on the shadows, the lighter they become. If you were trying to match those shadow tones in your drawing, you would continually make them lighter the longer you stared into them.

The common utterance is, "I don't know what tone to make it. It's different every time I look at it." This fluctuation of tonal values is caused by the continual dilation and contraction of the pupils. Conversely, when you squint, this dilation and contraction is greatly reduced, and tones fall into their proper relationship. When you begin a drawing, squinting also prevents you from being engrossed in detail. Your vision encompasses the total scene when you squint, creating a chiaroscuro or light and dark effect.

Squinting stabilizes tonal values and makes them easy to ascertain. So try to get into the habit of squinting or half closing your eyes when you look at the subject or model; keep your eyes open wide only when you look at your work.

William Mosby, one of my very capable and influential instructors, always put it this way: "Your drawing, with your eyes wide open, should look like the model does with your eyes half closed."

As you sketch from your cast or live model, try to make squinting a habit. Squinting works the same way whether you use photographs or a living model as copy; however, the effect is more subtle on photographs.

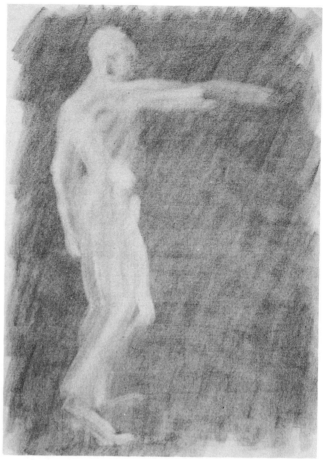

Step 1: *I spread on a middle tone. I don't want to make this tone quite as black as in the previous projects, because I prefer to have patches of black in more selective areas.*

Step 2: *A ghost-like image begins to appear as I wipe out the figure with a chamois. Most of the cast is in the light.*

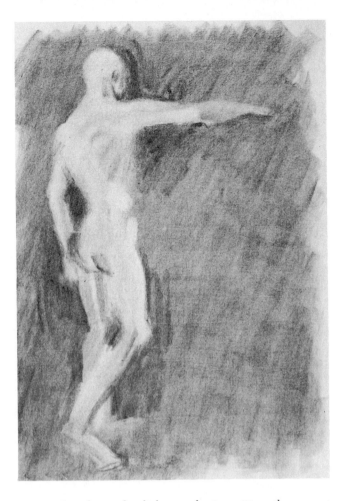 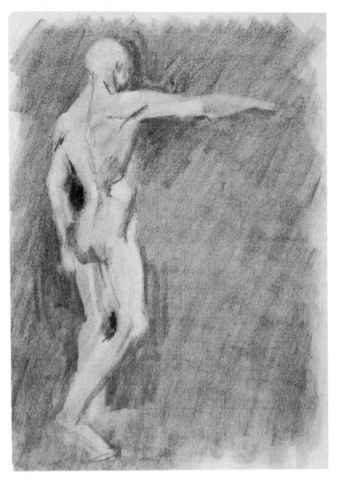

Step 3: *I reshape the lights to begin getting the correct proportions. I do this by shading (darkening) around contours. I also add a few halftones on the interior. I make some darker places in the background. These darker areas are part of my future thinking about the general pattern of tones for the whole drawing.*

Step 4: *I locate the extreme values, i.e., the very light and dark tones. The lightest tones are the highlights on the head, shoulder, and back. I put a spot of extreme black next to the lower back region. Another prominent dark spot goes between the legs. I add more in between or halftones on the figure. I also add alignment tones which focus on the spine, the underside of the shoulder muscle, the small of the back, and a halftone on the underside of the buttocks.*

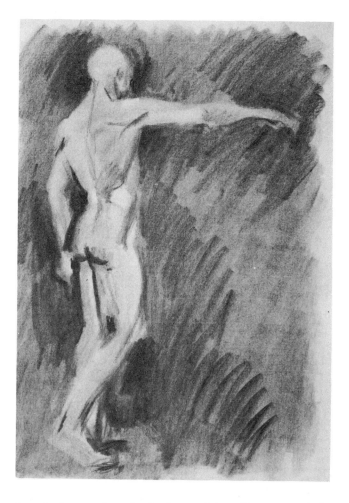 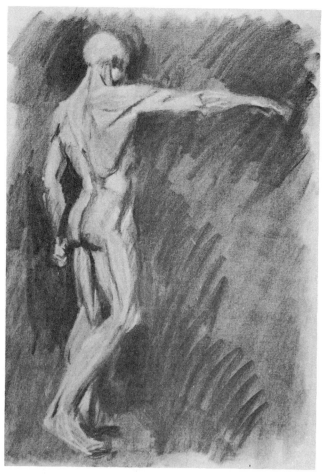

Step 5: *I strengthen the background by adding more darks, especially around the contour of the back. At the same time, by darkening these contours, I shape the periphery of the figure cast.*

Step 6: *Now, I pay more attention to and develop the interior surface, the tones, and accents. I pick out the highlights on the skull a bit more. I do more shaping of muscle structure through the back and legs with the addition of halftones.*

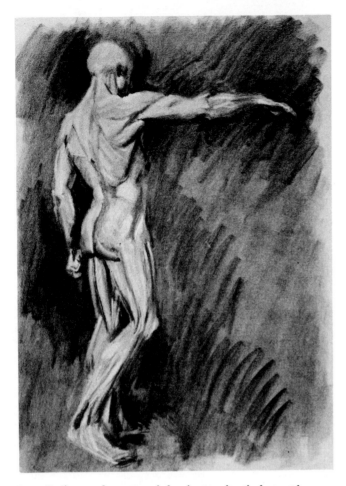

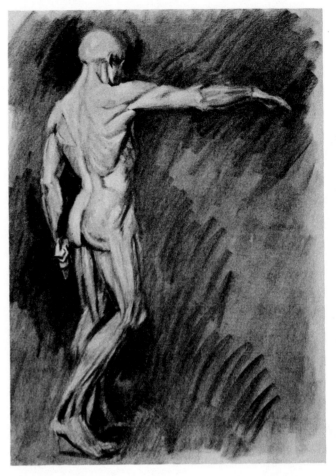

Step 7: *I'm at the point of developing details but with some restraint. This is the tedious part — refining the proportions and working in the finishing details. When I'm working out highlights, halftones, and shadows in small specific areas, it's easy to overlook their place in the whole context. I must soon adjust these to the over-all tone relationship.*

Step 8: *In this step it's important that I regain the large tone concept. The top half of the cast is generally lighter than the leg area. I have to subdue a lot of highlights and middle tones in the big areas. I also have to sacrifice some of the modeling in the upper back.*

Step 9: *For refinement I do seemingly opposite things. I bring out some accents and details; others I deliberately lose or subdue. I should point• out that in addition to being studies, these drawings should be statements of the total effect. I could have gotten too interested in details or fascinated with the muscle configuration. But these considerations must give way to the appearance of the whole cast as an object in the light. I have to de-emphasize the modeling on the cast to keep the drawing from being jumpy, i.e., uneven, and lacking in unity.*

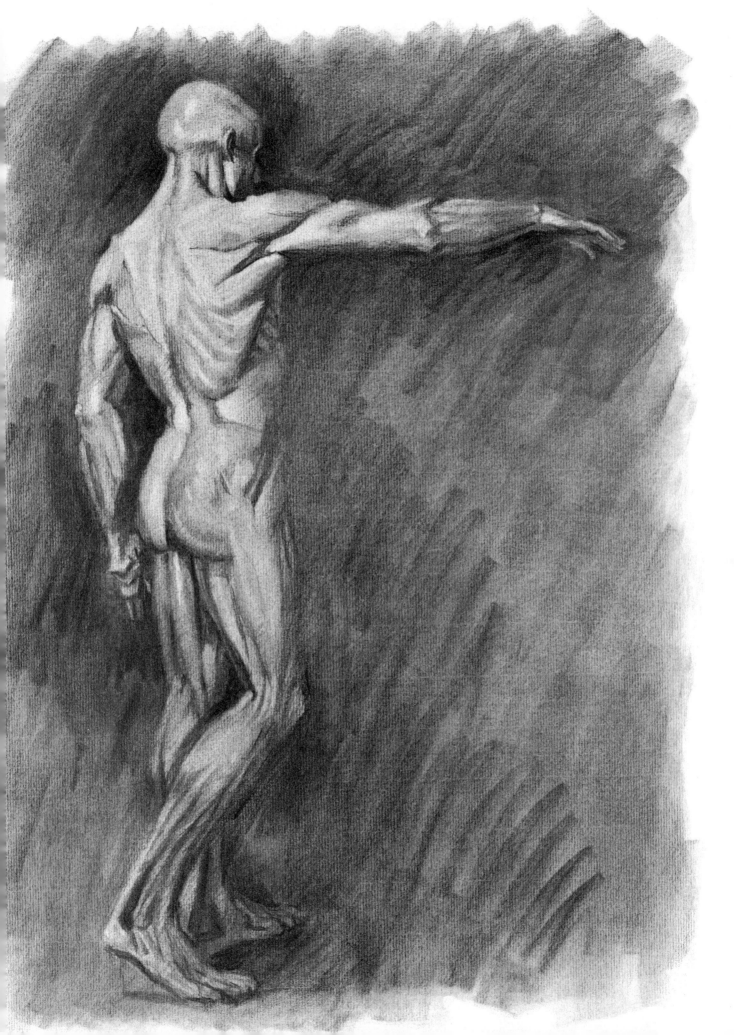

Figure A *This is an example of a high keyed drawing. The darkest tones used anywhere fall somewhere near the center of our ten tone scale. This key imparts a delicacy to the picture, even though the figure is muscular and rugged and the plaster is a hard material.*

Figure B *It's difficult to draw a white cast in a low key. No matter how dim a light I put on it, its natural whiteness offers temptation to follow the bright highlights. I force them down to a value around the middle of the tonal scale.*

PROJECT 6

KEYING
A
DRAWING

When describing the value of tones in drawing or painting, an analogy to music always provides the easiest explanation. An art student with knowledge of the musical scales and keys is one step ahead in understanding this analogy. But even if you haven't been exposed to musical terms, the concept of tonal values isn't difficult to understand. (See Figures A and B for examples of high and low keyed drawings.)

THE VALUE SCALE

The artist has what he calls a scale of tones which can be compared to the musical scale of the piano. The exact number of different tones that your eyes can distinguish is difficult to establish. It has been theorized that this scale is somewhere between seven and ten tones on a gray scale. But these numbers depend on the conditions under which these tones are studied.

You might be astonished at this low number of tones. It could seem to you that there are many more tonal values between that dark doorway and the intense glint of sunlight bouncing off that chrome! There are probably more than ten different tones between those extremes, but it's almost impossible to count them scattered as they are. The only way to compare tones is to arrange them next to one another.

Make a gray scale as I've done in Figure C. Lay out a row of ten squares, each about 1 1/4'' square. Start with a square of pure white (paper) and make the squares progressively darker until you end with black. Make each tone as even and smooth as possible. Do they have a distinct separation in tonal value? You'll notice that the edge nearest the next darker square looks lighter. This can be called a *double contrast force*. Not only do you react to the contrast of the squares to each other, but that reaction in turn forces an illusion of contrast within the square itself. You'll see later how this double contrast force will become a problem in determining values on the figure itself.

VALUE KEYS

The row of tones you laid out is the full scale of tonal values and can be called *full contrast*. In Figure C it's from arrow to arrow. Full contrast is known as one kind of a *key*. Most drawings are rendered in this full contrast key. Sometimes you might want to *raise* the key or make it *high keyed*. You then use, as the lowest tone, a value higher up on the scale as in Figure D. Reversing the mood, or key, you can begin with a lower tone and use a range in the lower end of the scale, as in Figure E. In both of these cases you play it in a "close" key — that is, you have to work in a, sometimes confining, narrow range of tones. For another key, use only the tones at either extremity of the full contrast scale, leaving out the middle ones for a special effect of great contrast. (See Figure F.)

When you're told at the start of your drawing to *key it*, you should immediately determine the middle tone as well as the two extreme tones. Find the darkest spot on the model or copy. If your drawing is going to be full contrast, make that spot pure black. Next, find the lightest spot and erase out that spot from the middle tone. You'll then have three basic tones of the key: the lowest tone, highest, and middle tone as in Figure G. (The middle tone can be in the area of the center arrow.)

Faults in drawing, like spottiness, holes in the figure, loss of form, edges turning out instead of going back, or any areas that come forward or retreat when they shouldn't are usually caused by ignoring the following rule. Divide the row of values, in the key you're using, at the center. Use only the ones on the light side of center for tones in the light and only the tones on the dark side for shadow tones as in Figure H.

INTERPRETING TONES AND THEIR VALUES

Shading a drawing to look exactly like what you see in sunlight, a spotlight, or any strong light is a problem because of the different light intensities you're working with. When a model or subject is in a spotlight, the subject is illuminated more brightly than normal; the subject is

also brighter than your paper. It's never advisable to have your paper in a brilliant light; it's a strain on your eyes. The finished work wouldn't be lit as brightly anyway. If your paper is sufficiently lighted, you'll notice that its tonal value is lower than the model in the spotlight. You can demonstrate this by cutting a small window in the drawing paper and holding it up so you can see the model through it. Compare the tones. Even white paper has a much lower value than the model.

Vibrations of light paint a picture with considerably more tones than you can ever reproduce using pigments. Pigments aren't sources of light, only reflecting or absorbing agents. The whitest of pigments and paper will *absorb* half the light that hits them. Black will reflect a great percentage, about 10%, of light back, making the black appear to be a very dark gray. The extremes of light and dark in nature can't be duplicated with art materials. Compare a color photograph print to a projected transparent color slide and see the difference. A stained glass window is another good example to use. It has a wider range of tones because light coming through the glass intensifies some colors while others are left in shadow.

Realizing the limitations imposed upon you by pigments and materials will save you a lot of frustration. Try to be satisfied with just an interpretation. You can't draw with light, but you can with charcoal!

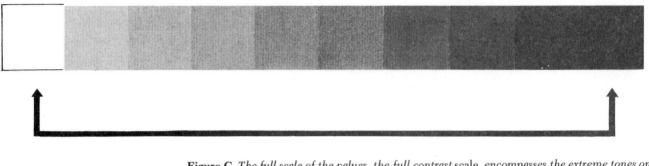

Figure C *The full scale of the values, the full contrast scale, encompasses the extreme tones on either end.*

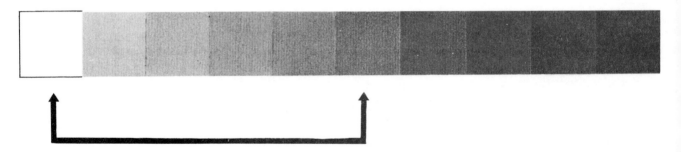

Figure D *The high keyed value scale begins higher on the full scale of tone values.*

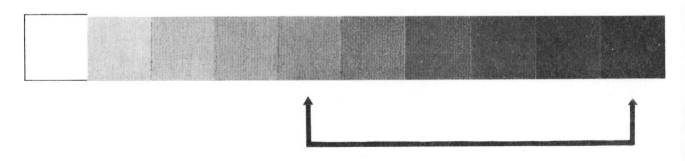

Figure E *Conversely, this lower key starts with a lower tone and uses the range at the lower end of the full contrast scale.*

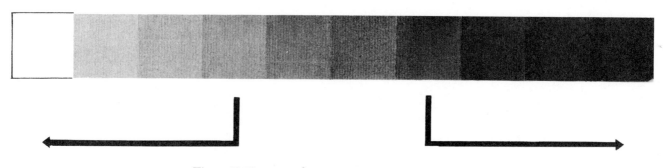

Figure F *Using just the extreme tones at either end of the tonal scale creates special effects of great contrast.*

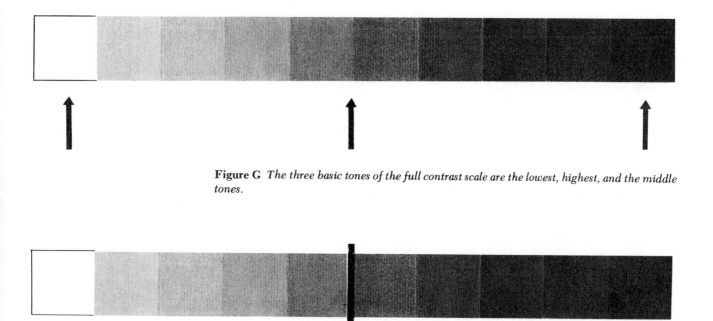

Figure G *The three basic tones of the full contrast scale are the lowest, highest, and the middle tones.*

Figure H *To avoid many tonal problems in your drawing, divide your particular key in the middle and use only those tones on the light side of center for tones in the light, and vice versa.*

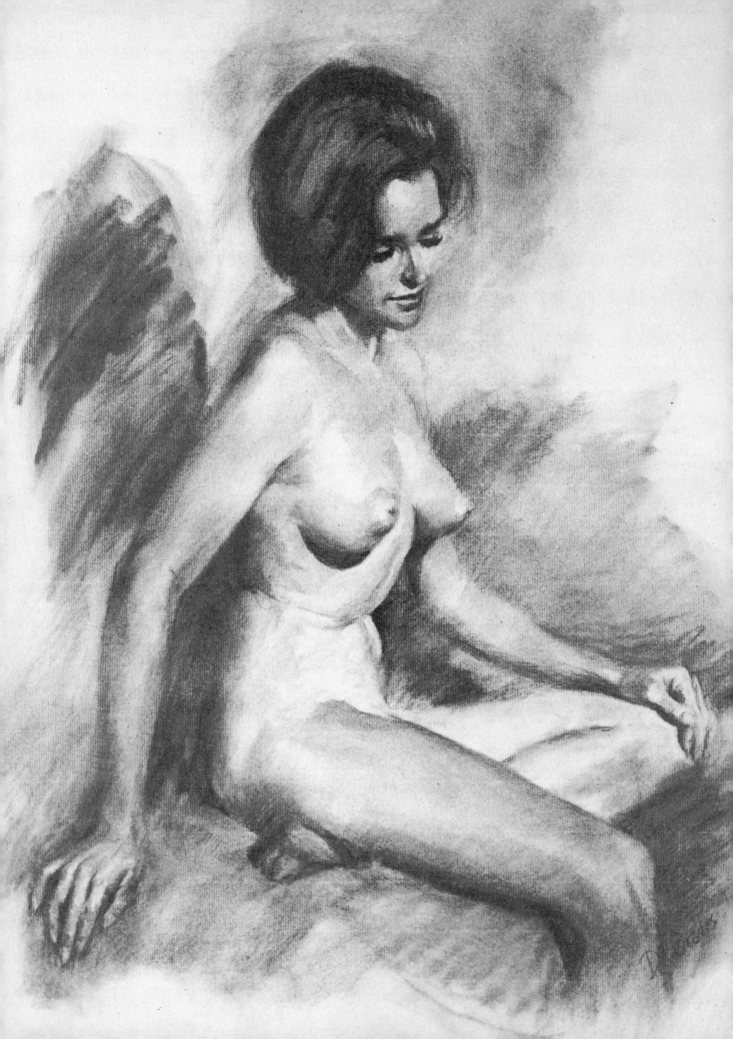

PROJECT 7

TRANSLATING
COLOR TO
BLACK AND WHITE

Comparing tones is the next important step that follows closely on the heels of the last project. The question is how do you determine what tone a particular color seen on a model will be on your paper? Previously, when you established the key, you nailed down three *key* tones which became points of reference: the highest or lightest tone, middle tone, and the darkest tone. These, then, are the basis for comparison in determining other tones. Pick any area that you're in doubt about. Squint at it, and ask yourself how it compares to the key tones. Which tone is the area in question close to? Is it as dark as the black tone, or closer to the middle tone? Always compare a particular area to two or more tones. You should estimate the quality of tones in the larger areas first. So another good habit to develop along with squinting is constantly comparing.

JUDGING COLOR INTENSITY AND TONE

I hope you won't be dismayed that I've slipped another still life back in at this place. I'm giving you a natural transition from project to project. Now that you're ready to work from the figure itself, one particular problem might trouble you. Before you weren't troubled by any color on the subject matter since you were drawing casts, etc. If you're going to work from live models yourself (not from my drawings), you immediately have to contend with various colors on the figure, different skin variations, hair color, lips, eyes, etc. (See Figure A.) If there's a costume on the model, this only emphasizes what I'm talking about. How do you turn those colors into black and white? In this project I recommend a still life consisting of all the white objects we've had plus the addition of something colored. An apple will do very nicely.

LIGHT AND SHADOW WITH COLOR

For the moment consider this thought. *Any* object in a simple light situation is going to have the same light and shadow elements as illustrated by the opening projects. It doesn't matter whether it's white, colored, or completely black. It will have a lighter side and a shadow side. Even jet black objects or black materials will show the effect of light hitting them. It's a very common mistake to draw a costume, such as black trunks or leotards, without any feeling of light on them.

Be careful to look for this effect. Remember I said that light and shade give an object form? Keeping that in mind, notice how (squinting) the light and dark effect on the apple is a whole range of values lower than on the white objects surrounding it. The lightest tone on the apple, excluding the highlight, isn't too much lighter than the shadow of the white objects.

Notice the slight lessening of color intensity as you squint your eyes at things. Objects with color are actually absorbing all other rays of light except the color they represent. If this is true, then the object will look slightly darker because of the loss of reflection except for one group of light rays — its color.

Figure A *Here you'll note that the areas of the figure that appear to be darker are the effect of the different pigmentations of the body. These must be translated from color to tonal values in the charcoal drawing. For example, the hair appears to be quite dark in the charcoal drawing unless the subject has very light blond hair. The extremities of an adult (face, hands, and arms) have an abundance of capillaries which give a reddishness to the skin. The middle of the body, that's protected from the elements, is lighter and a more delicate color. When transposing them to black and white, you can get the effect of those local colors by making the redder parts somewhat darker.*

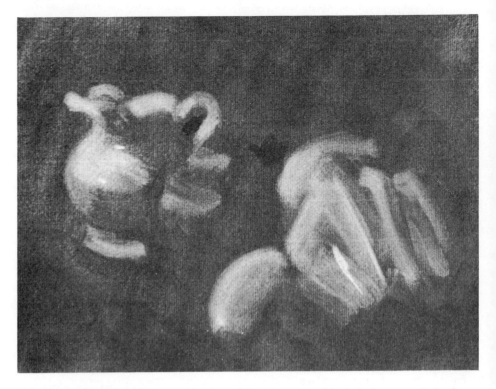

Step 1: *After laying in a fairly dark background to represent a black cloth in a spotlight, I start painting in the white shapes with the chamois. Notice the key tones — two black spots, and white highlights on the hand and on the pitcher. The apple nested between the other objects has the same basic tone as the background. With a couple of halftones for the two lightest areas on the apple, it begins to take form.*

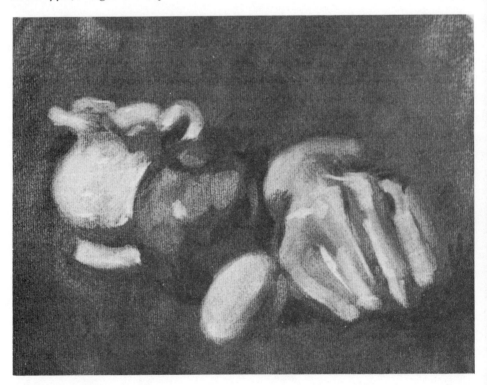

Step 2: *I need more contrast to show the substance of the cast, the egg, and the apple. I'll heighten the light parts on all the objects. To give peripheral shapes to the objects, especially the apple, I add many shadow areas. I establish the key tone of the apple itself from the highlight value to the darkest tone. The mass of the halftone around the highlight gives the apple its "shiny" texture. The reflected light from the hand is so strong on the apple and the egg that I indicate those, and I shade in the halftone shadows on the fingers.*

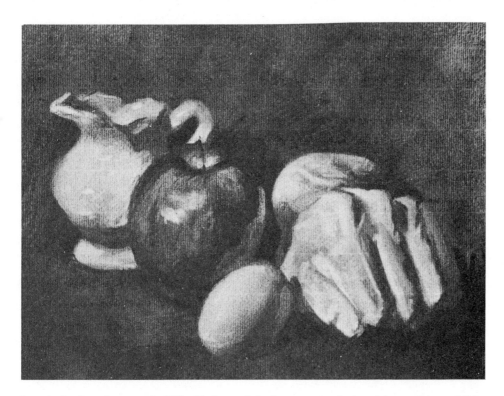

Step 3: *I refine shapes and add highlights and shadow tones to the lip of the pitcher. I add the stem and the streaks on the apple. I darken the bottom of the whole picture, but you'll see that I change my mind in the next step. The form of the egg is made clearer by working in more subtle values.*

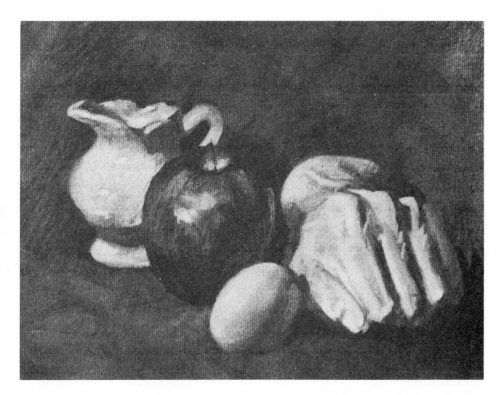

Step 4: *Softening is called for in some places, such as the light part of the hands. I raise the tone of the foreground but then add darks against the top of the pitcher to balance the pattern. The point of this demonstration is to show that by making the tones of the apple dark, it appears as if it has a deep red color to it. As I mentioned in the text of this project, compare the basic light tones on the apple to the shadow on the pitcher; they're about the same value.*

PROJECT 8

SOME BASIC
FIGURE PROPORTIONS

Let's approach the study of the figure the same way you've expressed simpler solid objects, that is, with concern for *external* appearances only. There'll be problems enough in the beginning, developing an eye for the pictorial aspect of the figure, without being burdened with all of its intricate, underlying construction. Save that for later. Your eye-taxing problem now is to search for the multifacets of lights, halftones, shadows, and their components. All these will soon enough reveal the construction of the figure beneath, when you've correctly indicated their shapes and tones on the paper.

TWO GOALS OF LIFE STUDY

There are two inseparable goals in a life class. One is learning proportions, actions, and the character of the human figure; the other is training the eye to see the subtle changes in tones and shapes on the figure. It's my belief that the first goal can be achieved by doggedly pursuing the second goal. Moreover, each pursuit enhances the other.

As a means of becoming a draftsman and expert on the human figure, there'll never be a substitute for working with the beauty and majesty of a nude model in the spotlight. To work directly from nature's most intricate and wondrous creature is to be endlessly inspired! Not only are the external features always interesting, but a good model can tirelessly show you that the body is capable of an infinite number of graceful, rhythmic, and strong dramatic poses. A student who complains about a pose or grumbles about having the same model all the time is either lazy or unimaginative. Many masters have used the same model for years. I wish it were within the scope of this book to furnish the effect of a live model. However, I believe that in most places today some kind of life class or workshop is available. I urge you to take advantage of it. If not, provide your own models. It shouldn't be difficult to have someone pose for you, at least in a bathing suit or leotard. Photographic copy should be the last resort.

When I speak of proportions, I mean the organization of all the parts of the figure into their correct relationship. Since you're concerned with *seeing* the larger part first, don't examine the details any more than necessary to give you a feeling for the correct proportions. If you're wishing for absolute rules for proportions, you'll probably be disappointed. Figure artists throughout history have used various proportion keys — many have devised their own. The only thing these masters might have had in common was to use the head length as a base. You'll have to be less specific in your thirst for axioms and accept a more generalized set of rules for setting up a figure. You must commit less to memory in terms of rules for proportions. You must gain the confidence to adjust your drawings to what you observe in the model before you.

ESTABLISHING PROPORTIONS

The problem at this point is how to set up a simple standing figure in a given area and make its proportions correct for that size. Discipline yourself now to always prepare a figure for a certain height or size and a definite spot on your paper. Placement and size of figures in illustration or painting shouldn't be left to chance. It's necessary to be able to easily manipulate these factors for the sake of the composition.

In a standing figure, the procedure is to make a mark for the top of the head and another for the feet. If the balance of the figure is fairly formal, place a very light vertical line to indicate approximately where the figure will be — left or right. If an arm is outstretched, be sure the figure is placed so that the arm clears the edge of the paper. I've seen students crippling or withering an arm dreadfully after a bad placement, trying to get it all on the paper. If you can't bear to start the figure over, it's better to run the arm off the edge — at least what's on the paper will be correct! In a future project, I'll explain how to compose the figure on the page for proper balance.

Divide the distance between the marks for the head and foot into eight equal parts. Now that you have established

the placement and divided the height, you need to begin fashioning a base to build the figure on. This I'll call the *gesture tone*.

Study the model or copy a minute. Then, taking a stubby piece of charcoal start in the top eighth division making a series of arm swinging ovals for the head. Break from this on a downward swing through an imaginary line for the center of the model's body. At the halfway mark simulate the direction and action of one leg. Make a loop for the foot and retrace your path up that leg to the center junction. Indicate the other leg in the same way. Travel back up that leg tone and continue on up the middle to a point about half a division below the head. Swing back and across to indicate a base for the arms. In the same manner as with the legs make a tone for the general action of the arms. The length of each arm, measured from the pit of the neck to the fingertips, will be comparable to about four heads. Be careful here! That distance depends upon the arms not coming forward or going back in any direction. Here's why memorizing rules for proportion relationships in terms of numbers is faulty. For example, if an arm is extended toward you, it no longer appears to be the length of four heads.

STAYING LOOSE AND FREE

Don't feel that this first swing you've taken through the figure has to be absolutely accurate. In fact, the looser and freer you are, the more likely your figure will be in proportion. Also, the tone can be heavy and wide because you need a solid foundation to work on. This is more than a stick figure. From it you're going to get both the actions and proportions for the figure. Furthermore, you'll have a base of material (charcoal) on which to model.

The steps in continuing this drawing are the ones used in the previous projects: squinting to see the simplicity of tones making up the effect of light, establishing the key of the drawing, and from there on comparing one tone against the other.

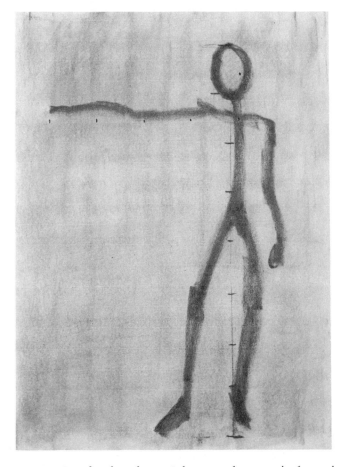

Step 1: *For this first figure I begin with a simple forward standing pose, with one strong, side light. I tone the whole background with a light, over-all middle tone. I strike a vertical line, and mark off eight parts. Four of these units I'll use to position the figure on the page by establishing the length of the outstretched arm with them. This forces the body over to the right side of the picture so the hand won't be cut off. Don't habitually start a figure in the center of the page. I make the gesture tone starting with the head. Although I use eight units (heads) for a base, the figure will be less than that.*

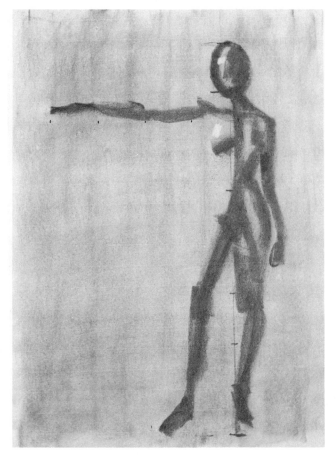

Step 2: *The body form I put in more heavily on the shadow side to get some substance and shape. I use two white spots of highlights in their approximate positions to key the lights of the drawing. If you'll notice, the feet slant down, indicating that my viewpoint is high enough to show perspective at the feet.*

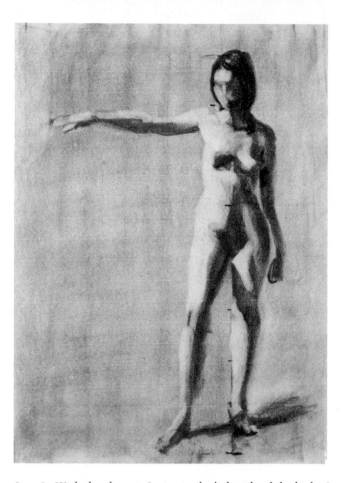 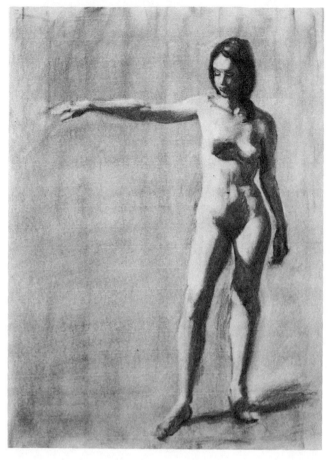

Step 3: *With the chamois I wipe in the light side of the body. I put in the dark hair tone which shows how the head is turned. It adds to the height of the crown, above the head mark. I then can vaguely position the eyebrow line with reference to that and the chin.*

Step 4: *Next I go over the whole figure correcting the contours either by adding tones or wiping them out. Noticeable changes occur where I raise the light shape on her left thigh and lower her right hip. This gives the proper swing to the hip area.*

Step 5: *I readjust some tone values — especially in the middle area. They're too hard, and some around the navel, too dark. I soften a lot of tones with the sponge. I do more work on the head to complete a very basic study without any frills.*

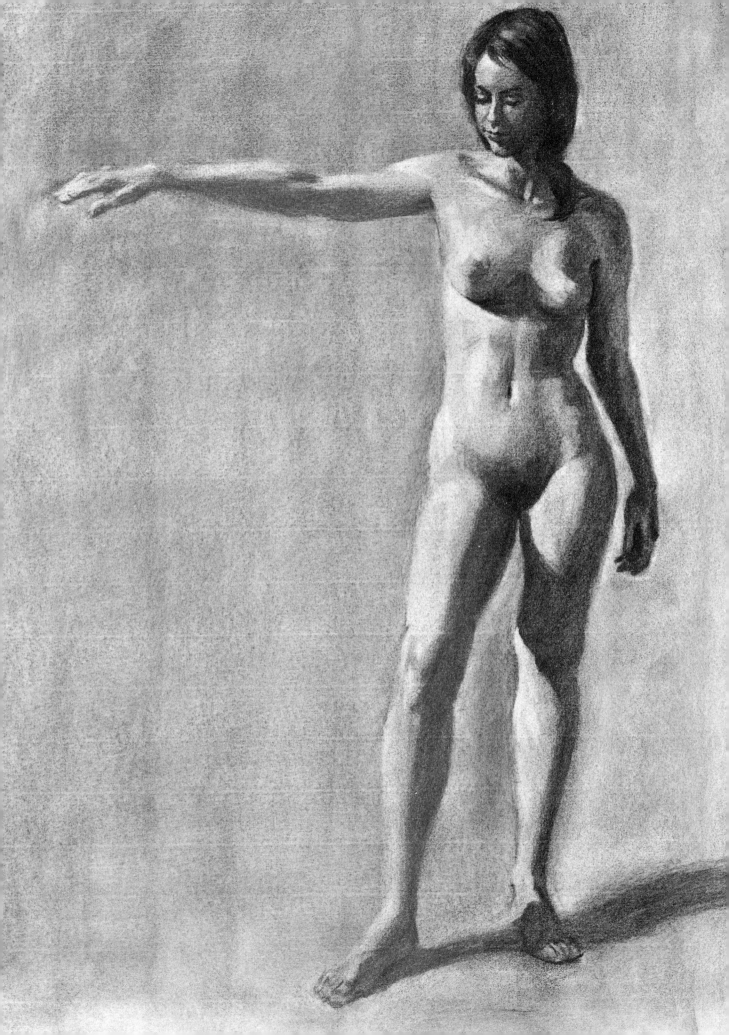

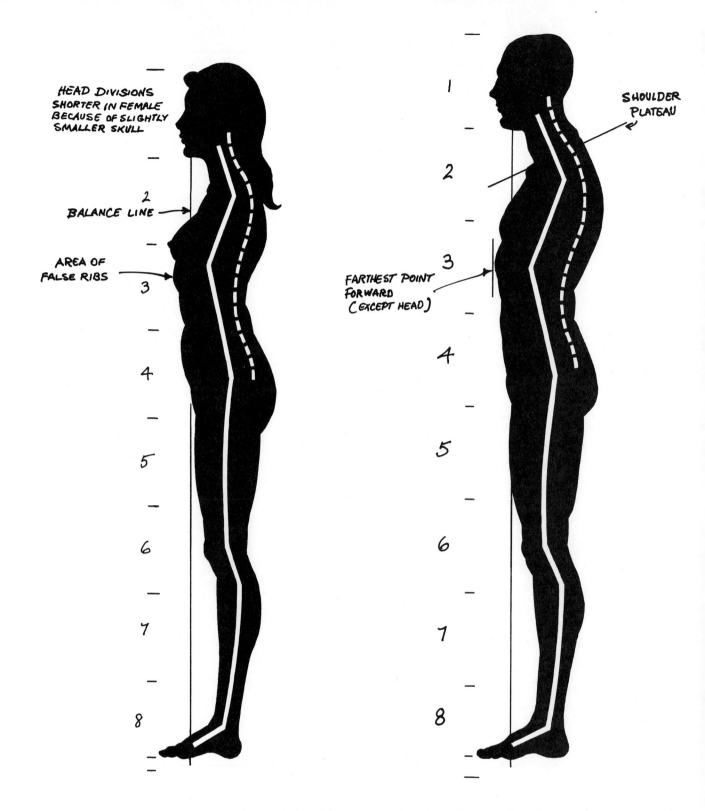

HEAD DIVISIONS SHORTER IN FEMALE BECAUSE OF SLIGHTLY SMALLER SKULL

BALANCE LINE

AREA OF FALSE RIBS

SHOULDER PLATEAU

FARTHEST POINT FORWARD (EXCEPT HEAD)

Figure A *(Left) and* **Figure B** *(Right) These silhouettes show the general configuration of the spine (dotted line) and the action line (solid white line). The action line in the trunk follows the spinal column somewhat. The action line isn't intended to imply a bone structure; it's imaginary and should only serve to get more swing in the side view. The academic figure traditionally has been seven and a half heads, but I believe vitamins are pushing us toward an eight head figure. The eighth head is marked in these drawings if you want to stretch the figure to its ideal length. The balance line is seen from the chin to the ball of the foot. I think it's easier to locate than a line from the center of the head to the instep. Notice the longer chest line in the male; conversely, the longer middle line of the female.*

Project 9

KEEPING THE FIGURE FROM LOOKING "STIFF"

"Why do my figures look wooden or stiff?" students often ask. Stiffness in figures is usually due to a few simple faults in forming the figure's main action line. I'm using the word *line* in this project to express a direction or flow. *Action,* as it's used here, doesn't imply physical movement, but rather a condition or expression of attitude whereby the figure seems alive and ready to move.

When the human being is standing, his posture isn't as ramrod straight as you might imagine. Upon careful observation, you'll discover that from the side view the main action line (using the spine as a base) has a natural curvature. In other words, it has a "set" curved action from that view with very little capability of changing except through the central or lumbar region (bending) and the neck (moving the head). Since the spinal column only has the ability to bend forward in the center and flex at the neck, plus its "set" curvature, you have to get more action by the addition of other parts of the body with their inherent action lines.

EXAMINING PARTS OF THE BODY

Working from the head down on the side aspect of a standing figure, you can make the following observations. (See Figures A and B and their corresponding numbers.)

1. The neck doesn't grow straight up out of the body like a tree. It does, however, arise almost perpendicular to the shoulder plateau. This plateau slants forward, jutting the neck out at an angle, and thereby thrusting the head forward. What fools you about this angle, is the vividness of the long straight neck muscles attached behind the ear, dropping almost straight down to the collarbone, as you'll see in Figure C.

2 and 3. The action line of the neck merges with the line of the chest which goes in the opposite direction. So the farthest point out front is the body at the lowest part of the chest cone. (The female breasts will generally protrude beyond this point.)

4. The top of the hip bone tilts forward, making the action line in that area of the body retreat. Therefore, a line connected to the chest line angles back down to meet at a point near the top end of the thigh bone.

5. The thigh bone here dictates the action line which drops almost straight down, but with a gentle arc to it.

6. Think of the upper and lower legs not as continuous but rather as overlapped. At this knee area you'll see that the action goes backward once again.

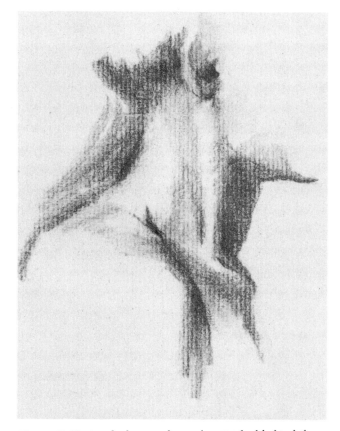

Figure C *Notice the long neck muscles attached behind the ear dropping almost straight down to the collarbone.*

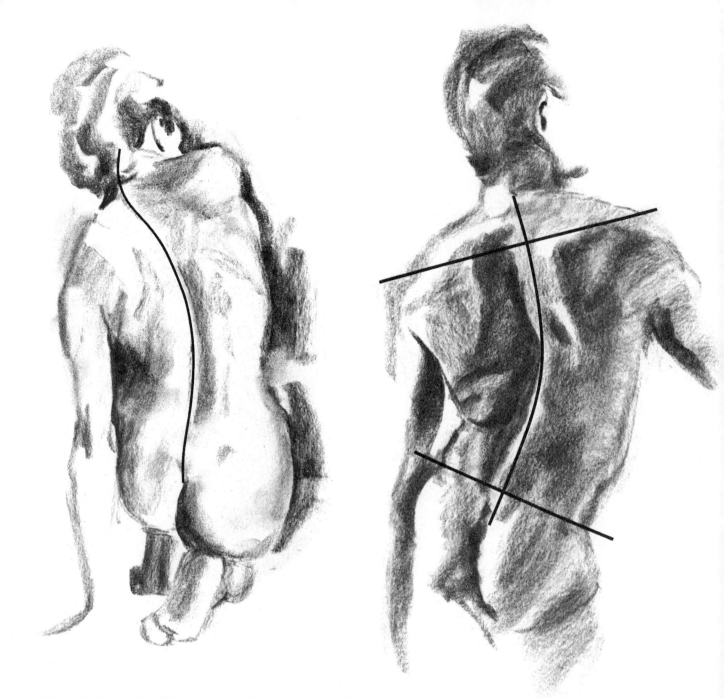

Figure D *More of an "S" curve is produced in the normally straight spine by tilting the head to one side.*

Figure E *Whenever the center of the spine bends, the lines of the shoulder and hips always swing away from each other in opposite directions.*

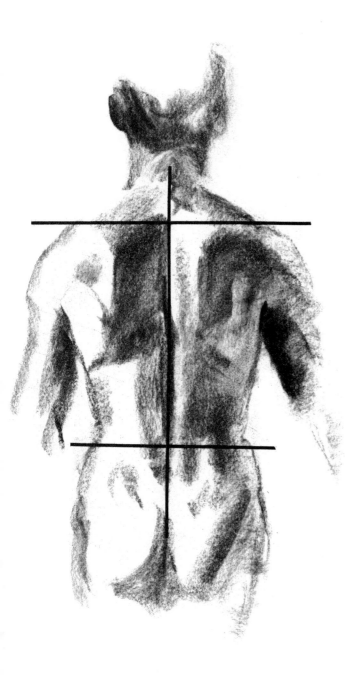

Figure F *When the spine is straight, the lines of both the hips and shoulders are parallel to each other.*

7. From the knee, the action line arcs almost imperceptibly forward as it falls to the feet.

8. At the feet, curiously, the action line has returned to a point where the ball of the foot has aligned itself directly under the chin. If a figure is balanced on one foot, *that* foot will always be in alignment with the chin. If the figure distributes the balance over both feet, the chin will be directly over a point *between* the feet. (This detail of balance happens regardless of viewpoint.) If you study and apply all of these facts, they should keep your figures from looking stiff in the *side* view.

MOVEMENTS OF THE SPINE, SHOULDERS, AND HIPS

From the front or back view any action or curves that occur depend upon how the body has positioned itself. Normally, the spine is straight but it can assume, in either direction, a slight curve through the central region. More of an "S" curve is achieved by an additional movement of the neck vertebrae, tilting the head to one side or the other as in Figure D. This sideways movement of the head manifests itself in the way the line of the shoulders and hips behave.

At the points where the shoulders and hips cross the spine, they form right angles to the spine and that configuration is quite rigid. Whenever the center section of the backbone bends, the lines of the shoulders and hips *always* swing into opposite directions from each other (Figure E). These shoulder and hip lines are only parallel when the middle part of the spine is straight. (See Figure F.) This opposite movement of the shoulders and hips is one of the most important aids for imbuing the standing figure with action.

THE EXPRESSION OF ACTION

The neck bones and, to a slight degree, the chest vertebrae are the only parts of the spinal column with the ability to rotate. In 3/4 angles, you have a combined effect of these front and side actions which helps eliminate the "stiffness" problem. You're mostly bothered by this rigid look in figures when you have a standing or walking pose. Any pose that has a lot of contortion furnishes its own solution to the action problem. Additionally the human slouches or contorts himself in ways that stray from an ideal figure. A certain amount of these kinds of characteristics can give more action to the figure, but they must be handled with care lest the figure become some sort of a cartoon. Also, each model has a body uniquely his own!

There's a difference between a figure at rest but having action (that is, life) in the lines of the pose, and a figure seemingly caught in motion (physical activity). I'll discuss, later, action as applied to the physical movements possible for a human.

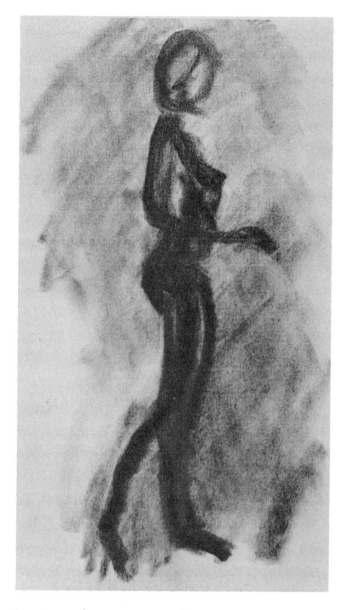

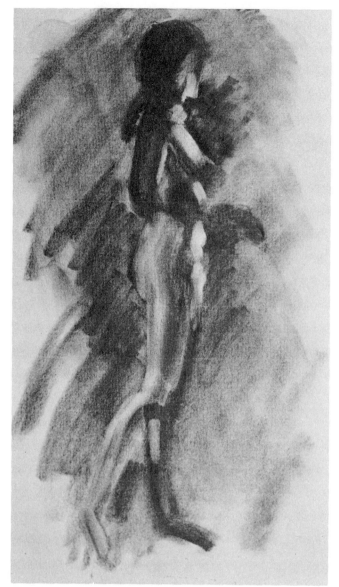

Step 1: *Smudging in just enough tone in the background to surround the figure, I put in a very bold gesture tone. Going farther than the kind of stick figure of the last project, I get as much of the body shape as I can in the dark, gesture tone.*

Step 2: *Several things are accomplished in this step. I wipe out the light shapes, the main ones on the front of her body and the secondary light on the lower back. This particular view needs some backlight to give form to the figure. However, I don't want to dwell on reflected lights at this time. To have enough contrast between the figure and background, on the front side especially, I add more tone to the background. I tone in the general shape of the hair.*

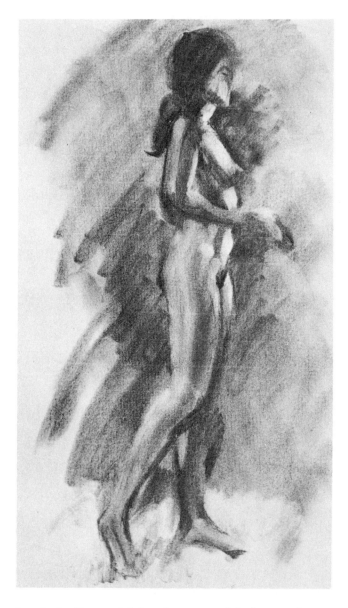

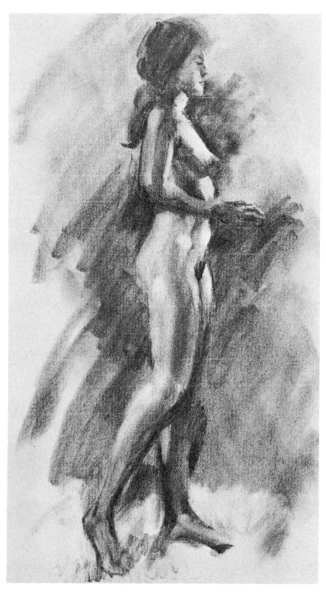

Step 3: *At this stage I define the contour of the figure to show its "action." I darken the underside of the jaw and make a light shape for the neck. Notice the angle this light makes thrusting the head forward. A more definite contour for the chest cone establishes the farthest point "out front." I have already shown the slight arc to the thigh, but with my finger I locate the spot for the top of the hip bone. In that area, the contours of the belly as well as the thighs are defined. These tones, plus the spot for the pubic hair, throw the angle of the hip in its tilting position. The feet and legs are given more shape locating the termination of the "action" line.*

Step 4: *A few more shapes are added to the back of her head. One at the top is a sweep with the side of the charcoal that leaves almost a line but a slight tone also. A very casual, curved shape at the upper part of the back is all I need for the final hair shape. The nose and mouth are added. Using a sponge and pulling some of the tone from the underside of the jaw, I'm able to make the side of the face. Fingers are vaguely indicated. Her buttocks are lightened and brought out and back. This emphasizes the action still more.*

Step 5: *(Following page) This final stage is the polishing stage. I do this by sharpening details like the line of the eyebrow and darkening the nostril. I define the lips by darkening the outside contour and lifting a tiny light on the top lip. I do more shading on the jaw shadow making it smoother. A few wide sweeps of really dark charcoal show the curls of hair on the front of her shoulder. Using a sponge, I soften the arm tones and the edge of the shadow along the breast. Then coming down the leg the dark spot in the background is made into a longer shape to give a base to this background.*

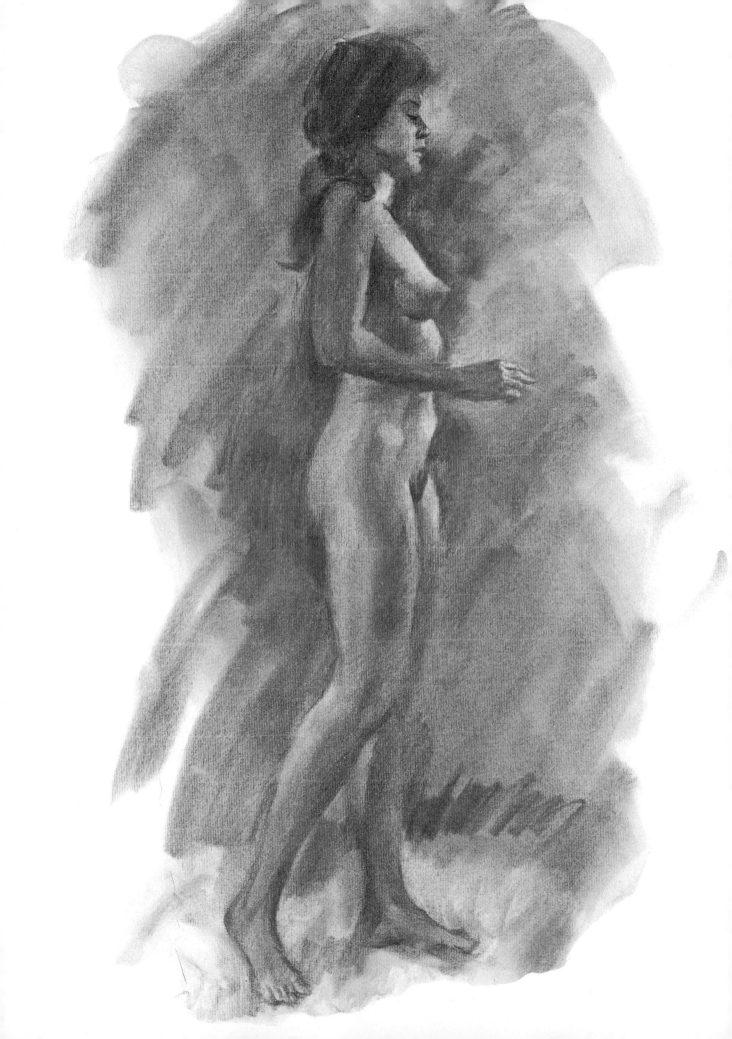

PROJECT 10

SEEING LARGE TONAL MASSES

You'll note that I refer constantly to *seeing* throughout this book — seemingly more than to drawing. Naturally you can't draw without seeing, but when I speak of seeing, I really mean *observation*. Developing your powers of observation is essential to improving your draftsmanship. It's startling to find that you can go through life seeing but not really observing. In the program of a good art school the study of life drawing should be, and generally is, a mandatory subject in the first part of your training. But the student may not realize that while he's learning to draw, gentle fingers are raising his eyelids to reveal things he's never noticed before.

MASS VERSUS DETAIL

In a previous project I made the statement that you should see the simpler, larger masses first. Looking for the larger masses is difficult because the natural tendency is to drift toward developing the details. You begin to discover that there's a tug of war: your vision must struggle between expansion and contraction. You learn gradually that it's more important to look at the over-all concept than to see the specifics.

In your first stages of learning, you have to constantly curb the urge to dwell on minor items. You must push yourself back from the tendency to zero in on particulars. For example, when you have trouble with proportions there's generally an error in the larger shape. It seems so obvious that the smaller shapes can't fit into an incorrectly shaped container — which is one way to think of a larger mass. If enough thought and time are given to drawing the larger shapes, then the smaller items will fit into place. You'll have solved many of the detailing problems early in the drawing.

SIMPLE STATEMENTS IN TONE

I've spoken of the larger masses only in terms of shape. It's also necessary to reduce *tones* to simple statements. This, too, is difficult because careful observation can reveal many nuances of tone. The reins have to be pulled back again. Can you, at first, simplify an area into one statement of light and dark? If there's just one light source, this usually can be stated as one tone for the light side and one for the shadow side.

On a toned paper if you're permitted to use only two simple masses of tone — without carrying the statement farther — you can make a reasonable indication of the figure. If you can resist the temptation to be more specific and you devote all your energy to getting the proper relative tones and their shapes right, you'll have the solid beginning of a drawing.

STAYING WITHIN THE LARGE TONE

Continuing this practice of working large masses first, the next logical step is to break down these already established areas into the next largest components. In developing the smaller tonal changes within the larger changes, always stay inside the confines of the big basic tone you've shaded in. You probably shouldn't vary any part of it more than one tone lighter or darker. For example, if the greater mass has been laid in as the eighth tone on the gray scale, then it shouldn't change more than one tone on either side — to either seven or nine.

As you break these down further, you should stay increasingly closer in tone to the previous changes. It's important that you keep within the context of the big statement; otherwise, loss of form will occur and the drawing will look spotty.

If it seems difficult to get beyond a certain point in shading in the more subtle tones, then I'd stop — always on the side of simplification. If only two or three of the stages we've talked about produce something fairly explicit, then stop while you're winning. It takes increasing application and practice to see and control the rendering of the gossamer tones that give a drawing that polished look. However, by constantly honing your powers of observation on the larger impressions, you'll eventually see more and more subtleties.

Step 1: *I start with a tone on the paper as usual. The tone goes beyond the figure, at least far enough for a vignette effect. How dark to make it depends on the total subject. If the background and figure are both fairly light, then it isn't economical to put on too much charcoal. The subject seems to call for a light middle tone.*

Step 2: *With a short piece of charcoal held on its side, I make a broad, sweeping gesture configuration. This should be a fast stroke — almost in one continuous motion. In this project, I'm trying to be more definite in my first statement. You'll notice some parts of the stroke are lighter, some darker. I'm already starting to think about where my big lights and darks are going to be. Notice the "S" curve down the middle of the figure. This is a "basic action line" of the figure.*

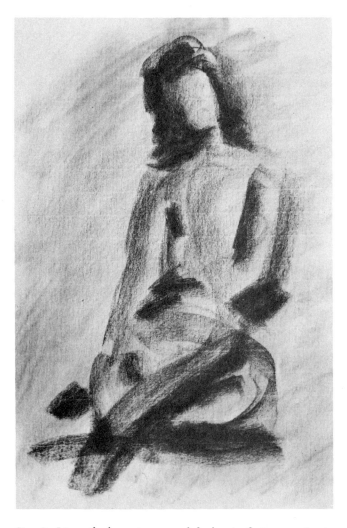 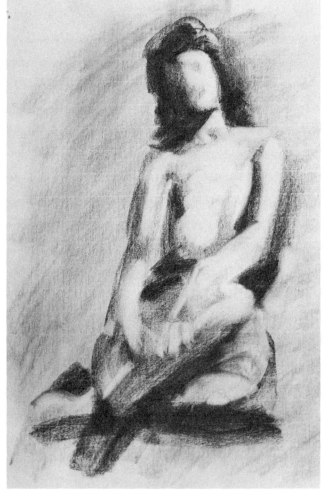

Step 3: *I tone the largest masses of shadow in their approximate position on the gesture line. They can be simple and nearly all the same tone. Even at this early step, I make these tones as near the big basic shape as I can. If they aren't correct, I'll be in trouble later. These passages will be drawn more slowly and deliberately than in the last step.*

Step 4: *Using the chamois I wipe out in a simple statement the areas of the main lights. Now the original gesture line is almost obliterated. Notice that as I wipe out charcoal on the face, I leave a little tone in anticipation of where the eye is going to be. I also wipe out some tones to approximately indicate the fingers.*

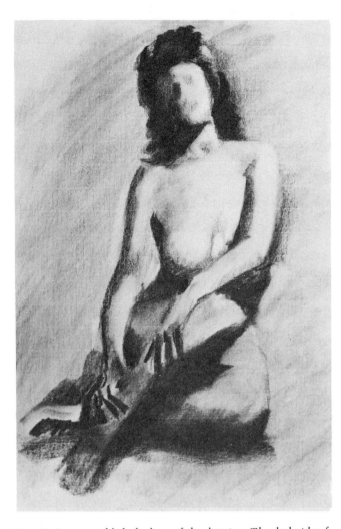 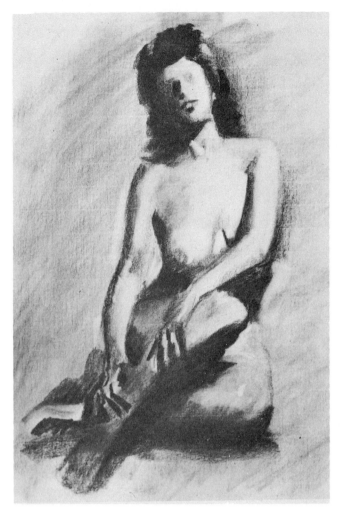

Step 5: *I now establish the keys of the drawing. The dark side of the hair is to be as black as I can make the charcoal. The largest and lightest area is on the breast. I've waited longer to do this than I'd normally do because the key tones are larger spaces and close to the big tones. I consider some of the darks of the fingers as necessary now. Some of the middle tone expanses on the chest are adjusted, also the tones on the arm. Back to the legs, I merge the shadow that goes around the leg with the ground shadow. I give more curve to the angled leg and darken the form of the cast shadow on the other leg. That shape gives a clue to the construction of the foreshortened leg.*

Step 6: *Now I feel the need to draw some of the smaller basic shapes. All I have to do is reshape areas a little bit, like the forehead, or strengthen a smudge I'd made before indicating the nose. The very simple shapes of the lips are drawn in. I lift out a small light at the throat. I'll show some effect of color around the nipple. I've put more tone on the back of the upper hand and lift out more lights on the fingers to produce a truer shape.*

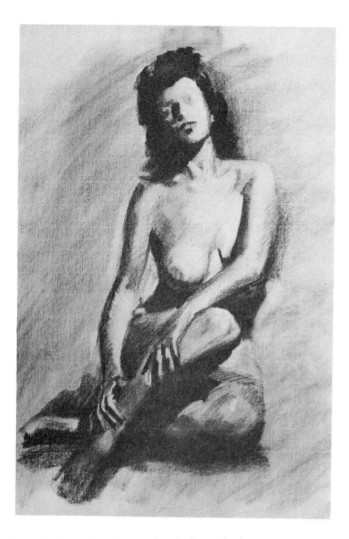

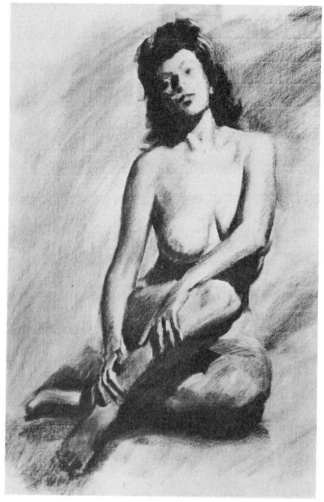

Step 7: *Now's the time to break down the larger masses into smaller components, always based on the larger concept. This stage and the next one take the most time — the period when all drawings are a struggle. The noticeable change is in two areas; across the chest and around the legs. See how I've changed the tone over the breast slightly and altered tones to show the anatomy of the collarbone area; notice how the tone around the knee brings it forward.*

Step 8: *I feel that her right upper arm is too short, so I change that. I feel that I can bring out her left side by darkening the upper background slightly. Erasing a sharp edge along the outside of the arm and the partly hidden breast, I define that side of the figure. Now it's a good idea to go back to her right arm and sharpen it too. I carefully tone it darker until the outer edge is a sharp, dark edge. I make small spots where the pupils of the eyes will be and add light tones for the eyebrows. Using the puff I've softened areas on the chest and arms and also intentionally lost some edges.*

Step 9: *(Following page) Now come the details. All I need are accents to strengthen what's already there. This stage should go the fastest if I've been careful in the previous steps. I've changed the hair shape slightly and worked out the facial features. I darken the smudge for the pupil of the eye and work the eyelids around it on both eyes. I accent the eyebrows. The lips were about the right shape; so taking a pointed kneaded eraser, I pull out the light on the lower lip corner and make a light line under the dark part of the upper lip. An accent line is put in to show the pressure of the arm against the thigh. With the kneaded eraser the last thing I do is pick out any highlights that have been lost.*

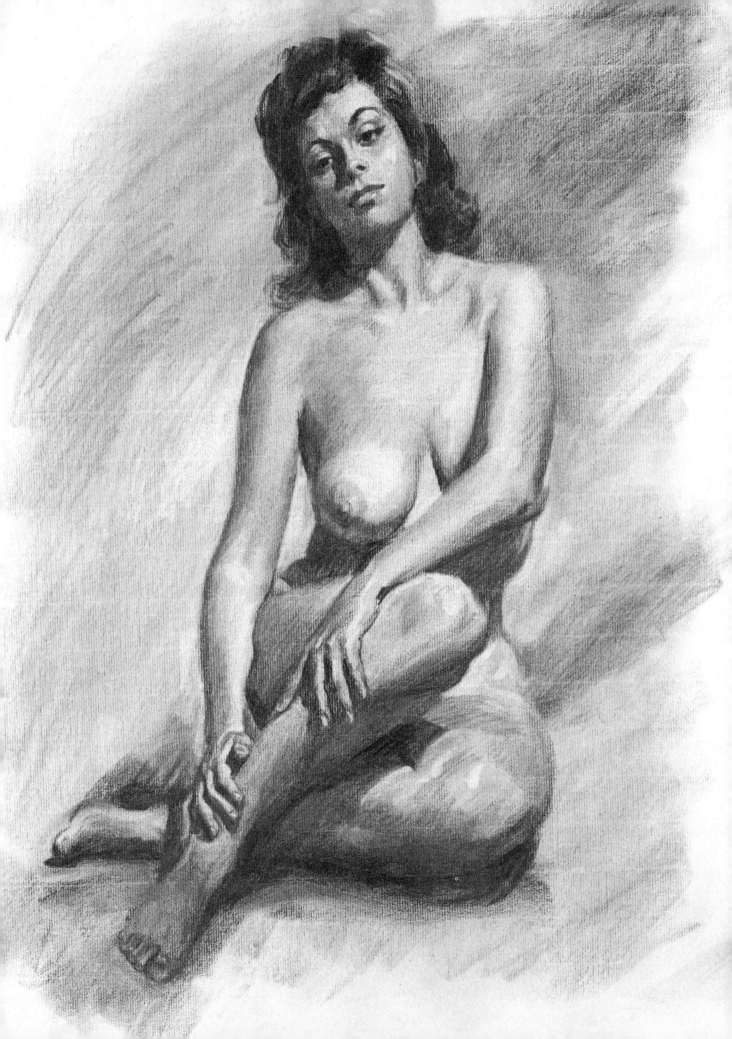

PROJECT 11

ALIGNMENTS: CONSTRUCTIVE AIDS TO CORRECT PROPORTIONS

In Project 4, I left you with the thought that there was more to draftsmanship than just being good at drawing a beautiful eye, ear, or nose by themselves. Assembling all of these parts and placing them in their proper relationship becomes the next problem. Mastery of this relationship of parts to the whole is the essence of attaining proficiency in the craft of drawing.

CHECKING RELATIONSHIPS BY ALIGNMENT

A student watching me demonstrate will ask, "How do you expect us to know where to put all of those smears and smudges exactly, unless we make an outline to tell us where they go?"

It may seem as if the figure is already mysteriously there — ready for me to see and reveal. But there's no mystery. While I'm wiping out the charcoal for parts of the figure, I'm carefully checking the interrelationships of all parts of the figure by alignment.

If there's any secret to this kind of alignment, it would be that my vision is split or spread out, so that I'm looking at two different parts of the model at once, coordinating their relative positions. Preferably, I try to spread this "split" vision as far apart as possible. For example, while observing the head of the model, I'm looking at the foot also. As I look at the foot, conversely, I notice how the head is positioned in reference to that foot, continually relating. Besides looking at the model with this separated vision, I constantly watch the placement of the parts with regard to the two dimensions of the paper and picture.

ALIGNING BY TRIANGULATION

If you find it difficult at first to develop this *sensory* way of looking for alignments, a more *mechanical* way involves sighting. To do this use a straight-edged object, like your stick of charcoal, as a sighting device. Looking at the model, line up the head over the weight bearing foot — the balance line (in a standing pose). Along that line from the head down to the foot check the points of the body that it touches or goes through. Establish these in your rough layout.

The next step is to find a part of the body to the right or left of the balance line, such as an arm or leg. Its approximate position is at some angle out from the head. Sighting at the model, align the straight edge of the charcoal on whatever angle this part of the body is from the head. Carefully holding the charcoal stick to retain that angle bring the charcoal down to your paper and draw a line to where this new body part will be. Now, look at the model from the foot up and out to this same body part and determine that angle by bringing the charcoal stick down to the paper again and drawing a line. Where the second line crosses the first one you drew out from the head, you should find the location of the new part.

This is one example of simple geometric triangulation which can be used for checking other relationships. Note these in the demonstration steps. Practice this sighting technique even when you're not drawing. Squint one eye and see how the world is lined up.

USING LINES FOR CONSTRUCTION

I hope I've begun to convince you that a line isn't an integral part of nature. With a mass drawing technique, you shouldn't have to start a drawing in an outline fashion. But now let's see how you *can* use lines. We'll make use of them only as *constructive aids* in our middle stages of the drawing. These imaginary flow lines I'll call *alignment lines;* they can be straight or curved. Often one of these long, sweeping, curved lines goes down along one side of the figure, continuing across the body at the hip to follow the inside of the thigh. Other examples, seen in a front or back view, are flowing lines along one arm and continuing across the body to the opposite arm. On the slightly turned front view imagine a curve around the back of the head, coming down to bisect the center of the body in the front and continuing down the thigh.

In the demonstration steps the center line is shifted to one side showing the turn of the body. I found another

alignment — almost a straight line — along the outside of her left thigh continuing past the knee, cutting across the shin bone to the inside ankle contour. I should point out that these alignment lines don't follow the contour precisely. They're not intended to include any details. They skim smoothly over the figure, often going through or behind a part or parts. These can be drawn in, but keep in mind that they'll be erased out again. After construction lines have served their purpose, they're of no esthetic value in a strict tonal or mass drawing.

ESTIMATING CONTOUR ANGLES

I include in the alignment process estimating the degree of angles caused by contours. Judging an angle correctly is tricky. It seems easier to estimate an acute angle than one that's obtuse. You have a choice of estimating the amount of an angle by either looking at the inside or outside of it. Notice in my demonstration the figure's left hand. Moving your eye around the outside of the bend in an arc, note the distance it has to travel from the lower boundary of the arm to the top edge of the hand. The inside angle of the arm is a much shorter distance between these boundaries, therefore easier to duplicate.

Making a facsimile of a curve is another difficulty. A simple way to construct a curve is by using a series of straight lines. It's the difference between drawing a circle and a straight-sided shape like an octagon. You'll find it simpler to draw the octagon first; then round off the corners to form a circle.

All of these construction aids serve as a means of verifying the relationship of the pieces to each other. Think of the figure as a whole unit. This unit is the sum of the parts and their correct juncture with each other. The parts are secondary in importance to the way they're integrated. Practicing alignment will make you aware of this. Your sight will embrace the larger entity. Don't worry about the particulars; they'll fall precisely into place, if the greater concept is exactly right.

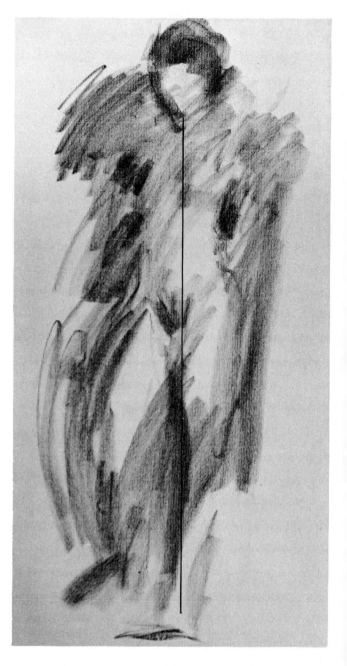

Step 1: *You probably think I'm inconsistent in the way I start each drawing. It doesn't matter as long as each way is done in a tonal mode — that much I'm adamant about. This is a loosely sketched image of the figure and the background adjacent to it. Notice in this layout I attempt to get a feeling of the tonal pattern. It doesn't mean that I'm pledged to those tones, but to be economical, you should try to get as close to the basic ones as soon as possible. However, don't worry if you don't hit them on the nose at first; with charcoal you have freedom to change. The solid vertical line indicates the balance line.*

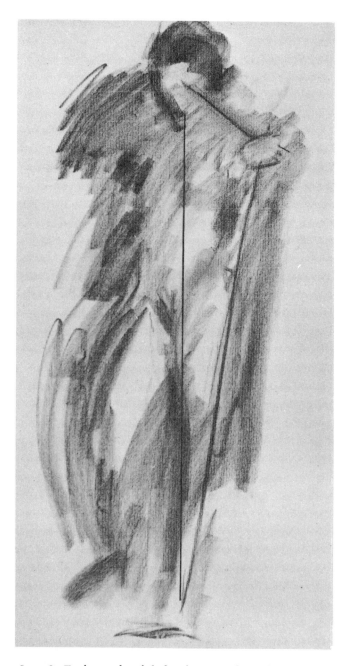 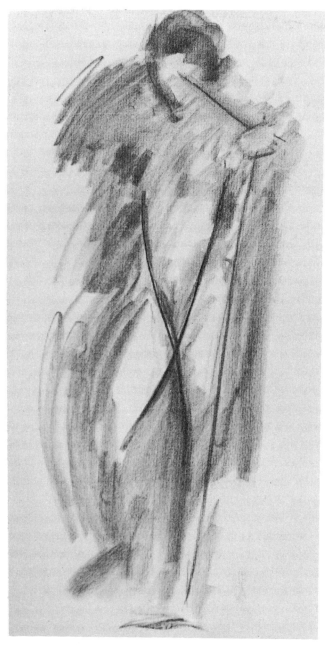

Step 2: *To locate her left hand, I use the sighting method described in the text and triangulate with the balance line. By sighting and then drawing a line down from the head, and one up from the feet, the approximate position of the hand (that is, the place where these two lines meet) can be found.*

Step 3: *In many front view poses, you can see the "X" symbol caused by the contours of the upper trunk forming lines that converge and cross at the crotch. The lines continue down to define the inside contours of the thighs. I'll call this the "Big X."*

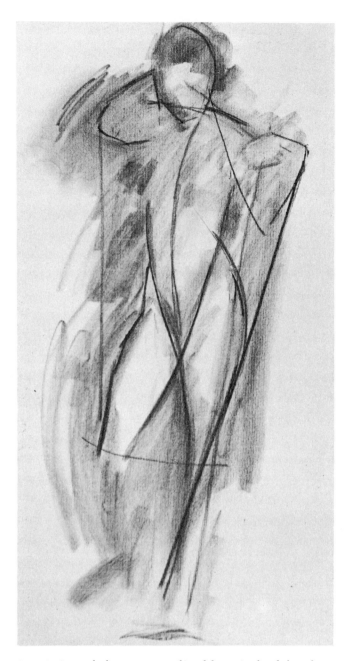

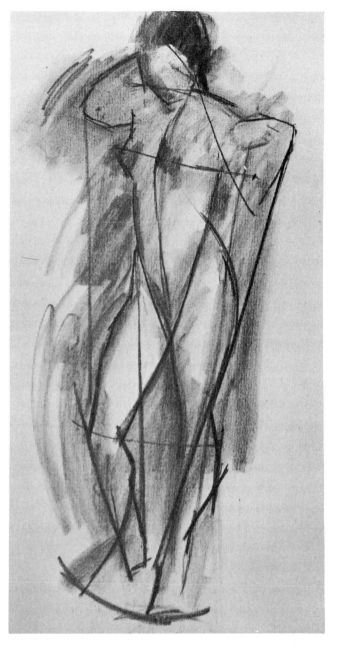

Step 4: *Several alignments are found here. A plumb line from her elbow locates her right knee. The flow line around the back of her head sweeps down the center of her body. Notice that this flow line sets the action line of the upper body and shows the slight turn to it. Demonstrated here also are ways of getting around curves by a series of straight lines — her right thigh and right arm bend. From the outside point of her left wrist, I can bring a straight line down forming part of the outside contour of the thigh. This same straight line also touches the outside of the knee cap and becomes the inside contour of the lower leg, following the shin part way to the ankle. I find a curved low line from this straight line upwards around her hip, crossing the "Big X." I indicate two other flow lines: one around her shoulders, the other under her left arm.*

Step 5: *Three alignments are shown now: across the nipples to the crook of her left arm, an arched line for the knees, and one for the feet. I search out the shapes of the lower legs, partly with straight lines. Another vertical line is used to align her right hip and her inside heel. Now, I feel I can start placing more tones in the hair and the chest area.*

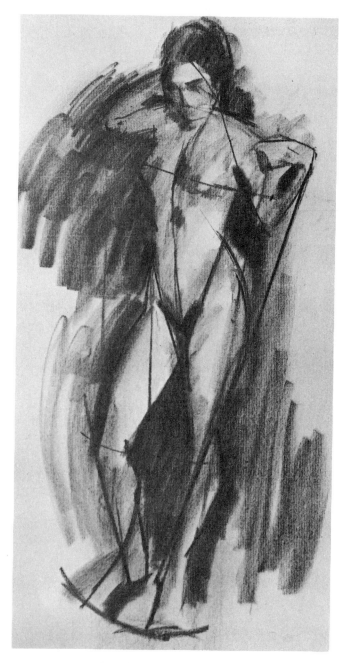

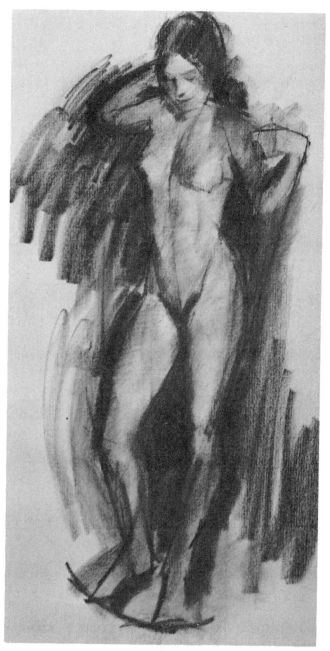

Step 6: *Having found all of the alignment lines I need, I start placing the larger tonal masses — some around the outside of the figure. I also place dark tones under her left arm, hair, "V" of the crotch, and breasts. I begin to block in her features also.*

Step 7: *I take the sponge and deliberately go over the whole figure, both to soften the tones and to begin losing the alignment lines. I also begin work on her face, refining her features. I always try to move away from a spot before I work on it too long. You should try to keep the whole drawing moving along at the same stages. If you don't, you're liable to lose the larger relationships you originally started with.*

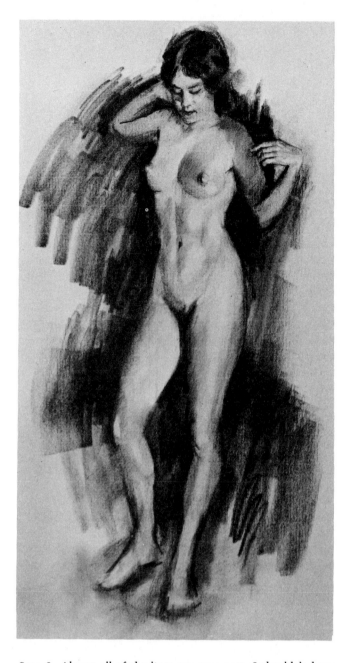

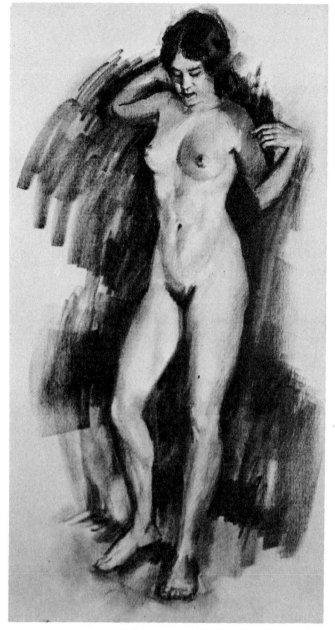

Step 8: *Almost all of the lines are gone now. I shouldn't have any trouble making alterations without them. At this point there's more adjusting of relative tone values. It's time for the details of the head and hand. The basic forms of the legs and feet are brought out more.*

Step 9: *When I begin the detail on the legs, I discover that her left leg has an exaggerated bend at the knee due to the inside calf muscle being too low. So I raise it up. I develop the feet to match the rest of the drawing. Some softening of edges also takes place.*

Step 10: *I am still dissatisfied with some things about the drawing, mostly subtle things. The shadow on her breast is too dark. The light on the left lower rib is too strong — that side should turn away from the light a little. The contour of her left hip gets too wiggly and indefinite, lacking a feeling of bone structure. Down the front of her left thigh it looks like the front is flat and wide; I've lost the roundness. The other thigh appears too light. I find I haven't completely lost the heavy outline effect around the legs and feet. I change all of these things. Does it help or did I go too far?*

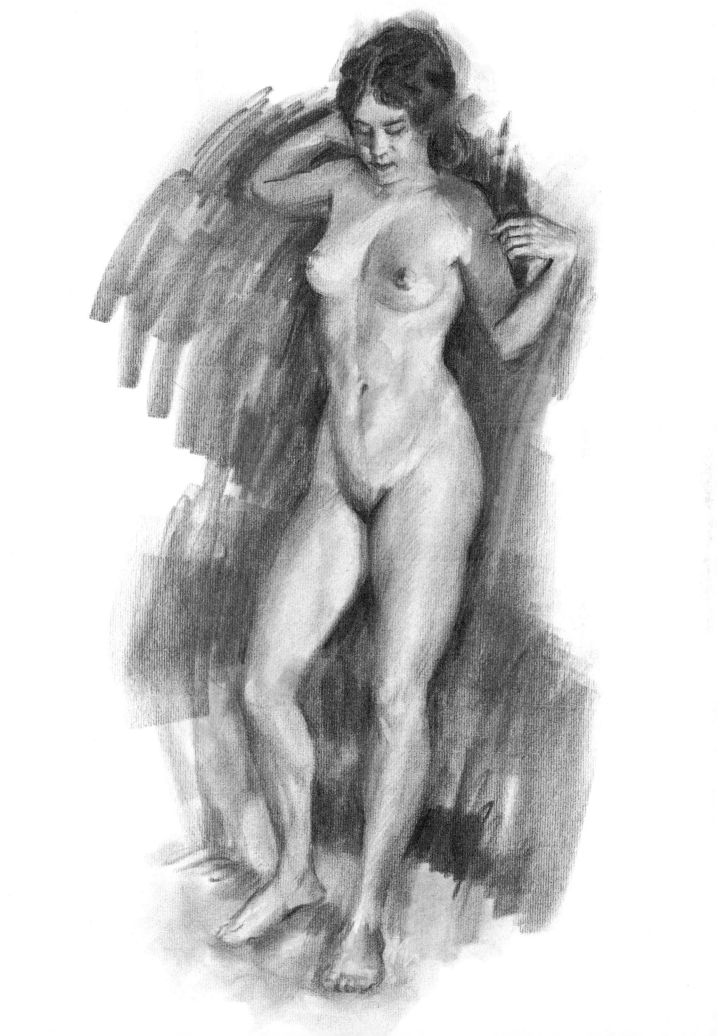

PROJECT 12

THE RECLINING FIGURE

When you're first learning to draw the figure, you grasp at any aid or device to get initial proportions. Somewhere you discover that measuring is a handy way to get parts of the figure related in size. I'm speaking about the common method of holding a pencil or (in your case) a piece of charcoal at a distance between yourself and the model to compare sizes.

USING A MEASURING DEVICE

I'm not at all in favor of using a tool for measurement, but neither am I autocratic about it. So if you feel it necessary to use this method, I would suggest the following rules.

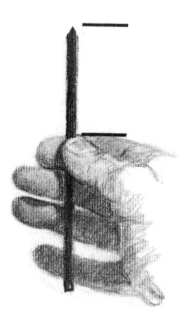

Figure A *To get initial proportions and compare sizes, a piece of charcoal held at a distance between yourself and the model can aid as a measuring device. The charcoal should be held correctly with the top of your thumbnail coinciding with the top contour of the finger in back of the stick.*

1. Hold the charcoal so that your arm is stiff and steady without bending the elbow. Be certain that the measuring stick is always at the same distance from your eye.

2. Keeping that same distance means you'll also have to keep the stick absolutely perpendicular as you raise or lower your arm.

3. Measure vertical or horizontal heights and widths with either one eye or both eyes open; either way provides no apparent variance. Horizontal spacings are more difficult to measure with both eyes open. In either case, it's much simpler to sight with one eye, whichever one feels more comfortable. Comparing vertical dimensions to horizontal ones with one eye proves to be quite accurate.

4. When holding the charcoal the top of your thumbnail should coincide with the top contour of the finger in back of the stick. The correct way is illustrated in Figure A.

Notice the stress on accuracy in those rules. Without that accuracy measuring is useless. There's a minimal number of measurable units that can be made with precision in the average classroom — usually the length of the head from the crown to the chin. The hair is an obstacle if it's thick or piled up. Then you have to imagine the oval shape of the head from the chin upward.

This system should be no more than a means of getting the figure roughed out, or as another way of checking proportions after your sketch is made. I entreat you to be brave and rely on your sight alone. Develop the facility of judging comparative sizes without devices.

PROPORTIONING PROBLEMS

The reclining figure, because it's unusual, immediately becomes a problem. How often do you observe people reclining? It's difficult to recognize a person in a position at right angles to yourself unless you know him well. Your

previous visual experiences — which are always ready to come to the surface — become hindrances in this kind of a drawing, and a reclining figure is something uncommon in a strict observational sense. It's a great temptation to want to turn your head to the same position as the prone figure to check the likeness. Try resisting that urge until you think you've drawn the reclining figure correctly; then turn your head. You'll be astonished at how incorrect your figure really is!

Invariably, you'll draw the figure stretched out too long.

The word "reclining" suggests length or stretched appearance. Another recurring problem is the inability to position the head correctly. The alignment procedure explained in Project 11 couldn't be used to a better advantage than in solving the problems of drawing the reclining figure. Very often these poses have horizontal background lines that can be used for alignment comparisons. If the view of the reclining figure is one other than straight on, foreshortening enters the picture. The task of foreshortening will be the topic of the next project.

Step 1: *The subject here is a reclining figure drawn in a high keyed mood. Like the last project, this opening step is an arrangement of tones that represent almost immediately the content of the picture. Using the side of the charcoal, I dash off broad, fast sweeps to make one complete declaration of the figure. Position, proportion, and linear alignments are strongly hinted at. To show tangents of the body (like the inside of the thighs and the lower part of the left leg resting on the platform), I draw in lines. This is explained in Project 3.*

Step 2: *This step is also a fast manipulation of the material (charcoal) to strengthen the first statement. Dark spots are temporary survey marks; they also set the dark key tones. Background tones force the contour at the top of the hip. Soft, quick, brushing strokes give the arm some shape. The "V" of the lower belly line is faintly drawn in. I darken the area where the knee will be on the lower leg. I also indicate the bend on the upper one.*

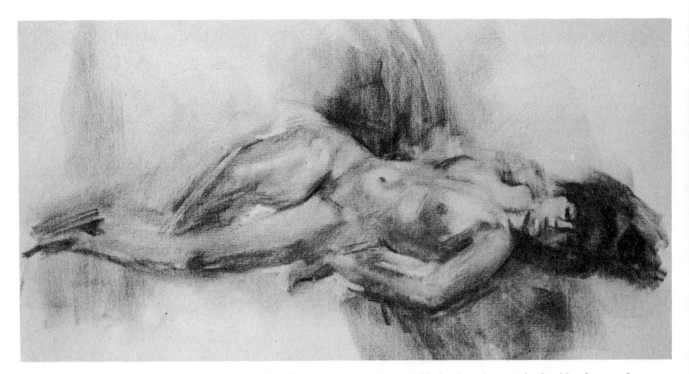

Step 3: *With a chamois, I wipe out areas of lights first: face, neck, shoulder, breast, chest cone, belly, ridge along upper thigh, and interspace between arm and body. For more precise lights, using a kneaded eraser, I nick out the light spots on the chin and upper lip, as well as a highlight on the breast. Then, I use the eraser to contour the shadow side of the upper breast, along the upper thigh, and between the thighs. I make a suggestion for the direction of the leg disappearing behind the lower one. The next business consists of accents all over the figure: the hair, accents for the features, etc. These accents are useful alignment marks.*

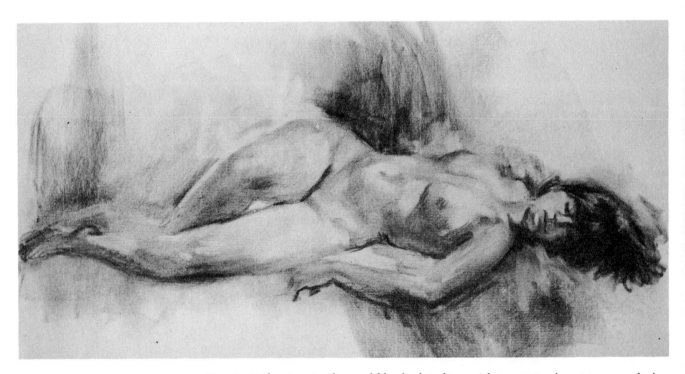

Step 4: *At this stage I soften and blend a lot of tones I have previously put in — on the legs especially. I bring out a more definite idea of the contour on the underside of the arm. Between the arm and body I wipe out the light area which creates the shadow of the body in that space. The line of the lip is put in. I shape the hair, which also gives the head shape, and put in the light part of the hair also. The foot is roughed in. I muse over whether I want to lose the edge on the upper shoulder and if the hand is too dark. I decide to wipe those a bit.*

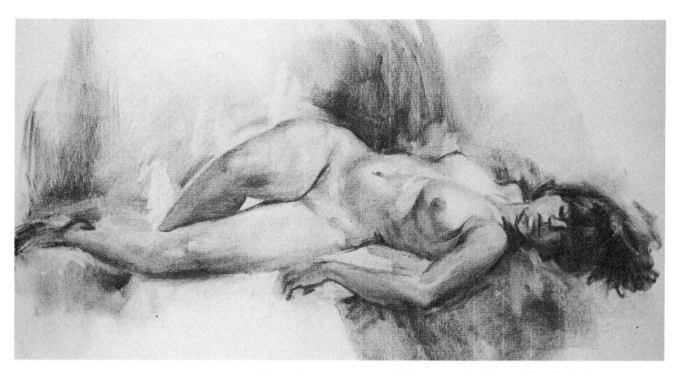

Step 5: *I change those same areas (of the upper shoulder and hand) back to my original conception. Refinement time is near so I develop the body subtleties. More attention is given to the upper thigh which, in this bent position, requires careful toning. Do you notice in this and the last project I'm rendering the strokes across or around the thighs? This helps to give them a foreshortened look.*

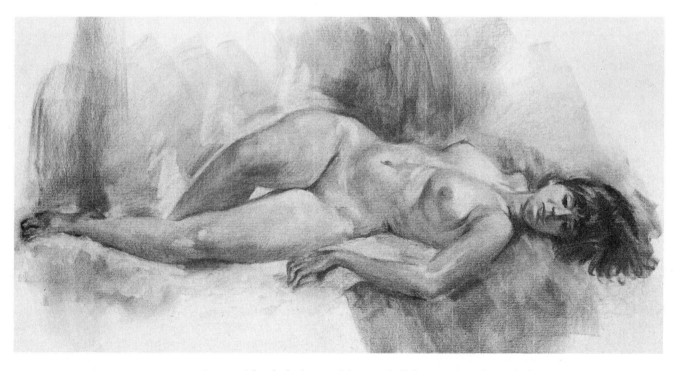

Step 6: *I finish the hair and face, and all that I want to do on the hands and feet. I spend still more time on the legs to be certain of the correct form and direction of the limbs. Deliberate use of a texture reinforces the roundness. This demonstration is a problem of horizontal alignments and also a test of how well the face and likeness can be done, without tilting your head. I must admit I "tilted" once in a while! This figure doesn't have a deep light and shadow feeling but more of a softly rounded one due to its many accents.*

PROJECT 13

FORESHORTENING

When starting to draw, the student often draws arms and legs as he thinks they should be — long things. The difficulties connected with so-called "foreshortening" stem from this tendency to forget that these limbs have a cross-sectional shape. If I should insist that a foreshortened leg, for example, be drawn just as it appears, a student will likely remark, "But when I draw it the way it looks, it seems peculiar or incorrect, not the way a leg *should* look."

Answering with a question I ask, "Does the leg look right on the model herself? Does it appear to be a leg as you would think of one?" When the student carefully observes, he is suddenly amazed that the model's leg *doesn't* look believable from his viewpoint. The subconscious desire to draw the leg in its most common dimension, length, has clouded his vision. Figure A (on page 72) shows a typical leg pose that is often drawn as if it were seen from the ceiling.

FORESHORTENING AS BODY PERSPECTIVE

In a simple comparison, objects like pipes and tubes change appearances entirely when you view them on end. There's no longer any appearance of length. To vividly demonstrate this loss of length in a foreshortened limb, draw it with just a contour outline. (See Figure B.) What is that strangely shaped object? It has no resemblance to a limb as you usually picture one. Now draw this same limb in a mass or tonal method and see the difference (Figure C). A limb positioned as I've drawn it in Figures B and C needs every bit of tonal gradation possible, every subtle nuance to make it appear as a human appendage and not a vague blob.

Foreshortening arms and legs, or any part of the body, is a situation involving perspective. Perspective is concerned with the effect of objects diminishing in size as they go away from you. This is obvious with geometric shapes — a building, a road, railroad tracks, rooms, etc. Arms and legs also have perspective, but with them it's just more difficult to determine.

The standard approach is to know what an arm is, and how to draw it, and *then* put it in perspective. But I feel that since perspective isn't scientific, only an illusionary experience, you should focus your mind and eye on the visual illusion. Forget, temporarily, your preconceived notions about what the arm is actually like, *physically*. If you reproduce precisely the tonal formations of the model, you'll create the illusion of the parts that are foreshortened or in perspective.

DRAWING WHAT YOU "SEE"

I'd like you to try an experiment, using yourself as a model. Look in a mirror and thrust your arm straight toward it. Turn the hand so the palm faces the mirror; position your hand so it appears close to your head's reflection. (My hand appears to be the same length as my head, but the actual measurement is a length from the chin to the hairline.)

Now, observe the form of the arm as it comes out from the shoulder. Starting at the shoulder only a small portion of the shoulder muscle can be seen as it disappears behind a form which is the upper arm. That upper arm form, in turn, vanishes behind another shape which is the forearm. Finally, the palm of the hand has covered a large amount of the top edge of the whole arm. Since the arm isn't exactly a perfectly round tube but changes direction and shape along its length, various places show themselves and disappear.

I believe that life studies which start with an intense course in anatomy burden you with a knowledge of ideal structural proportions. These proportions vanish (or appear to) in positions such as the one in the experiment with the hand. With all due respect, instructors of figure drawing start backward. I believe that they (and you) should begin with what you actually *see* (observe) when you look at the model. Then, it's time enough to discover what's physically there in terms of bone, muscle, and other material.

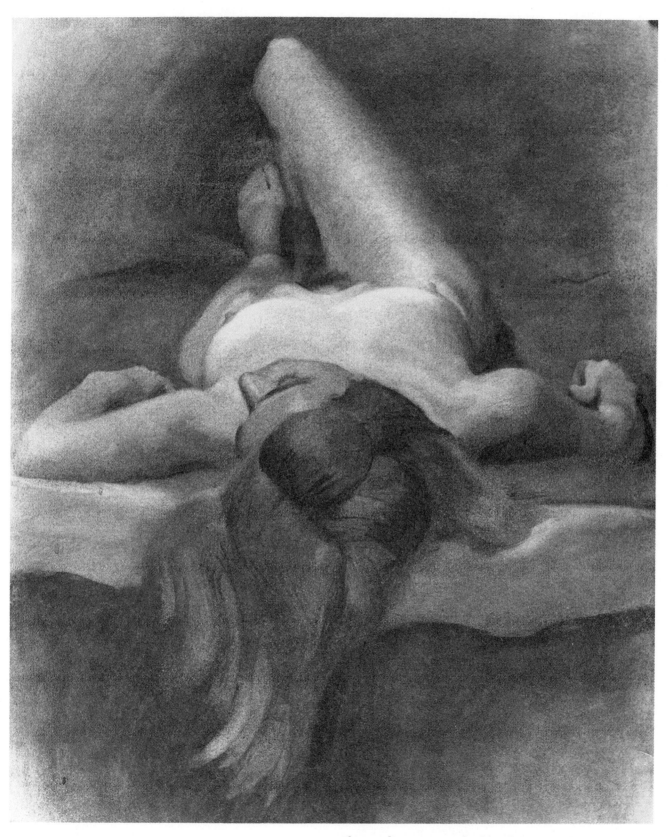

This is a dramatic example of foreshortening. If you compare the size of each part of the body you'll see that preconceived size relationships are no longer of any help. A drawing of this pose or similar foreshortened situations depends entirely on observation (perception) only. The thinking switch should be turned off.

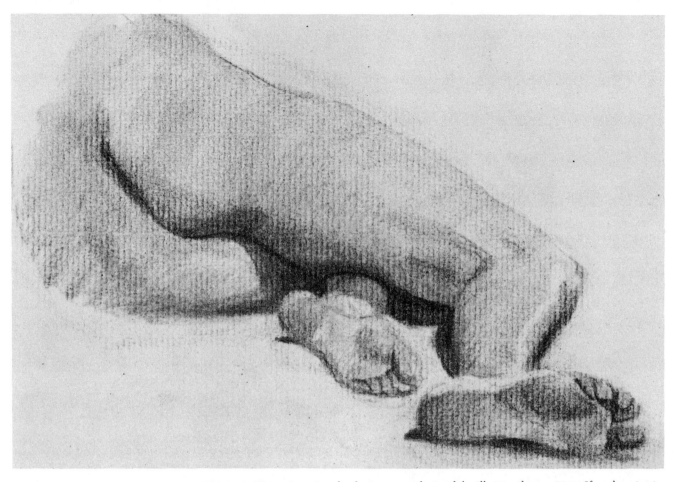

Figure A *Many times in a back view pose the model will sit in this position. If you're viewing the model in this position on a raised platform you don't see any length in the lower limbs. They have no resemblance to the lower leg shapes, most of which are hidden behind the feet. Notice the difference in size between the two feet indicating their relative locations.*

Figure B *This is a contour of a foreshortened limb. Can you guess what limb it is? There's very little constructive data to give you any idea. Look at Figure C for the tonal conception.*

Figure C *Here's a tonal drawing of the same limb outlined in Figure B. You can see the importance of tone masses for identification.*

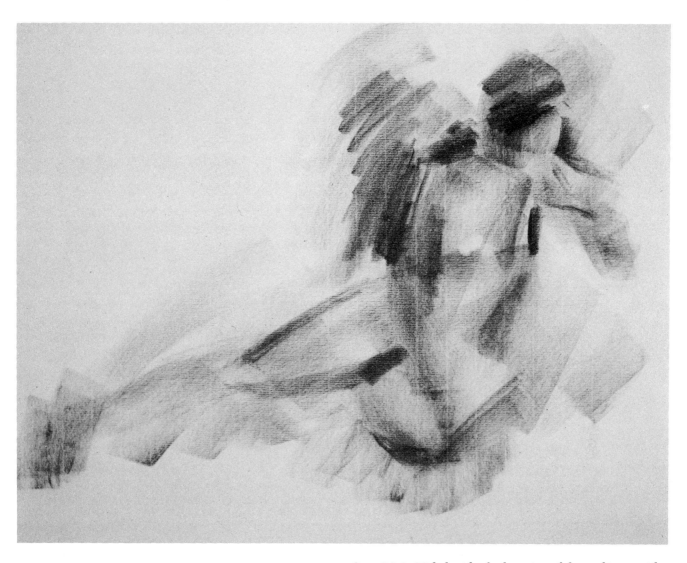

Steps 1 & 2: *With the side of a short piece of charcoal I start with a vague over-all image of the figure. I've repeated this approach several times, hoping it will make a strong impression on you. I believe it's an excellent way to start a charcoal drawing. The method gives a conception of the whole figure at once and produces a partially toned paper to work on. I can now proceed with more conviction and boldness. I establish the darkest spot on the hair, right shoulder, under left arm, and between the legs. I indicate the highest tone on top of the left breast. With lower tones I begin to develop contours of the hip, legs, and arms.*

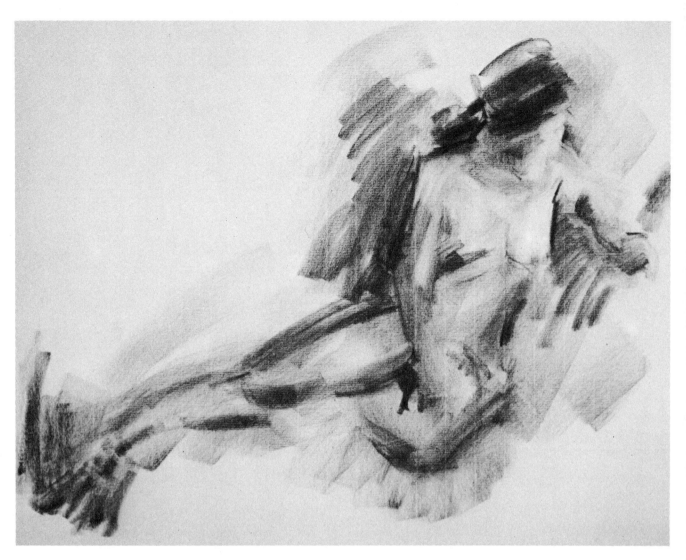

Step 3: *I still keep the sketch loose, but I'm closing in on the proportions. I do more contour work on the legs and hips. The hair is defined to position the head and face. I bring up the tone on the chest, collarbone, and her left arm.*

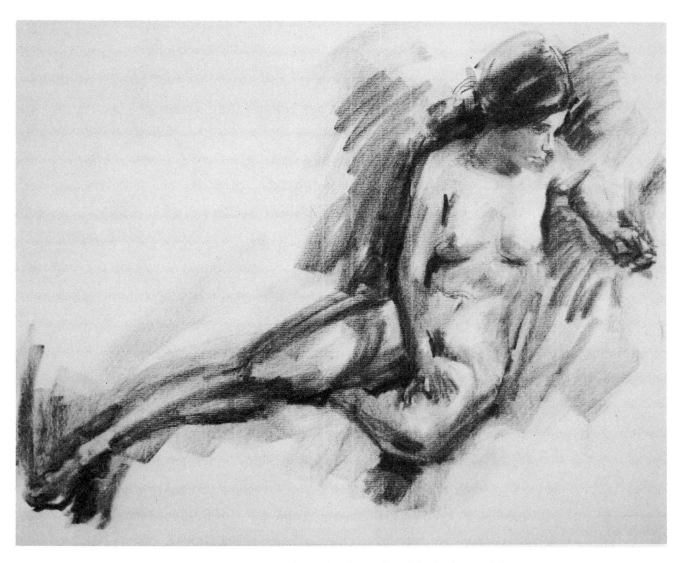

Step 4: *Using a chamois on the trunk and thighs, form and the third dimension begin to appear as I develop some of the tonal values. Even the cast shadow of the arm gives depth to the drawing. Putting tone next to the mouth, plus the shadow under the chin, thrusts the head away from the shoulders. Hands and feet are brought up a step in tone. The shadows of ridges on both lower leg bones are drawn in. I make some narrow tones to define the head shape more.*

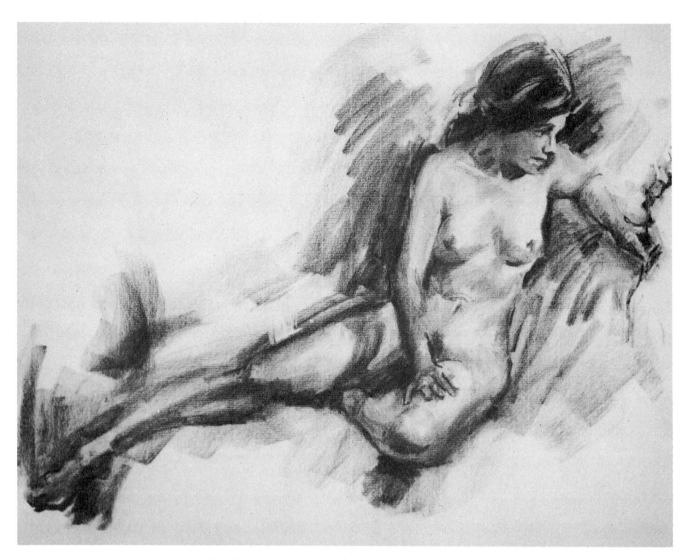

Step 5: *I put more tone in the hair and erase out some background to show the knot of hair in back. I make a note of the muscles showing in the neck, and also the structure of the collarbone. The face is worked on but by no means finished. I experiment with the position of the model's hand holding the flower. Notice that I indicate two clues to the roundness of the foreshortened leg by two bits of shading, one starting at the little finger and going around the knee, the other circling the leg near the ankle. Though these still need refining, they begin to demonstrate the bent knee thrusting towards us — a foreshortening problem.*

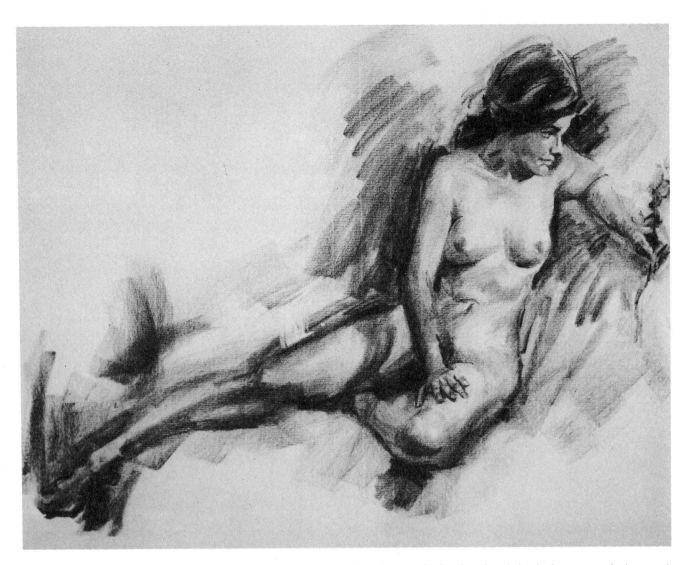

Step 6: *There's something about the way the head is placed that looks wrong. That's one of those problems that can often be a trap, and you must study it carefully. Very many times the error isn't at that point (the head) but somewhere nearby. This nearby error affects the appearance of the first spot in question, misleading you. I decide that her left shoulder is up too high (see Step 5), making the head look as if it's lowered too much. Cutting down the shoulder corrects the mistake. Had I changed the head instead, I would have been in real trouble. More work is done on the face and her right hand.*

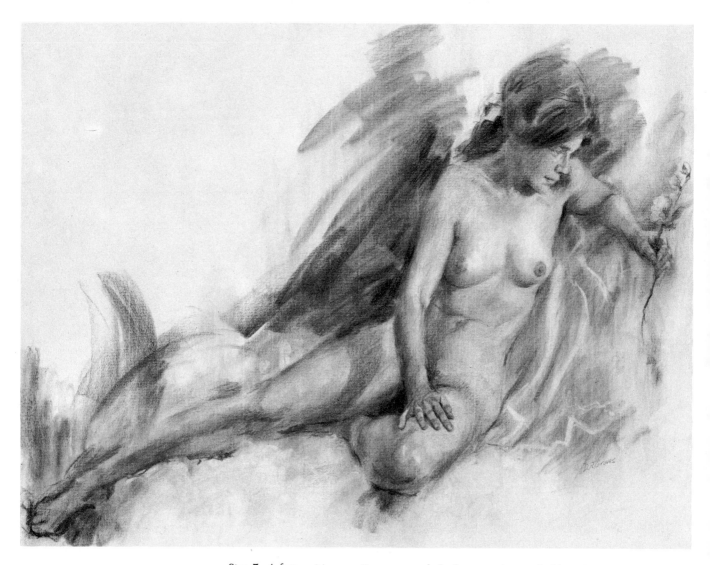

Step 7: *A few major corrections are needed: changing the arm holding the flower, and slightly altering the angle of the body. It isn't too late, even at this time, to do them over. The change in the arm consists of raising her left shoulder and shortening the lower arm. This arm is another foreshortening situation. To shift her position, her right shoulder is cut in and angled more; the body contour on the other side is pulled in at the hip. I change her extended leg to twist down and forward. After that, I go over all of the drawing as I shade subtle variations. The hand is carefully detailed, because I want it to be a noticeable feature of the drawing. Special attention to foreshortening is given to the forward leg, so that it thrusts out from the figure. Also, where the thigh emerges from the hip, shading provides the third dimension.*

PROJECT 14

IDEALIZATION
OR
INTERPRETATION

"The figure should not be copied slavishly." That phrase is frequently used to admonish art students. It has a certain ring of appeal, as if it's the first great step away from being an amateur. The stage is set for a mood of great creativity. It would indicate that you're going to interpret immediately, with no limitations to hamper the awakening of the great artist sleeping within your soul. This notion of not copying is a noble one and I'm not minimizing creativity; it's only that the timing of this creativity is wrong.

COPYING THE FIGURE

I'd like to show you that there might be some fallacy in this noncopying idea. When you sit before a figure model for the first time, you're confronted with a complex and mysterious subject. It's absurd to believe you'll be able to make an intelligent decision about what should be changed, omitted, or added to the drawing of a model so it will conform to an idealized figure or be a worthwhile interpretation of the model. Nor do I believe there's any hidden instinct to guide your hand. Just because you've lived as one of the species or been surrounded by them doesn't give you any natural ability to capture humans in charcoal. If you have any preconceived notions about the figure, they're likely to blind you to what you really see in the model. Any changes made in the model's figure must be done with a thorough knowledge of the body and much study. That kind of knowledge can only come from copying the model that you've been given as closely as possible.

TWO CREATIVE DIRECTIONS

From a basic study of the figure you can veer off into two directions, idealization or interpretation. Idealizing usually takes place in commercial art illustration. There are certain accepted standards set by illustrators as to what constitutes a well-drawn figure. It isn't always explicit; then you have to rely on a "feel" for what's a good illustrative figure. Sometimes illustrators come on so strong with a new set of standards that they become innovators of a fresh style. Their figure drawings are constructed quite differently than before, yet still *based* on the academic human form.

By interpretation, I mean an evaluation of your thoughts that spin off from an academic knowledge of the figure. In both idealizing and interpreting, the progression starts with a thorough knowledge of the figure, and that knowledge develops after many hours of drawing. it. Lacking this fundamental experience, in either case, your figures will be nothing more than either primitive or amateurish looking. If you want to be a primitive, you have to be untainted by any instruction; and I'm sure no one wants to be an amateur.

I've given you the illustrator's specification of eight heads for the figure because of the simplicity of measuring for them. In Project 9 I gave you a diagram of the ideal and also a more modern academic figure height. Any set of sizes or academic proportions cannot possibly fit every human; hardly any two are alike, except for identical twins.

Therefore, in the beginning you should develop an eye for what a figure looks like. Copy the model as well as you can. When the masses, the position possibilities, the articulation, and the size relationships become fixed in your mind, *then* you'll be able to get away from copying the model slavishly — and you should! Your unique interpretation of the figure or model is as inevitable as developing your own handwriting. It's a revelation to see a group of students working from a model who are about equal in experience and training. You'll see that every one has gotten a likeness of the model, but every drawing is different. Each person has done his drawing in his own manner, his own interpretation.

Step 1: *Starting with swift tones made with the side of a piece of charcoal, I make some up and down sweeps for the background. The light is coming from the viewer's right. Without lifting the charcoal I make other strokes, searching for the form of the figure.*

Step 2: *With darker tones I enclose the periphery of the figure, encircling an area for the face and shading the shadow between the legs. Taking a chamois, I put in the lights on the belly, breasts, thighs, face, and left arm.*

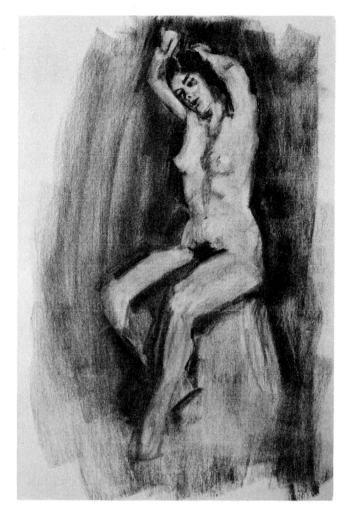 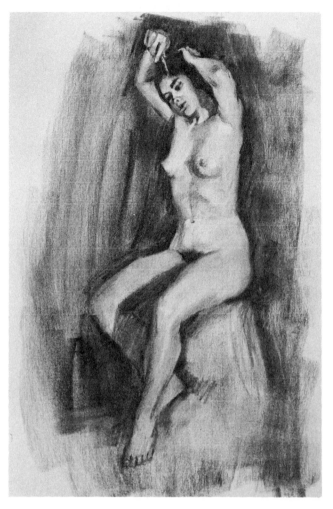

Step 3: *Many more darks are added here, including more in the background. Definite indications for the hair shape and placement of the features in the face are next. I put in dark accents around the legs and feet plus the "V" of the pubic area. With the puff I blend the highlights and halftones together over the whole body.*

Step 4: *I clarify a lot of things here: the drawing of the hands, face, and feet. The process of smoothing contours and rounding tones is started here. The line of her left hip and buttock is defined. The halftones on the legs are softened.*

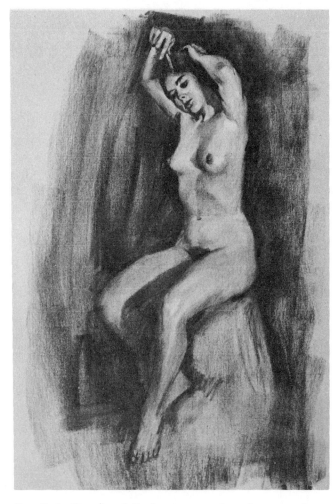

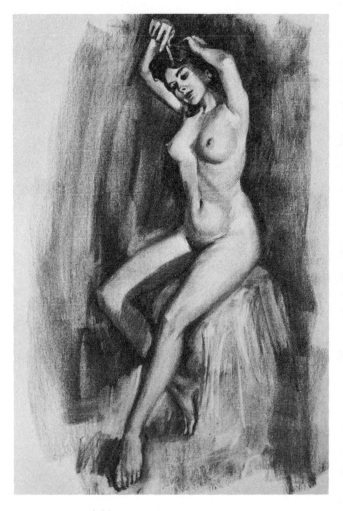

Step 5: *I refine the whole drawing enough to show you a figure that closely represents the model. I work on facial details and refine the shadow down the inside of her right leg and the lower part of her left leg.*

Step 6: *Now, I deliberately change many proportions to conform to an "ideal" figure in art. I make the arms more angular. Nipping in the waist makes her more ideal and gives more arch to her back. This also raises the breasts which I make fuller and rounder. The pelvic area is simplified and the belly rounded. The legs are made much longer and thinner. I fluff out the hair in a more attractive style. The jaw line is simplified and the lips are more fully drawn.*

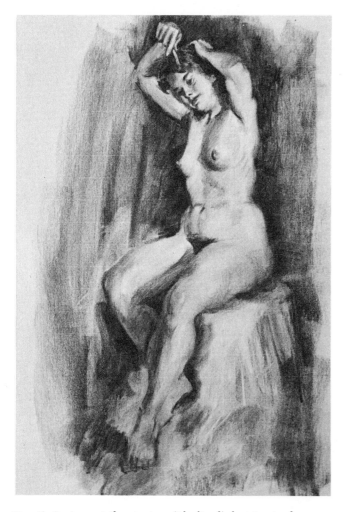

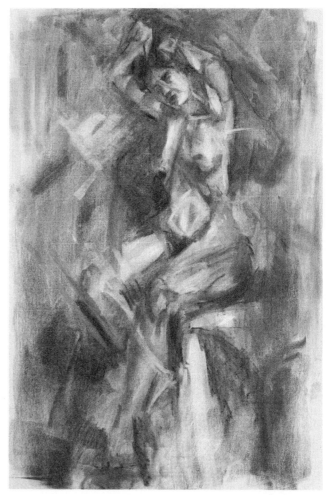

Step 7: *I wipe out the previous (idealized) drawing to show you a more interpretive kind. Let's suppose that I want a drawing of the figure that's more chunky and heavier. The legs will be shorter again. The breasts will be smaller. The arms will show their weight and development more. I see her face with more character, less glamor. This is exaggerated to show how you might react to a model in terms of a personal viewpoint, yet still maintain a sound figure.*

Step 8: *Again, I'll wipe out the previous interpretation in Step 7. In this kind of an interpretation you're not concerned with the perceptual impression but rather with integrating ideas about the figure into a design plan. The surface appearance is disassembled and reorganized into a new description of body and environment. The parts of the figure and surrounding atmosphere are interchanged to emphasize action, thrusts, and rhythms of the figure — also to make the atmosphere participate in the figure. The picture likeness is de-emphasized with as much freedom as you like. The design can transcend any need for an exact reproduction of the subject.*

PROJECT 15

WHY STUDY ANATOMY?

Other courses of study in figure drawing almost immediately turn to the subject of anatomy. I'll surprise you and say, "Let's *not* now." This, possibly, will cause stern disapproval and controversy. I've talked in terms of drawing impressionistically — from visual sensations. You've been learning to draw what you *see,* not what you *know* about the subject you're drawing. Drawing strictly from visual sensations, you really don't have to know much about the inner construction of anything. I wonder if excellent still life painters have ever studied in depth, biology, geology, chemistry, botany, or any science related to the objects they paint. Does a flower painter know or care about the torus, or know the names of the four whorls on a flower? Doesn't this situation sound familiar when you think of figure study from the anatomical viewpoint?

THE BURDEN OF ANATOMICAL STUDY

To construct a figure with an anatomical framework, it's essential that you have a high degree of knowledge of artistic anatomy. You should know about 550 muscles and 206 bones, their shape in an infinite number of positions, their correct place and relationship to each other, and a clear understanding of the articulation of those parts. You should also know their functions, which would include the knowledge of the origin and insertion of the muscles. Confronted with a study of this kind, the beginner has a tremendous task to accomplish before he ever puts any charcoal on the paper. It's discouraging and confusing.

"SEEING" FIRST — ANATOMY SECOND

Understand that I'm not against learning your subject well and having the confidence that goes with that knowledge. You can and should work from a model, learning to *observe* first. Then, if you become curious about aspects of inner construction, study anatomy. It will come naturally and as your drawing becomes more accurate, you'll want to know what causes the shape and contour of various parts of the body. That's the time to begin digging into an anatomy book. It will mean much more to you after you've been drawing for a while.

To include a course of anatomy in this book would be unnecessary, since there are already many good comprehensive books on the subject. To start your library I would suggest the low cost, but information packed book by Edmond J. Farris, entitled *Art Students' Anatomy.* Later, if you are getting really enthused, there are books like S. R. Peck's *Atlas of Human Anatomy for the Artist.* A classic book on the subject entitled *Artistic Anatomy* by Dr. Paul Richer, translated and edited by Robert Beverly Hale, has recently been released.

It's a good idea to have several for cross reference, to cover aspects that might be missing in one book. If you want to go all out, get a medical anatomy book. Know your subject. But time should be parceled out in different directions in the study of art. Develop your hand and eye. After that, your imagination and creativity will have the necessary tools with which to work.

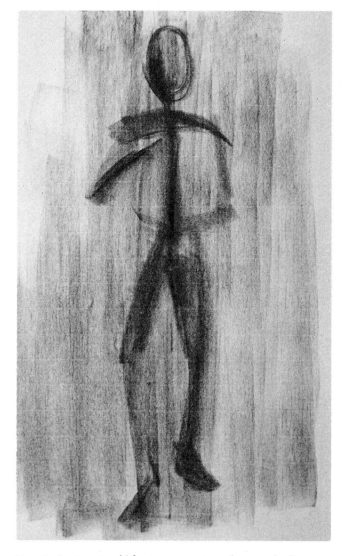 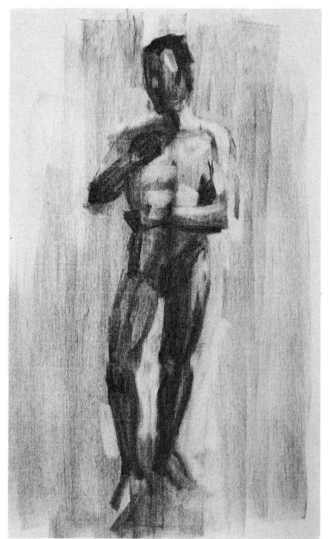

Step 1: *I set a simple basic gesture tone for a male figure — broad shoulders and narrow hips. Notice the curvature of the forearms; this isn't accidental. The structure of the forearm is a gentle curve. The same is true of the thighs.*

Step 2: *Roughing in the main shapes of the body is done here. The highest key is shown with lights on the forehead and chest, as well as on his left shoulder and left side. The darks, or low tones, I locate on the hair and under his left arm. His left leg is also a dark tone, especially toward the bottom. The body begins to take shape with over-all contour tones.*

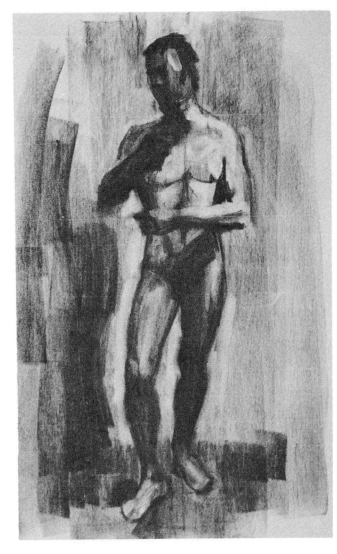

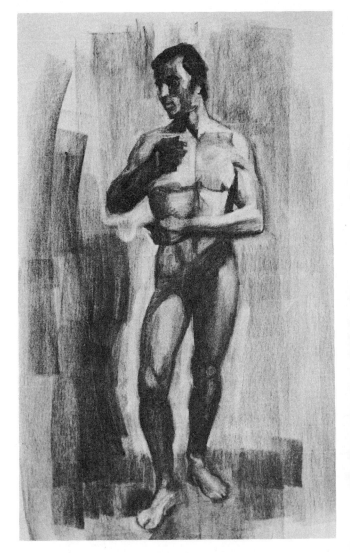

Step 3: *Here I get a close resemblance to the final values and place them as near to their proper places as possible. Many parts of the figure are darkly silhouetted against a light background. The shadow of the figure is off to one side, forming an "L" shaped element with the dark floor. There's a better formation of all body framework at this stage.*

Step 4: *The contours are shaped more carefully. Notice I make the chest lighter around the dark hand; this thrusts the hand forward. The head begins to have more solidity by simple value changes: the light on the nose, around the mouth, and along the side of the face. The addition of the mouth line and the shaping of the hair also help.*

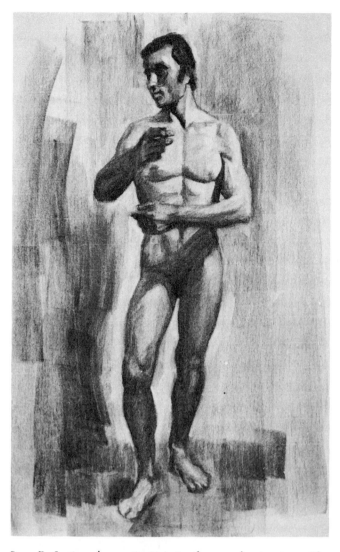

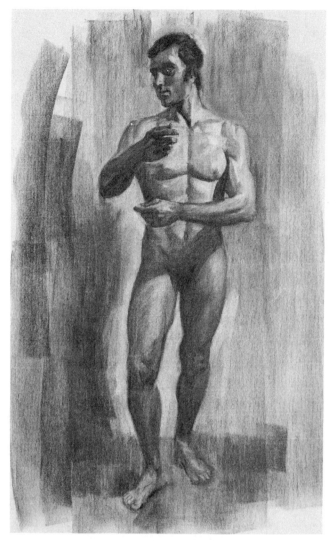

Step 5: *I give closer attention to the muscle structure. The model's muscles are clearly defined in many places — especially around the chest and arm area. In order to give hardness to the muscles, the halftones and subtle values aren't blended into one another too much.*

Step 6: *This step consists of strengthening my decisions about accents or tones. Two changes in the drawing are made. I fill out his right side along the hip giving the stance a more solid look. Also, the lower hand is reduced in size as I touch it up. You should notice in this pose that your viewpoint is high level and close to the figure. You have a feeling of looking down on the feet. Another thing, the hand comes forward because it's dark and larger than normal, giving a feeling of third dimension. Slight finishing touches are added to the face and hands.*

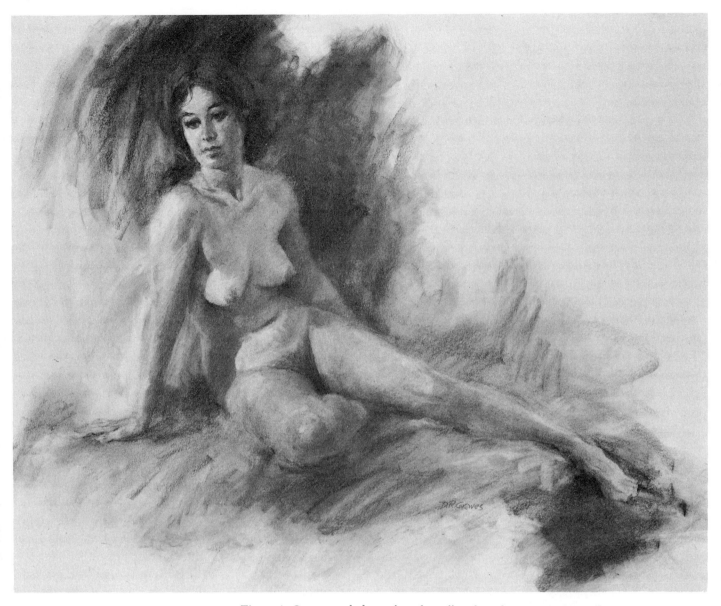

Figure A *Compressed charcoal works well and produces interesting effects, not only on the illustration board that I've used in the demonstration series, but also on the white layout bond paper that I've used in this drawing. Various techniques are used here: rubbing with the fingers, leaving strokes of charcoal rough, and making tinting strokes with a kneaded eraser. The blacks produced with compressed charcoal are rich. This type of charcoal also fixes well.*

PROJECT 16

MALE AND
FEMALE FIGURE
DISTINCTIONS

In case you haven't noticed, males are different from females. With the current "unisex" thinking of certain fashion designers, very little difference is acknowledged in the shapes of men and women. But they're there! Through the eons, the structure of a human body has changed; even in a few generations it has become, on the average, somewhat larger and taller. But the distinction between sexes has remained unchanged.

The classic difference between male and female has its roots in biology and environmental demands — woman as the childbearer, and man as the hunter or provider. The possibility exists that these will not be the roles of man and woman in the future. Who can say if this will have any influence on the structural evolution of man?

COMPARISON OF ANATOMICAL DIFFERENCES

For the artist curiosity about anatomical data need go no further than the skeleton and the outer covering of muscles, glands, fat, skin, and hair. Homogeneous might be an appropriate word to describe the skeletal and muscular structures of the female and male. That is, they have the same number and kinds of bones and muscles. There, however, the similarity ends. There's a difference in the relative sizes of the bones to *each other* within each sex. In the most striking examples, there's a complete reversal of relationships: the chest cage is small, the pelvis (hip bone) large in a woman and, conversely, in a man the chest cage is large and the pelvis small.

Moving out from the framework of the body to the covering, the muscular development is distributed differently in the male; it's generally greater in the arms and the upper trunk. The muscles of the female thighs are larger (again a throwback to the need for supporting herself and a child). It isn't true that a male figure model makes a better muscle study. This depends solely on the thickness of the outer tissue. If there's no fat and the skin is thin, boundaries of some muscles can be obvious on either sex. One of the best models I've seen for muscle study was a thin black woman.

However, studying anatomy from a model is an arduous task and only a limited amount is possible. Origins and insertions of muscles are buried too deeply to observe. Most muscles blend together, making separation difficult to define. Besides, each individual has his own peculiarities as far as the type of his muscle development. Some specific muscles can be more developed on one person than another and even slightly variable in shape. Different occupations are usually responsible for the variety of these subtle differences.

SOME STANDARD PROPORTIONS

The rudiments of the human anatomy can be accepted as standard up to a point. Where the proportions and structure start to diverge from the norm, you have to be visually or perceptually alert. Anatomical specifications aren't entirely reliable, unless they're verified by keen observation. Here are some.

A female should look narrow at the shoulder and slightly wider at the hips. The male should have broad shoulders and narrow hips. The man's chest being deeper gives him a longer waist. The opposite is true with the female, who should have a deeper pelvis area, causing the waist to look shorter and also tending to make her legs look shorter. The side view of the hip bone in the female might be more tilted, making more arch to her back. A female's hands and feet should be smaller than a man's in proportion to her body. The neck of the female can be slightly longer and thinner. Because of her narrower shoulders, her arms at the elbows are held closer to the body, making the forearm swing out; whereas the man's arms hang down in a straighter line. The arms appear to follow the contour of the hips on both sexes. The skin surfaces of the female should be smoother.

FAT DEPOSITS, SUBCUTANEOUS
PROMINENCES, AND HAIR

When you stray from those ideal proportions, both sexes take on distinguishing features due to age differences and

the gamut of size from lean to fat. Fat distribution on the two sexes takes diverse directions. Fat deposits on the female are noticeable on the mammary glands, the back part of the upper arm, the hips from the top of the pelvis down, the pad directly below the hips in line with the lower boundary of the buttocks, and on the legs — especially in the knee area.

The male betrays his weight in the middle. This location bulges out in all directions to form his "spare tire." Fat deposits make rolls above the hips and across the back. The abdomen protrudes starting at the lowest ribs and forms two bulges as he tightens his belt. The legs of a man would not have fatty pads but an over-all apportionment.

The parts of the skeleton rising to the surface of the body are known as subcutaneous prominences. They're the collarbones, the breastbone, wrist bones, the ulna (lower arm bone), the shoulder blades, tips of the vertebral spines, some ribs, the front tips of the pelvic wings, the rear of the pelvis at the sacrum (in the form of dimples), the patella (knee cap), and the shin bones. Many of these places become dimples on people who are overweight. The skull, hands, and feet surfaces are almost totally bone prominences. With the exception of the pads on the hands and feet and the heavier muscles around the cheeks, the covering on these areas is thin; the majority of the muscles are flat and thin. All of these subcutaneous spots are in identical locations for both male and female.

The growth of hair in both sexes is different. The pubic hair on the female stops in a line across the lower part of the abdomen, whereas the hair on the male continues up the center line of the body, sometimes almost joining the hair, if any, on the chest. Today, the beard is often one of the most distinctive features of the male, but not necessarily the length of his hair!

Step 1: *In this demonstration I do something different for you. I use compressed charcoal on illustration board. This requires a slight change in procedure. I have to be more cautious in the early stages. Dark heavy applications are difficult to remove without leaving a stain. Breaking a round piece of compressed charcoal in half, I use it on the side and put in a vague image of the man, increasing the pressure in the darker areas.*

Step 2: *I slide the piece of charcoal on its side around the contours (This technique is illustrated in Project 1, Materials and Exercises Figure L.) Notice this technique around the arms and back. Along the legs, I pull the compressed charcoal across the form of the leg. I begin to work a little darker in this step. This method is one of creeping up, working gradually darker from a pure white background.*

Step 3: *In Step 2 the proportions are beginning to work, so with more assurance I become bolder with the dark tones; some are very definite, for example under the shoulder blade, spine, and arm crease. The finger is very handy to use with this medium. A lot of the tones are rubbed smooth — around the head and shoulders, and background. I don't use too much pressure when rubbing. This makes erasing easier which I do for the light ridge of the shoulder blade, cutting around the shoulder contour, lifting the light next to the deep shadow on the viewer's left, and a few light swishes in the background.*

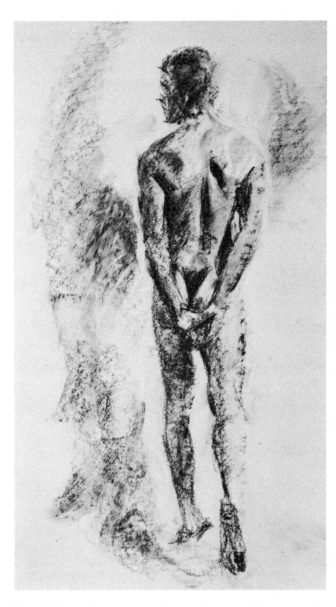 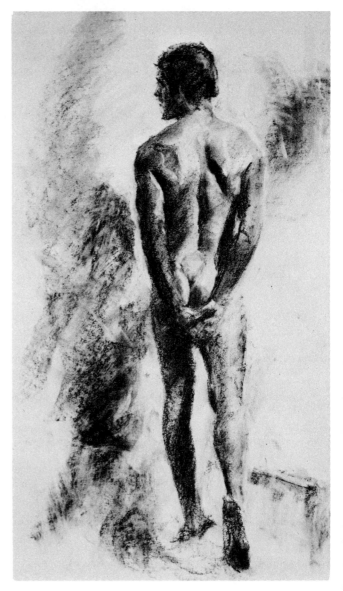

Step 4: *This is the time to add more charcoal, rubbing it in. The upper back is a little more finished than the rest. I add more shadow in the upper back and arms for interest.*

Step 5. *The lower part of the figure is smoothed and the left leg darkened. I lift out the lights on the buttocks. I remove his last bit of garment to reveal the diamond shape of the sacrum bone. I lighten the diamond of the sacrum and work in halftones on the lower back and right leg. I also block in the hands.*

Step 6: *At this point I clean up a lot of edges. I move in on the drawing of the head and hands, refining the details of both. I also brighten up the lower left arm. Some "noodling" is done here but not too much. I find that this medium works well with this technique. Lifting out lights with the kneaded eraser is satisfactory. Unless it's too black, I can always get back to a white surface. I leave some areas rough, showing the texture of the board; I think this texture offers a nice contrast with the slicker parts.*

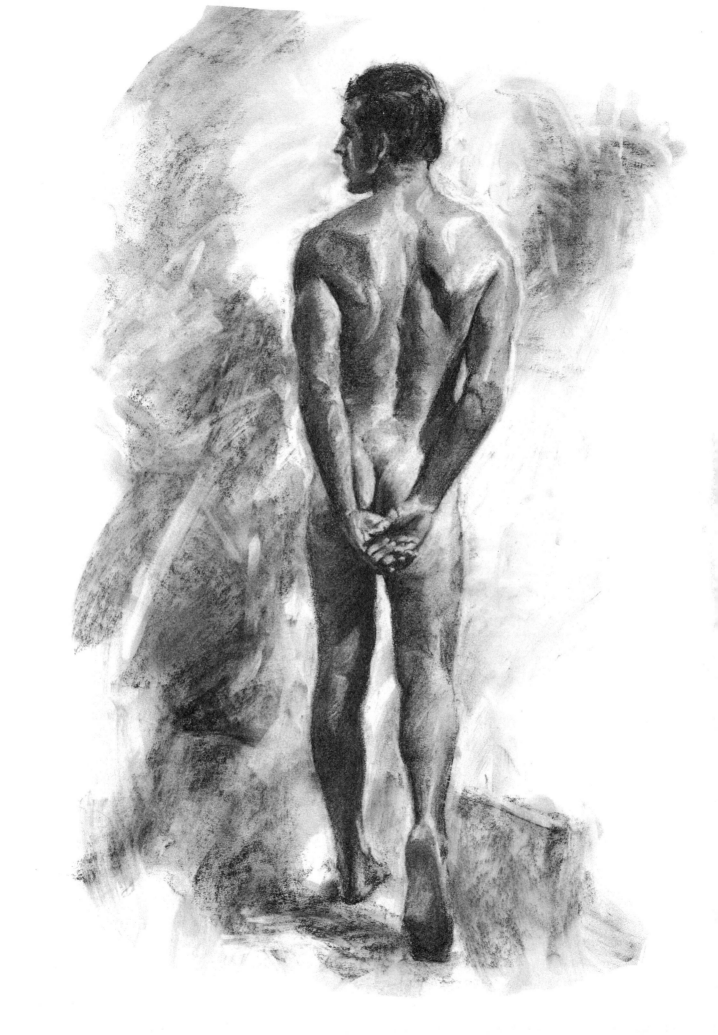

Figure A *This diagram is the traditional optical illusion, the upside down, right side up, stairway. There are two sets of negative and positive shapes interlocked. Since they're identical you can see either stairway at will, but only one at a time.*

Figure B *First, I drew a figure's silhouette in solid white on a black background. Here are the cutout black negative shapes of that figure in disorder.*

Figure C *When assembled properly, these black negative shapes form the silhouette of the figure.*

PROJECT 17

NEGATIVE
SHAPES

One of the interesting and complex features of art is that there are a variety of ways to reach a goal. In this book, the emphasis has been primarily on cultivating your powers of observation. As yet all of the resources available to your vision which can aid you in obtaining accurate two dimensional drawings haven't been explored. One you shouldn't overlook is the use of optical illusions.

I'm sure you're familiar with the optical trick of the stairway that looks alternately right side up and upside down. (See Figure A.) The picture presents two subjects: stairways interlocked, using each other's shapes and boundaries. Since both stairways are identical in shape and size, the mind and the eye can, on command, see either one as a separate entity. But at the same instant one set of stairs is an abstract shape and the other a concrete shape. (No reference to the material of the steps intended.) While the stairs can be seen either way, the image shifting easily from right side up to upside down, it's evident that only one stairway can be seen at a time.

Shapes of things you see all around you, like figures, have both their concrete shapes as well as abstract shapes surrounding them. But most objects don't do these flip-flops, because the abstract shape is different and usually has no common identity with the concrete one. Therefore the eye doesn't read them as quickly as Figure A. Applying this principle to your drawing studies, the figure model represents the concrete shape and the surrounding back-ground shape is what I'll call the *negative*, or abstract shape. Forcing yourself to identify and separate the negative shapes surrounding figures will be an advantage as you'll learn.

SEEING NEGATIVE SHAPES

The easiest places to start seeing these negative shapes are the spaces between arms and the model's body, between the legs, or in any small area. Imagine these spaces as either islands or peninsulas on a map. Sometimes it helps to blacken all the background surrounding the figure. Another way to see these negative shapes is to scan a figure you've drawn from the edge of the paper in towards the contours of the figure until you're aware of that large "outside" shape. These negative shapes of spaces borrow their contours from the principle (concrete) subject, the figure.

Once they "pop" into sight, you'll be able to bring them into prominence at any time. Try thinking of these negative shapes as you draw instead of the parts of the figure that are adjacent to them. In this way you'll have established, automatically, the correct form of the positive, i.e. the model's, shape. These negative shapes are easier to identify when the model is in a geometrical pose.

It's an interesting experiment to take black paper and cut out shapes to duplicate the negative shapes of a model's pose or a picture of a figure (preferably one with arms outstretched). Cut the borders in close enough to cut off some of the hands and tips of the legs so that the background separates into several pieces. Rearrange these on a piece of white paper to form the silhouette of the figure. It demonstrates how you can arrive at a solution of proportions by the use of the abstract or negative shapes. (See Figures B and C.)

USING THE GRID

The method of a grid pattern is usually used for enlarging or reducing a drawing. It consists of squaring off both the original drawing and the new larger or smaller drawing with an equal number of squares. You then duplicate the positions of all the parts of the original drawing on the same related place on the other new grid. Lines or tones should cross both grid patterns in the same place.

Using a variation of this idea, imagine that you're going to reduce the model on the stand to your paper using a grid pattern. You'd have to install a huge frame in the same proportions as your paper immediately in front of the model. It will have wires crossing it to form squares that are equal in number to those you've lightly drawn on your paper. Observing the model through the wires, locate reference points of her figure that cross the wire squares.

Then, find the related squares on your paper for proper placement of those points. The contours and edges of your figure should bisect the grid in the same related squares as those of the model and the wires.

The object of this project is to show you that subject matter has contour, edges, and planes within a two dimensional frame of reference. It's true that the figure has parts or areas that recede or come forward in the third dimension. Even so, it will have boundaries that appear to move only in two dimensions.

TONE MOSAICS

Here are more thoughts on how to augment your powers of observation. When I traveled in Europe, I visited St. Peter's Basilica in Rome. In one of the treasure-filled nooks I found what I thought was a painting. After a closer look, I discovered to my amazement that the "painting" was done with very small, mosaic tiles. What you're doing when you draw and paint is to lay down patches of tone or color — a type of tonal mosaic. The difference between a drawing and a mosaic is that in a drawing all of the edges are fused together. This may be another way to help you translate the subject into a tonal arrangement. In Figure D, I've made light patches that represent intervals of light streaming across a model. With that much suggestion only you can see what I'm trying to convey.

Figure D *By simply using a kneaded eraser on a toned background, I've drawn a figure with strips of light across it. Correctly placed a few pieces of the incomplete mosaic show a vivid image of the subject matter.*

Step 1: *This is my favorite way to start a drawing, and I think it's a very easy one. It's a quick way to get both the background and figure conceived in an instant. The importance of the relationship of values and proportions is given precedence immediately. I might remind you that one of the reasons for using white instead of toned paper is the freedom I have in choosing any kind of background — from a smooth, even tone to a free form shape as in this project.*

Step 2: *Just to be certain of the position and length of the figure, you'll notice I mark the center line and also the mark for the head, feet, and crotch. I also take out the highest key tones with a kneaded eraser above his left shoulder, on his right hip, forehead, chin, and right ankle.*

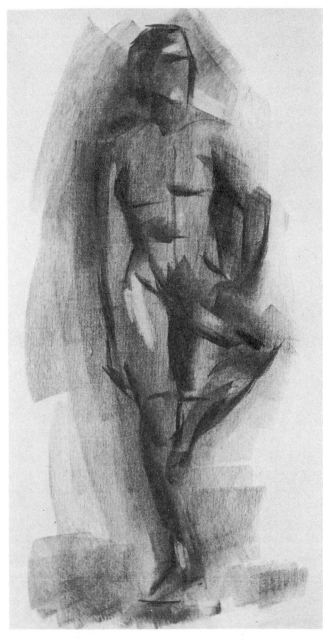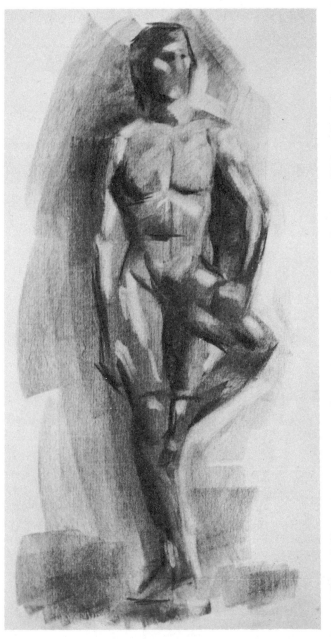

Step 3: *My rendering procedure is different here. I use the technique described in the first chapter. I run a piece of charcoal along its edge to get, all at once, a rounded contour and also the accent of the dark edges. However, I make no lines with the point of the medium.*

Step 4: *I add more lights here to his right arm, the upper chest, and top of his left leg. I lift out a light under his right eye, and thereby set the contour of the cheekbone. With my dry finger I begin working on some halftones for the upper chest, collarbone, and shoulder area. The top of the figure is a bit more finished than the rest.*

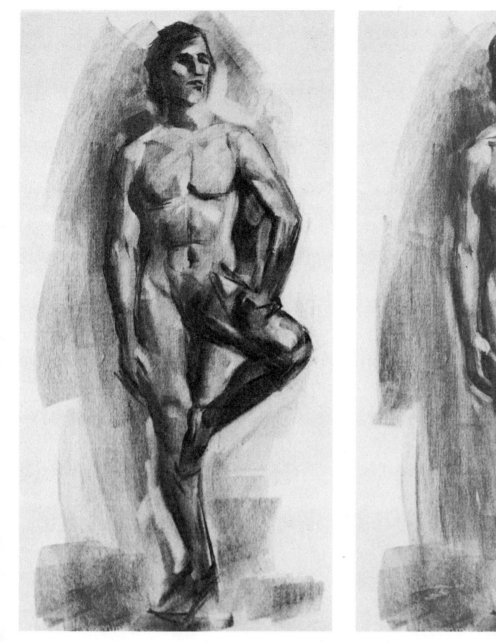

Step 5: *Again I slide a piece of charcoal around the contours to strengthen the drawing I already have. New perimeters are blocked in on the outside of both arms which I felt weren't wide enough in Step 4. The insides of the arms are indicated as well. Note at the inside of his right arm I have at once defined the contour and made the hole between the arm and chest. The sliding charcoal also shapes the hand on his left thigh and cuts across the hand to show the knuckle line plus the curve of the fingers.*

Step 6: *The shape of the figure is made more distinct by rounding some of the jagged edges, and softening points with the sponge. This is apparent at the legs and hands, the eyes, and at the dark tone curving around the wing of the nose to form the shadow. With an eraser, I show the cords of the neck. Accents are placed for the pit of the neck and the top of the right collarbone. The dark accents on his left hand show the separation of the thumb and some fingers. By wiping out areas and adding accents, the feet are more fully developed. Notice the upper foot is divided into two basic parts at the toes: one tone for the large toe, the other for the rest of the toes. The underside of the knee cap near the foot is darkened.*

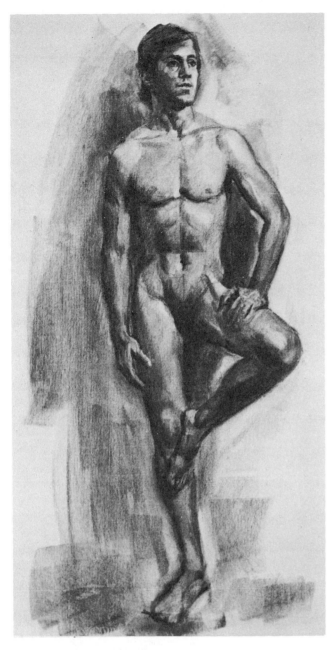

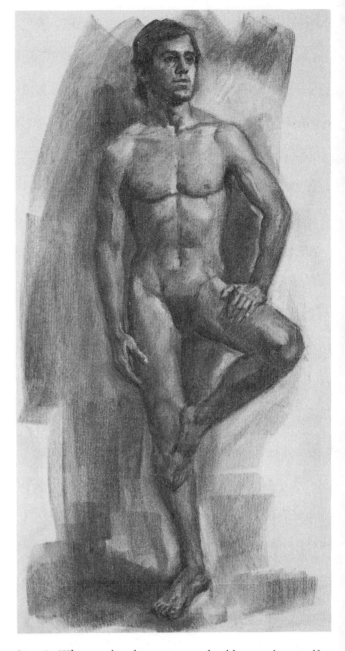

Step 7: *To achieve a likeness, more shaping, toning, and erasing takes place but in continuingly smaller shapes. The operations are more delicate here and require more control. In this step I shape the hair to show the higher part of the head toward the back of the skull. Eyebrows are heavied up. His eyes have pronounced lids so a line is placed above them. The lid itself is lightened with the eraser. Since a smudge is already there for the eyes, all I do is lighten around the iris. Notice that the whites aren't the same tone value on both sides of the eye. A small spear shape under the eye shows how the opening of the skull affects the skin folds there. The accent on his right cheek now has been spread into a halftone to curve around it.*

Step 8: *When you're drawing, you should remind yourself to quit when you're ahead, winning. His left eye is darkened and softened around the lids. The tones on the side of the nose are blended slightly. His right cheek seems to sink in, so I lighten a small area on a level with the bottom of the nose, extending down to the mouth. The abdomen area is still too blocky, so I blend it some. Notice that the color of his left arm gets darker. This is the translation of skin color (more tan on the lower part) into black and white. His left hand is refined into more definite planes formed by the turning of the fingers. The first joints of the fingers turn into the light at a right angle to make them lightest. Dark accents show at the knuckles usually. Finally, the lowest foot is worked out in detail. Very often there's a common tone, either lighter or darker, just before the separation of the toes.*

PROJECT 18

TWO SOURCES
OF LIGHT

In Project 2, I stressed the importance of using a single light source as a means of revealing the true form of a subject. Lighting a small still life without having stray secondary lights is fairly easy, but with a figure lighting is more difficult. Many of the preceding figure projects have a little reflected light creeping in here and there. In this project, I've used a figure pose that's carefully illuminated to point up secondary or other light sources. The figure in the demonstration up to and including Step 5 has no reflected lights on it at all. In Step 6, I bathe it lightly with a second light. I could have stopped with the first phase of the drawing as the one light almost explains the figure's form and is adequate for a subject that's partly in deep shadows. At times, however, the surrounding atmosphere is resplendent with different lights competing with the main light source. So you're compelled to learn how to deal with them. This means the additional challenge of controlling more subtle values.

VALUES AND SECONDARY LIGHTS

Charcoal tones available to us for the light side are used up in the main light areas. What do you do when there's another set of values needed due to additional light sources? There's a strong urge to use the same high or "light" values again for the secondary light areas. But you should *only* use the range of tones you've reserved for the shadows. It will require a sharpening of your vision and facility to shade in the more delicate shadow values. In the second phase of the demonstration where I introduce the reflected light, I have to control the tones caused by secondary light sources, so they don't compete with the tones resulting from the main light source. When I first put these secondary light values in they looked correct. Then they jumped out from the drawing so strongly I had to "knock" them down. Sometimes you get so interested that you render these secondary tones too light.

When you have two light sources, there's a strip between the two light areas which is darkest of all the tones in a reflected light situation. It's usually at an edge or turning place. This dark tone is called a *core*. The core separates the main light halftones from the reflected light halftones. The safest way to produce the effect of a reflected light is to make the shadows an average solid tone. Then shade in the darker core along the turning edge. This way you can be sure not to get shadow values too light. Review Project 6 on keying a drawing. There I explain that the scale of tones chosen should be divided in half; don't use tones on the light side for the shadows.

Figure A *The arrows indicate points often observed in this kind of a pose that seem like reflected light. These light places are only caused by the double contrast effect. This illusion is explained in Project 6.*

REFLECTED LIGHT AND DOUBLE CONTRAST

It isn't too tough to handle a full contrast drawing such as I've done in the demonstration. You have almost five values to play with in the shadows. But in a drawing with a narrower range of tones, you can be in trouble trying to put in any secondary lights unless they're just hinted at. You're better off just putting in a core, as I've described.

Even in photography where there's a studio full of lights, it's very tempting to use many light sources. The top photographer, however, will use a single main light and other illuminations very judiciously. Additional lights can be used to heighten a dramatic effect or explain the surrounding light conditions — but only as long as you don't lose the illusion of form.

Once in a while you're fooled into thinking there's a reflected light on part of the figure. This can happen when a dark background happens to be next to the figure on the shadow side. Due to the *double contrast force* described in

Project 6, the shadow appears to be just a bit lighter near the background. This is an optical illusion. In favor of simplicity, I would leave those illusions out of a drawing. See Figure A for an example of this false reflected light shown at the arrows.

GEOMETRIC POSES

Models often take poses which make the action of the body and limbs very angular. You can be thankful when they do, because then it's easy to get the action of the figure. Finding the gesture in this demonstration is child's play because of the obviously predominating geometric lines. Of course, these lines then form the nice negative shapes which are so great to work with. In addition, there's the almost total symmetry of the pose (with the exception of the angled leg). Poses of this nature train you to see the directions and angles that human figure components take.

Step 1: *A plain background is adequate for this demonstration. I want to call attention to the pose and lights on the model. A pose like this is simple to start because of its geometric shape. I use a fairly wide gesture tone to block in the pose.*

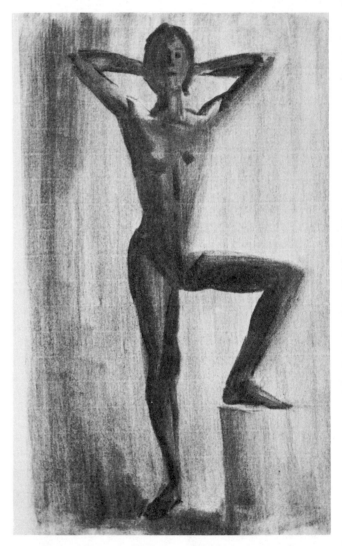

Step 2: *Added to the gesture tone are the dark tones. Dark smudges are placed in the approximate position of the features. The darks are broadly treated and placed in the hair, right side of her face, underarm, and right hip. There's a low key tone on her right lower leg to indicate the shadow cast by her raised leg.*

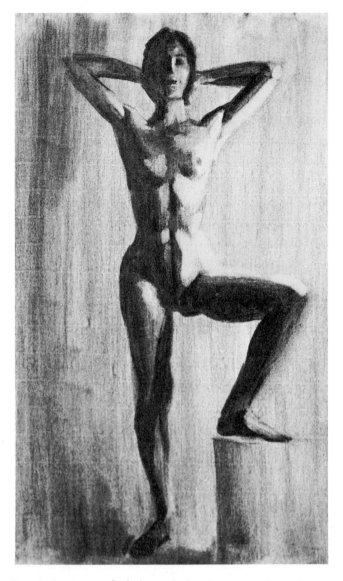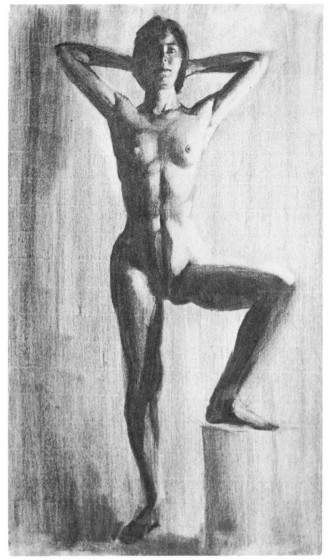

Step 3: *I wipe out the lights with the chamois on the underside of her left arm, torso, and left leg to the knee. There's also a high tone on the top of her right thigh and shoulder. Her right ankle and breast are worked on with halftones.*

Step 4: *A patch of light is placed above the eyebrows. The cheek is toned next to the nose, and connected to a tone going across the nose into the shadows. Another patch of light is placed to the right and above the eye beneath the eyebrow. Rolling the kneaded eraser to a point, I lift out the strong light on the edge of the eyeball closest to the light. The end of the nose is nothing more than a small, light elliptical ring with a black comma in the center. The light of that ring connects with the light down along the septum of the upper lip and forms the top shape of the mouth. There's a dark accent in the corner of the mouth on both sides. The upper lip is made lighter than the lower because of the low level of the light. A small light is put on the chin. Here, I also begin putting some halftones on the chest.*

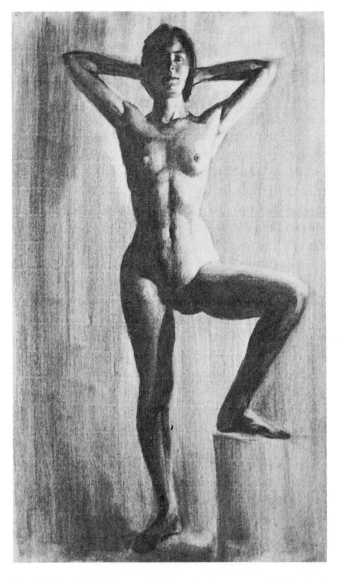 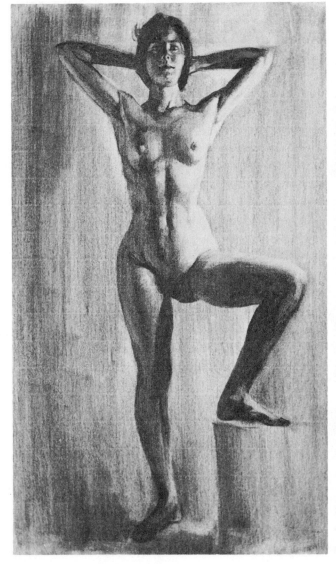

Step 5: *More halftones are put in on the lower part of the body. I bring up the tone of the lower belly and add more halftones for shape. Notice how these halftones round out the lower limbs also. In Step 4 I had lost her right heel. I bring it back with halftones and a darker tone in the background behind it. This is the last step with a single light source.*

Step 6: *The other light is turned on! Here I put in the light tones created by that second light. The modeling on the right side of her face follows almost the same series of steps as on her left side. The forehead is still in the dark, and a dark shadow drops from the mouth on her right side because of the slightly different position of the spotlight on that side. The front plane of the nose gets no light from either side.*

Step 7: *Studying the previous step, I realize that the secondary light tones jump out and are too hard. So I knock them all down. The upper part of the face is also a little too dark, and I lighten the whole area.*

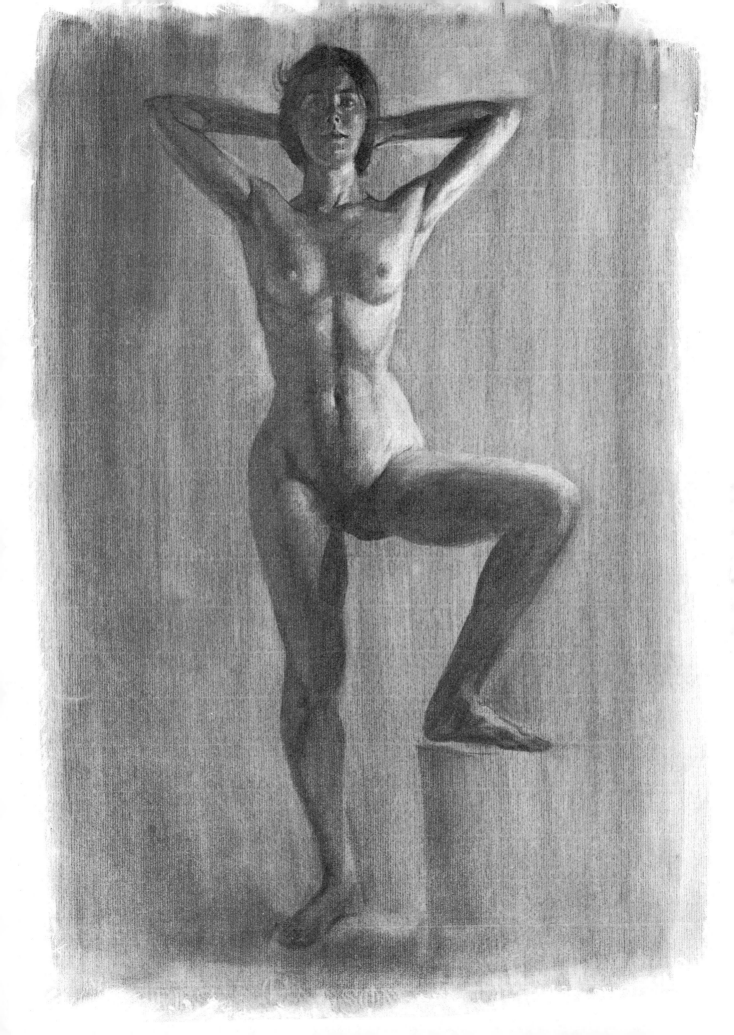

PROJECT 19

A TOUR
OF THE LIFE CLASS

It has occurred to me that you might never have attended a life class. If you have, you've probably noticed that every student has a different problem or bunch of problems. I'd like you to follow me on a tour of my class; maybe some of the questions that bother you will be answered here. I've worked with some of these students before; some of the others are new.

WORKING OVER THE WHOLE FIGURE

This girl has started a drawing done mostly in outline fashion. This is not one of my veterans, or else she wouldn't have begun that way. The obvious problem is that the figure gets too large down toward the legs. Also, the drawing around the head is tight — done without confidence. The lower part of the figure begins to get somewhat looser and freer.

Often the lower part of a figure gets too large because you start working the head of the figure without looking or relating it to the lower part. Most of you who are in the early stages of drawing aren't always full of confidence or loosened up. To work out her problem, this girl (and you) should move over the whole figure sooner, looking with the "split vision" I've mentioned. This over-all approach will loosen up the drawing — at least all of the pickiness won't be in one spot. She might also commence working from the center of the figure toward the top or even try proceeding from the legs upward, a change of habit.

SEEING LARGER TONE MASSES

The next student's drawing of the figure is fairly well proportioned with some tone value indication, but now he is concentrating very hard, trying to draw a pair of beautiful, long lashed, dewy eyes. Each eyelash is drawn with precision; the highlight on the pupil is there (in the wrong place); the so-called whites of the eyes are all pure paper.

His trouble is forgetting to squint, so he can see the larger tone masses first. Get those tones perfected and leave the fine details until last! Sometimes you think if you can just get a pretty face drawn, the rest of the mistakes will be forgiven. When you're doing a complete figure as a study, the whole thing should be well drawn; it's important to carry it all along and not finish any one part too early. If you're doing a portrait you have a reason to begin concentrating on the face (having first blocked in a sound foundation for the whole figure). After all, if the face doesn't resemble the sitter, the rest of the painting is useless. However, that's a special case. Now it's urgent to concentrate on all of the tonal values on the whole figure. Even small items like the eyeballs are round and should be shaded to show this. A beginner will often leave the whole eyeball white, making the eyes appear like holes in the paper. The eyeball is not white anyway; it has color or tone.

PRECONCEPTIONS AND FIGURE DISTORTIONS

Moving along, the next drawing is made by a part-time student. This man has a continual problem which is the opposite of the first student's. As this man works over the figure, the lower part gets too small. He has been conscientiously trying to approach the figure with a total concept, bringing all of the picture along together, but the problem still persists. It took me a while to understand why his figures' legs were always too small and short.

I learned he's a salesman who has to meet and talk to lots of people; so he relates to them somewhat emotionally. When he talks to customers in person he's usually standing, so he has developed the concept that a person diminishes in size toward the feet. Face to face, you could say this is true due to perspective. Figures that are close up would appear to get smaller toward the feet. This perceptual "hang-up" carried over into his drawing. He can possibly surmount this problem by overcompensating — drawing the lower parts of the body larger than he *thinks* they should be, until he develops a new concept of figure proportions. Quite often you must overcompensate to correct a habitual error.

PREOCCUPATION WITH DETAIL

The student next to him is supposedly doing a drawing of the model, but has several anatomy books spread out before him. He's trying to work out a constructive figure with bones and muscles. I don't object to that. What bothers me is that he's drawn a figure that looks like a wooden mannequin for figure study. After some discussion I discover that when he first tried to learn the figure, he *had* used the wooden mannequin.

I advise three things: first, forget about the mannequin and never use it again. Second, try to observe the model more — use it. That's why she's there. If you use a substitute for the real thing, that's exactly what your drawing will look like! Also, if the anatomy study confuses him, he should wait until his viewpoint of figures has improved.

The next student never gets a drawing completed. He's meticulous, using a finely honed hard charcoal, shading slowly in one area at a time. His work is like a stain slowly spreading out from one spot. None of the proportions or values relate to each other. My solution struck him as drastic. I told him to use a large, clumsy chunk of charcoal making only broad heavy passages to show the complete figure; then start the polishing business. Few artists can successfully work his way. The people who have the complete picture in their minds and can put it down, like unrolling a window shade, are exceptional.

SELF-CONCEPTS AND FIGURE RELATIONSHIPS

This student has completed a very nice drawing with well-controlled values. The relative proportions are excellent, but the figure is much taller and thinner than the model. This happens on all of his drawings. Guess what? He's tall and thin himself! When I call his attention to this fact (that all of his figures are built like himself rather than the model) he can't believe it.

Sitting next to him is an oriental girl who hasn't been drawing long. Though the model is caucasian, she has drawn an oriental face.

These last two students don't realize that you see and know yourself better than anyone else and are influenced by this. So you're apt to draw what you *know* instead of what you *see*. With awareness and discipline you can overcome this somewhat. But I think this characteristic isn't all bad and in fact if it's controlled it can give your work individuality.

And so you see, although these students' problems are as different and as unique as their personalities, there are only a few primary problems. These usually could be easily solved if it weren't for the psychological barriers both the instructor and student have to hurdle. As an instructor, I have to get to know the thinking behind what students do before I can help. As students, you're frequently your own worst enemies, refusing to recognize that your thinking has clouded and overcomplicated the drawing business.

If most of these students would let only the impressions that come through their optic nerves guide them, many difficulties would be resolved. I repeat what I've said before — you should put aside your preconceptions. Have a fresh look — and a wide one — so you can see the largest concept first.

Step 1: *I want to show you what can be done with a bristle brush and powdered charcoal. This technique is like painting. I simply dip the brush in the powder and apply it to the paper over a light undertone (also made with powdered charcoal). I can only make one dark brushstroke before I have to recharge it with charcoal. Notice the vertical line. This line is necessary to get the figure's correct stance.*

Step 2: *This pose appears to be a contradiction of the statement that the standing figure must have its head over the foot which is carrying its weight. I'm going to blame it all on the model. She managed to get out of balance, yet hold the pose. But her right foot is thrown back farther than it seems, so this foot compensates for her upper body part being bent over. I wiped out lights in this step with a chamois. The powdered charcoal comes off easily.*

 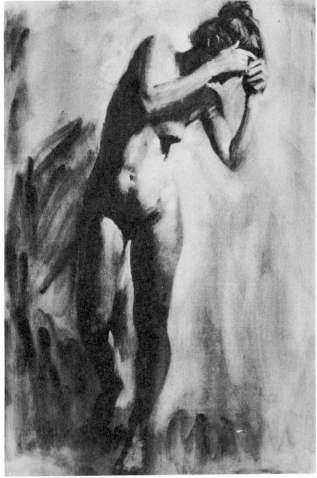

Step 3: *I paint on more blacks in the shadows and smooth the texture somewhat. The beauty of this type of rendering is its plasticity. The layout of the upper part of the figure in Steps 1 and 2 is wrong. Compare Steps 2 and 3. The charcoal can be literally shoved up into the correct position to re-establish the dark smudges. Then once more I clean out the lights for the new drawing. I block in the shapes of the hands with more definition here. A more clarified and corrected feeling of the body is achieved.*

Step 4: *I do more work on the hands, especially the subtle lights on the back of the hand. The fingers on her left hand are more carefully blocked in. I do a lot of blending with the brush. Notice how nicely the brush smooths the tones on the arms and body. The drawing of the front foot is brought out.*

Step 5: *(Following page) This step is just an over-all refinement of the figure. The shadows are left simple. There aren't a lot of details anywhere — just suggestions of things such as the sharp face contour with the lashes as the only detail. I leave the hands relatively simple. Also a few wisps of hair soften the look of the otherwise hard masses in the drawing of the head.*

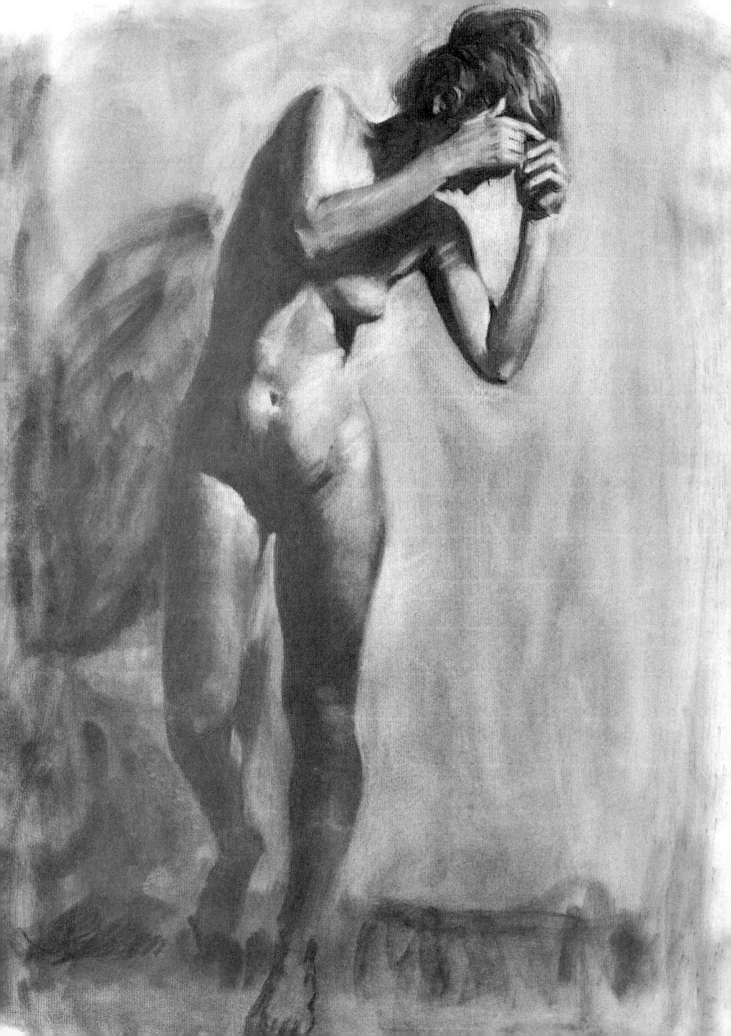

PROJECT 20

CONTROLLING EDGES

The mastery of a tone drawing or a painting is the control of edges. As you become more competent at rendering a drawing (observing more and transmitting most of what you see onto paper) you'll probably wonder what keeps it from having that extra something. What will lift your drawing out of the art school stage and give it that certain professionalism?

I'd like you to look at the model with a different objective in mind. Study the edges of all the contours. You probably haven't paid much attention to them until now. When you find out how important they are and can learn to control them, you'll be putting that frosting on the cake. It's as much a rudimentary error to think that all edges are clean and sharp as it is to believe there's a line around things. The visual spice of life is a myriad of various edges on everything. When you begin to see the subtle nuances these edges take you'll be looking for them everywhere. You can see the importance of edges in paintings by Rembrandt, Velásquez, or Vermeer. Analyzing these paintings, you'll learn the reason for their high level of craftsmanship, the masterly modification of edges.

TEXTURAL QUALITIES OF EDGES

Besides having length and direction edges have a surface quality and texture, modulated by light. The actual edge, regardless of texture or material, varies in degrees between a sharp edge and a soft edge. In other words, if you could actually feel edges, they would range from knife sharp to lessening grades of sharpness, to rough, and finally fuzzy ones. Your concern isn't how the edge feels, but what happens when light combines with its surface quality. Again, it's the notion about whether you should hold a brick and some mortar in your hand (and feel it) in order to successfully draw that building. I disagree with the necessity for this kind of experience. I've drawn and painted hundreds of things I've never touched — models included, especially! The tactile knowledge is certainly useful for the sculptor but not for the draftsman with two good eyes.

Your observation must be highly sophisticated to see modulations of tones in general. The most delicate of these modulations is seen in the variation of edges. In general, I advise you at first to keep all edges soft in a charcoal drawing. This is true also in painting. It's much simpler to sharpen up any edges afterwards than to start with all hard edges and try to soften them. One of the common criticisms of poor craftsmen is the "edginess" of their work. A drawing or painting full of hard edges looks cutout and pasted on.

The nature of light in reality causes objects to have *lost* and *found* edges. Try to use as many of these lost or *indistinct* edges as you can. These are the ones that'll give your work a professional look. Lost edges can make the quality of a subject become virtually part of the surrounding atmosphere. The nature of light, and consequently of shadows, causes objects to have lost, indistinct edges and found, that is prominent or hard ones.

MAKING HARD AND SOFT EDGES

You may want to bring one specific area into sharp focus to draw attention to it, and leave the rest of the picture all foggy. You can also make objects in a picture seem nearer by sharpening their edges, making the edges in the background soft. Of course, you can do all of this in a figure drawing.

Completely lost edges are very simple in black and white; you simply smudge right across the edge. You can also make jagged edges, uneven strokes coming across the edge, and spears of adjoining values which go into each other. Strokes of different values that parallel each other (in any order), and dots or specks of dark on a light edge or just the reverse are some other methods of softening edges. You may be resourceful and invent some of your own. Copy some of my drawings, those where I've purposely kept the edges sharp. Change the texture of those edges. The total change that takes place in the entire drawing will surprise you.

Step 1: *I use compressed charcoal on smooth illustration board for this one. Using the broadside of the charcoal, I smudge in a flat, gesture tone which leaves a rough texture. You'll notice some linear indications. Using lines plus some smearing, I'm not looking for the contour of the figure but trying to find segregated shapes. My finger traces a continuous smudge throughout the whole figure.*

Step 2: *I put down more charcoal and rub it some more. The lines of the background continue the flow of the arm lines. In this step the body is beginning to come out of the fog. Note that the position of the arms is a combination of a triangle within a trapezoid. The hip area is one segregated shape. The foreshortened thigh is broken into different envelopments.*

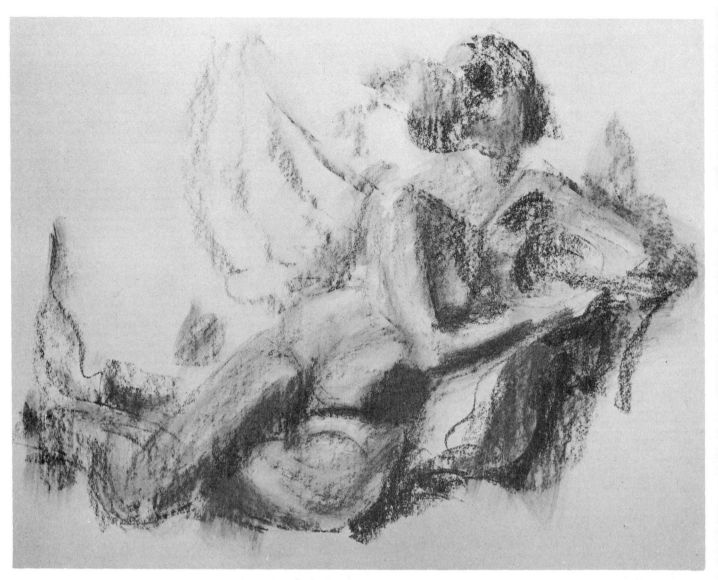

Step 3: *I think it's time to really whack in some blacks, so I can judge my darker shades correctly. I place some of these darks on the hair to locate the head shape. Darks are also added to the "V" of the crotch, her left hip, and around her left knee. I lift out a light on her right shoulder for the high key.*

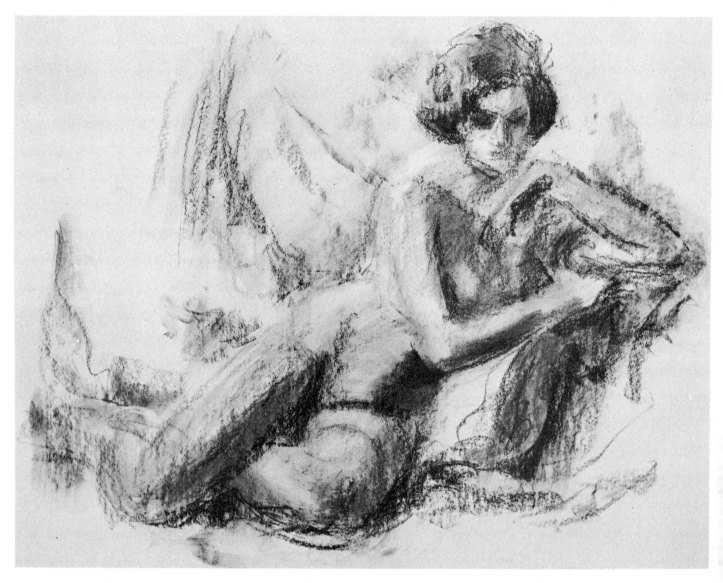

Step 4: *I begin to find more of the drawing — shaping the head and locating some facial features. I put in some very dark keys here, between her legs, under her right elbow extending down to the hip, and between her right arm and breast. The eraser is coming into use more here on the right side of her face. I think of this use of the eraser as "painting in whites." Try to think of it in that way, yourself.*

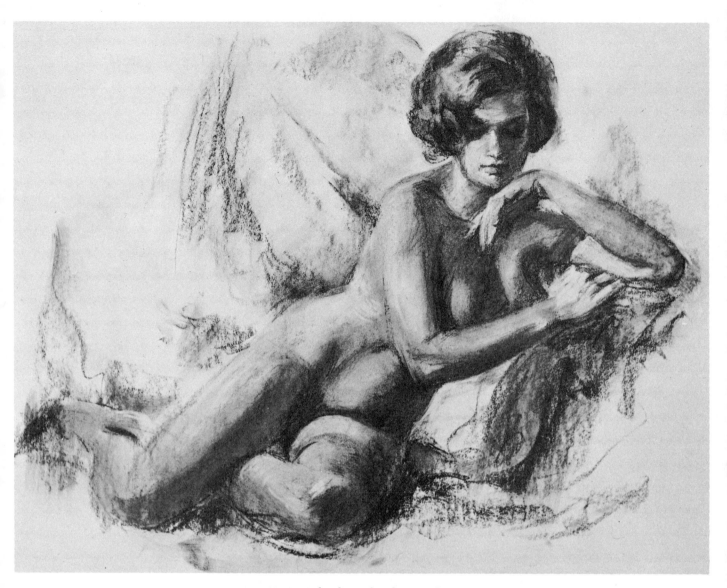

Step 5: *Using the charcoal with more of a point, I spend time going after values. There's plenty of rubbing in this step, too. Here almost all of the figure, except the feet, is basically modeled but still rough. I start working halftones in on the hips, belly, and legs in a crossways fashion to get a rounded look. I lift out a light click on her forward knee which also helps the rounding and thrusts the knee forward.*

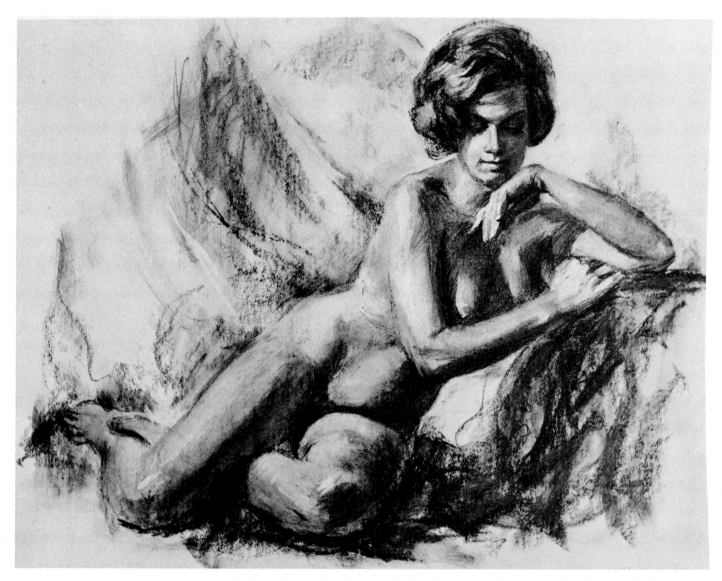

Step 6: *I smooth out a lot of tones, and refine the drawing of the face and hands more. I lighten up the breast and place more light on her right knee and right shoulder. I also model the right thigh more with subtle halftones. Her features are detailed here, and her hair is given more texture. I lift out a highlight on the tip of her nose, and add subtle halftones on her forehead to indicate the shadow falling from her hair.*

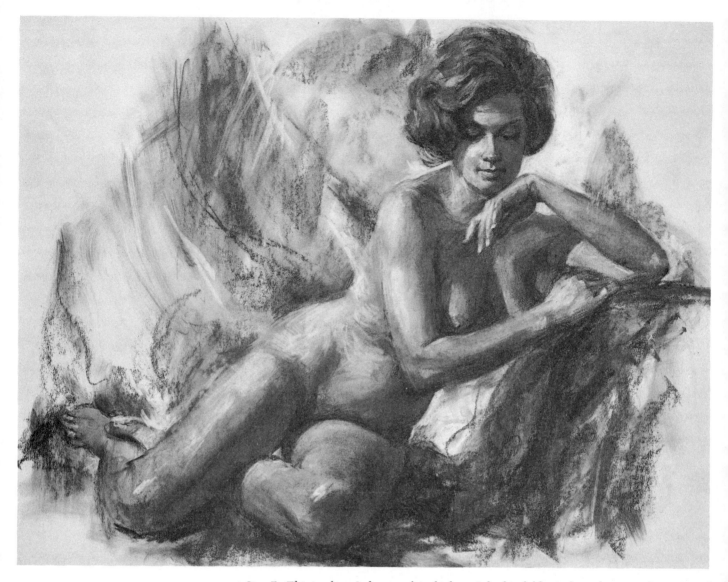

Step 7: *This is where I change a lot of edges. I do this deliberately to show you the variety of edges possible. Observe the many varieties around the periphery of the hair. Hair inherently is a symphony of edges. Around the body, beginning with the upper arm, I use little spears crossing the arm edge. A spot on the lower arm is smudged with my finger to break up that long, sharp contour. Follow her right shoulder line down around the hip to the thigh. See the various ways to handle that edge, from a soft line to small sharp places, completely lost edges, parallel lines at the hip, and ending with the jagged edge of the thigh near the knee.*

PROJECT 21

SCULPTURING, MODELING, AND RHYTHM

Now I'm really going to throw you a curve! I've been very adamant about having you see things in terms of two dimensions, reducing the subject to flat paper. Now I'm going to talk about sculpturing or modeling a drawing.

MODELING FOR ADDED DIMENSION

Art is full of seeming contradictions *unless* you take care to understand the frame of reference for a statement, as well as the statement itself. In this project for a while let's think only about a different way to approach charcoal, a procedure that requires a little imagination and will help you think more about masses. I'm going to tell you to draw in a sculptorly manner. That doesn't mean I want you to be a sculptor, but it expresses my feelings of mass drawing and the type of thinking it requires.

You're not suppose to "see" the model or copy as if it were clay, but you should make your charcoal drawing look like clay. Another way is to imagine yourself making a series of drawings of a sculptor's clay figure as he goes through the various stages from the armature to the finished piece. In the early stages of your drawing if you can actually think of shaping the material from rough globs to obtain the basic form, you've mastered the basics of sculptured or modeled drawing. It's impossible for a sculptor to model any details at first until the main, large masses of material have been modeled into proper proportions. This is also the most ideal way for you to proceed in drawing.

RHYTHM AND COMPOSITION

Rhythm is mentioned in many art books and art classes in relation to composition and to figure poses. And that's all — just mentioned. It's often not quite clear exactly what's meant by rhythm with regard to art. I think it would be simple to make another comparison to music. Music has a rhythm, a cadence or beat. Repetition of a configuration could be a pertinent description of rhythm especially when applied to graphic art. There can be many variations of beats or rhythms in a composition, and they serve to enhance its visual appeal.

CONSTANT AND PROGRESSIVE RHYTHMS

There are two obvious rhythms: a constant rhythm and a progressive one. (See Figures A, B, and C.) With a constant rhythm there's an exact repetition of shape. Progressive rhythms, those that increase or diminish in size, are usually scattered about in no particular order. However, your eyes can usually sense their presence and follow their flow. Even though rhythm lines may not be in positional sequence, you feel comfortable about a composition or figure if it's in progressive sizes. Naturally, the constant figures or beats are easy to spot; they usually occur in rows. However, if these aren't used sparingly, they're tiresome.

It's natural to be able to tune in to a rhythm or beat; you live with a constant and powerful one, the heart beat. Man has always displayed his sympathy for this pulse of life by having a cadence or meter in art, music, and poetry. Rhythm gives the visual world grace and beauty. Environmental planning today is static, a constant beat that's noisy and wearing. Nature or people provide the only relief. Without these there would be no progressive, rhythmic patterns.

In a drawing or painting also, there must be rhythmic forms to take away the dullness. One or several human figures provide this rhythm in a picture if they're in graceful, flowing poses. Actually, a figure can only give progressive rhythm because of the different sizes of body components. A hand and leg can form the same line but in varying sizes, thereby providing a progressive rhythm. Once you become aware of it, you'll be able to position the model to give you this rhythm. As you gain experience, you can slightly alter your figure drawing to give it more rhythm while still maintaining the structural integrity of your figure.

Figure A *This series of curved lines creates a constant rhythm.*

Figure B *These lines suggest a progressive rhythm.*

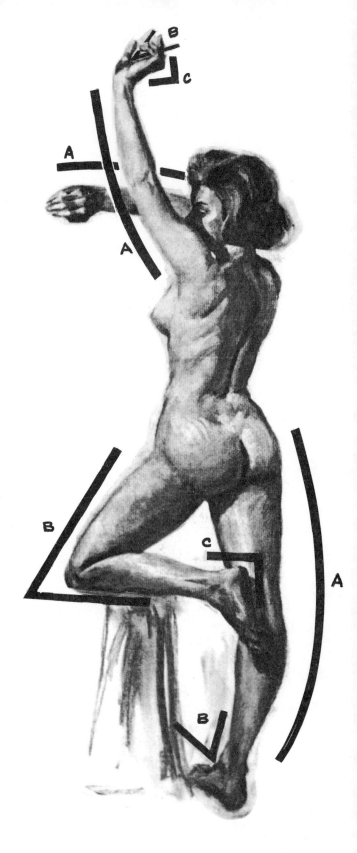

Figure C *The lines of a progressive rhythm usually are scattered like this in a composition or on a figure. The eye distinguishes their relationship, however, and the viewer "senses" the progression that's present.*

Figure D *In this pose there's a simultaneous combination of conflicting rhythms. Rhythm lines marked A might be the "adagio" movement. The lines B and C are points of quicker, sharper beats — 2/4 and 6/8 time. Notice the progression in size of these rhythm lines. The "adagio" lines (A) give the langorous, graceful action to the figure. The more angular lines (B and C) offer a nice contrast and also give the body its structural stability.*

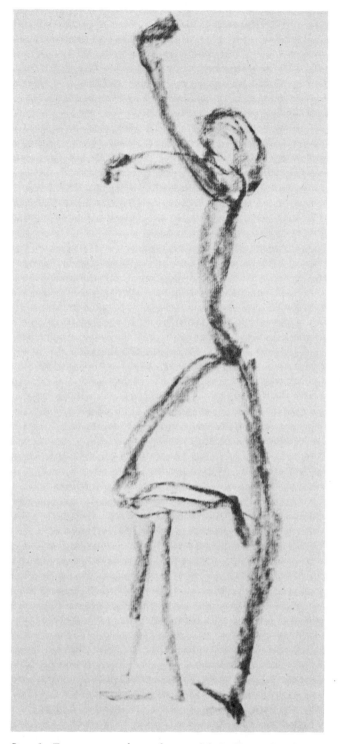

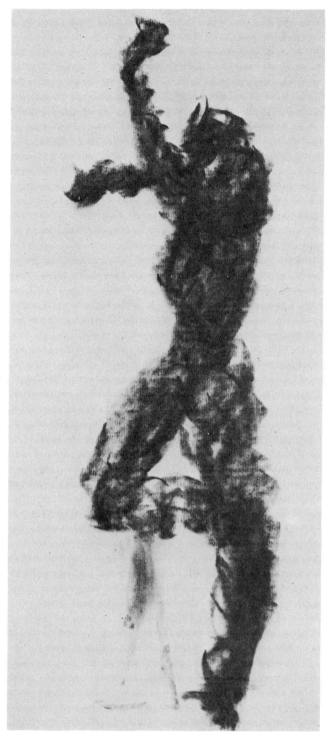

Step 1: *To create a sculptured or modeled effect, I first have to put in the "wire" armature. This preliminary gesture tone simulates the initial work of the sculptor with a wire-like indication of the figure.*

Step 2: *On top of the armature, or preliminary gesture, I put down the low key tones, very roughly indicating a figure. These tones flesh out the armature with large masses similar to those clay masses with which the sculptor would start.*

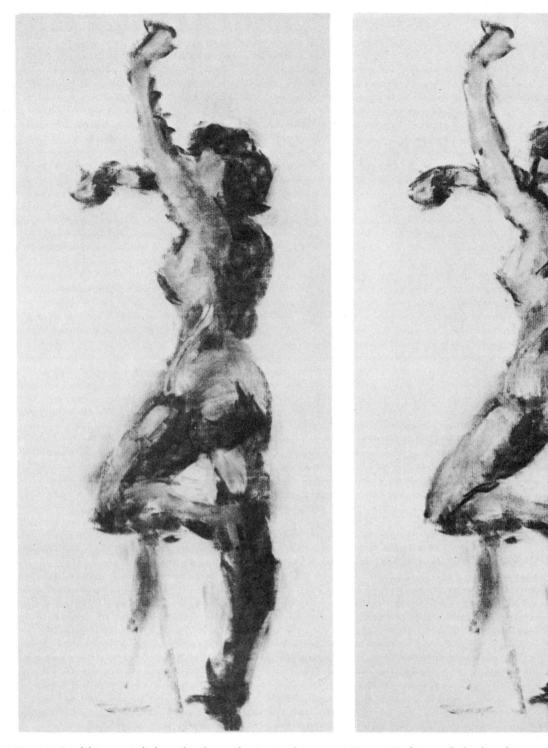

Step 3: *By lifting out lights, the figure begins to have a sculptured roundness. I take out these lights with a kneaded eraser on the raised arm, breast, and across the buttocks. The contours are roughly modeled at this stage, and I still have the freedom to manipulate the larger shape.*

Step 4: *Making a dark place between the arm and face pulls those places apart and provides the third dimension. The depression in the center spine area is darkened to give it depth. The same idea is carried out in the buttocks and leg region. Observe that I make no attempt to refine any of the figure until I'm sure of these big shapes.*

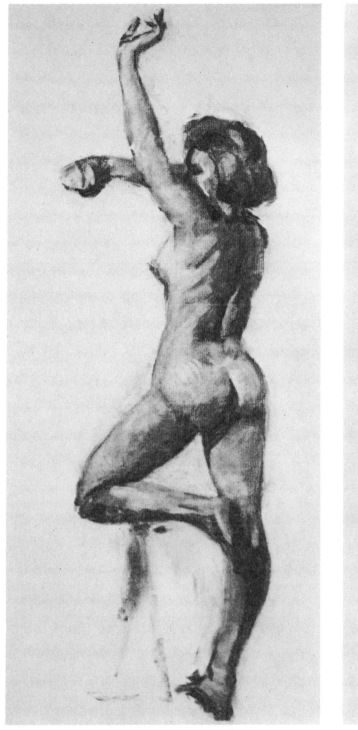 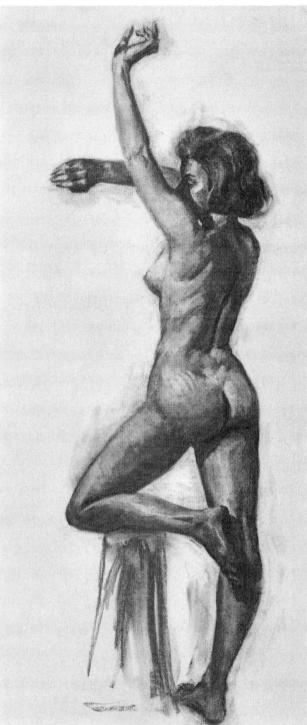

Step 5: *Feeling fairly satisfied that every part is in its proper place, I begin to smooth out the "roughness" with my finger and the puff. Notice that the lower hand is still a blocked form. I work in halftones down her left side and across her shoulders and arms. Also with a pointed kneaded eraser, I pick out some spears of light on her left buttock and down her face.*

Step 6: *There isn't too much left to do in this step. I sharpen contours, separate the fingers of the hands, and put in the details of the hair and face. Since the hair has a tone darker than that of the flesh, the appearance of the model has veered off from the monochromatic look of clay. You don't have to be completely faithful to the idea that you're doing a true clay figure. The main thing is to get the modeling concept present in sculpturing into your drawing.*

PROJECT 22

MOVEMENT
AND
MUSCLES

Any great motions performed by the human body result from two basic muscle functions: one is flexing: the other is extending. All bones that articulate with other bones are equipped with sets of both extensor and flexor muscles. If a limb moves in one direction, there has to be something to move it back. For the most part, this action-reaction accounts for the more than two to one ratio of muscles to bones. Muscles are connected at two points, the origin and the insertion. The origin is the point of connection to the stationary bone; the insertion point hitches the muscle to the bone that's to be moved. When these two bones are pulled close together they're flexed; when they're farthest apart they're extended.

The rotating action of the arms is achieved by muscles called pronators and supinators; their muscles also double as flexors and extensors. Rotation is a motion completely unique to the arm. A muscle is at rest when it's extended. When flexed the muscle contracts and swells. A muscle can never stretch — it's not like a piece of rubber.

CONTROLLED FALLING

All movements of the body consist of contraction or the pulling of muscles. In a sense, the body pushes anything by pulling, which is the contractile action of muscles. When you do your push-ups, your muscles are really pulling. Rising out of a chair is not pushing but several muscles contracting to perform that feat.

Walking on level terrain is really controlled falling. The body has learned to walk by trial and error. Watch a baby learning to walk. He actually falls forward until he reaches something like a sofa to stop him. As the body falls forward, one leg at a time goes out to catch the fall. Walking is actually a refinement of falling, but other movements are coordinated with it. A contraction of the large back thigh and calf muscles pulls the body into the next position for "falling" again. There's also a slight rotating or swinging motion of the body along with the forward gait. The arms swing in opposition to the legs, providing some propulsion, balance, and equilibrium.

Ascending stairs is the same falling forward movement but with the addition of the thigh muscles taking the full weight of the body up to the next level. Running is also falling forward but farther and faster than walking combined with a propulsion off the ground, a springing by each set of leg muscles.

THE MOVING FIGURE

There are always some muscles at work no matter what the attitude of the body. Even while you sleep many muscles are working. I have no data on the behavior of an astronaut's muscles in a zero gravity condition. But I'll venture to say that though his muscles are in as neat a stabilized condition as possible, some are still at work.

It's most important to know how the body does all of these movements. The muscle function is the "why" of these motions. In making a picture of a figure performing a movement, you "freeze" the figure at one point. If the limbs aren't positioned correctly the figure won't be convincing. It's not usually feasible to have a model pose in a simulated movement. Very few can hold a dynamic pose and make it look believable. You should sketch a lot from moving figures. Yes, you can do it after some practice. This will give you a feeling for what happens in a moving figure. A good model will do what are called sequence poses, going slowly through a common movement in steps and reversing the procedure.

ARM AND LEG MOVEMENTS

An average person's leg can move forward farther than any other direction, about twice what it can backward or sideways. (About 45° forward from the axis of the straight figure.) To get the leg higher, the knee has to start bending until the thigh raises to about a 60° angle. From the knee down the leg can only move backward. Any rotation of the leg is from the hip. The foot can wiggle in all directions but can move farthest downward. This gives the leg a more graceful appearance.

Arm movement is almost unlimited. You can touch any part of your body with your arm except most of that arm itself. If you think it's necessary, by bending your thumb backward, you can poke your arm's own deltoid muscle. The muscle structure of the arm and leg and their respective movements are vaguely alike.

The articulation of the appendages, feet and hands, is fairly versatile, the hands having slightly more latitude for movement than the feet. The outstanding difference between arms and legs is that the arm can rotate, a movement named after those muscles called pronating and supinating. The supine position is the hand turned outward from the body. In the pronated position, the hand is turned in toward the thigh.

The trunk isn't too flexible, as pointed out in Project 9.

Completely bending over is mostly the action of the hips but some curvature takes place in the backbone. Bending backward is about 1/5 of the distance of bending forward. Arching the backbone is a very slight movement and also the limit of the spine's flexibility in that direction. The neck vertebrae are constructed so that much movement of the head is possible, but the limit in any direction is near 45° from a vertical line.

You can appreciate the various kinds of articulation of joints needed for all of these movements. The joints can be compared to straight hinge, ball and socket, saddle joint, roller type, pivot, or combinations of these. This gets into the realm of the finer points of anatomy and I leave it to you, if you desire, to continue this study in one of the recommended anatomy books.

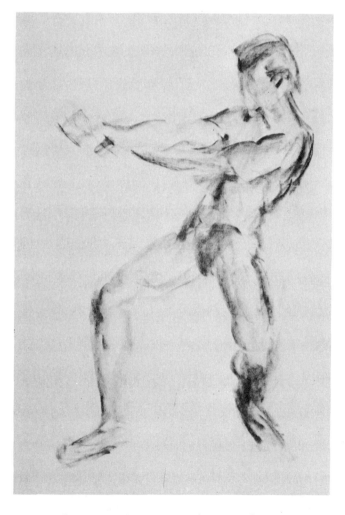

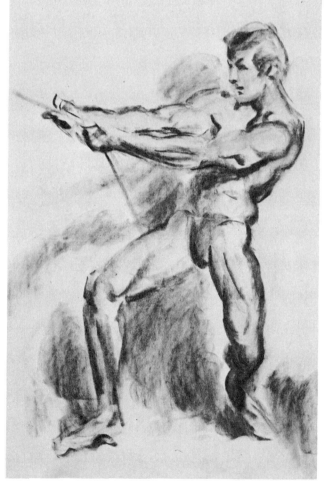

Step 1: *This pose suggests a spirit of tension plus movement. I begin directly with fast strokes in order to capture that feeling. The light originates from a direction near my position so that all of the contours get darker near their edge. To render this figure, I hold a short piece of charcoal tilted so that one side forms a sharp edge. The rest of the piece makes a soft blended tone.*

Step 2: *I keep the sharp edge of the charcoal on the outside of the figure. This makes the center part of the figure have the rounded appearance of muscles. Also, the light source makes the center seem the lightest part. Rendering with the charcoal held this way makes a quick and direct statement. The lower leg has to be almost completely dark, because it's in total shadow. This dark tone also suggests that the limb retreats from you.*

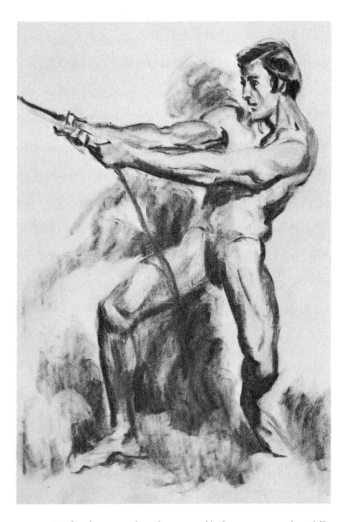

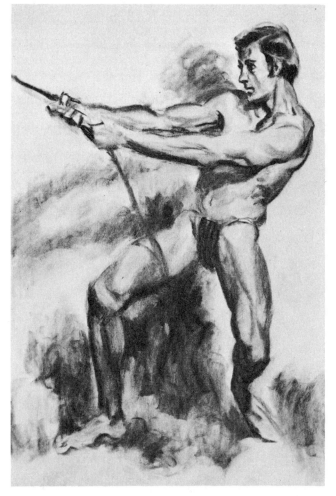

Step 3: *In this figure and in this type of lighting you need middle tones between the strong center areas of light and the dark edges of the figure. So I add halftones in places such as the side of the biceps on the far arm and along that forearm. In this and the next step halftones give strength and shape to the flexing muscles which gives the figure a feeling of potential power and movement. The model has black shiny hair calling for a mixture of very black tones and middle tones where the hair shines. The background consists of swirling patterns to suggest the motion theme. The dark spot for the eye is placed and encircled to show the wide open eye. The eyelashes position the eye itself. The cast shadow of the head on the far shoulder is suggested. A very black tone starts under the arm (the cast shadow) and loses strength as the arm goes farther from the body. As that space opens up, more light can get at it and cancel the shadow.*

Step 4: *Some contours are corrected here. The one around the shoulder shows the shoulder blade thrust out. The closest arm is too thick so the underside is raised. Unnatural bulges are changed along the back and his left thigh. His right shoulder looks almost dislocated, so I pull that shoulder contour back closer to the head. Note four arc-shaped tones (fairly dark) in the rib area. These are the serratus muscles attached to the ribs; they give more emphasis to the flexed muscles and also separate the side and front planes of the middle torso. A very light zigzag tone reaches around from those muscles to the navel and defines both the bottom of the rib cage and abdominal muscles.*

Step 5: *The over-all tone of this figure seems anemic so I lightly shade in a tone all over. This means I have to go back and pick out the smaller highlights in places like the temple and around the neck and shoulders. The main part of the neck isn't as "contrasty" and is slightly darker than the face. However, where the muscles attach at the shoulder the tendons require harder treatment; that is, darker accents next to small highlights. The strain of the muscles causes the attachments to be pronounced. The face isn't contorted, because this movement wasn't that much of a strain for this muscular model. Any stress involved is shown in the remainder of the figure. The far shoulder under the chin is made lighter, and the dark of the underside of the chin brings it forward and away from that shoulder. The line from the back of the neck down is straightened because that's all one muscle wrapping around the shoulder blades, attaching to the middle of the back.*

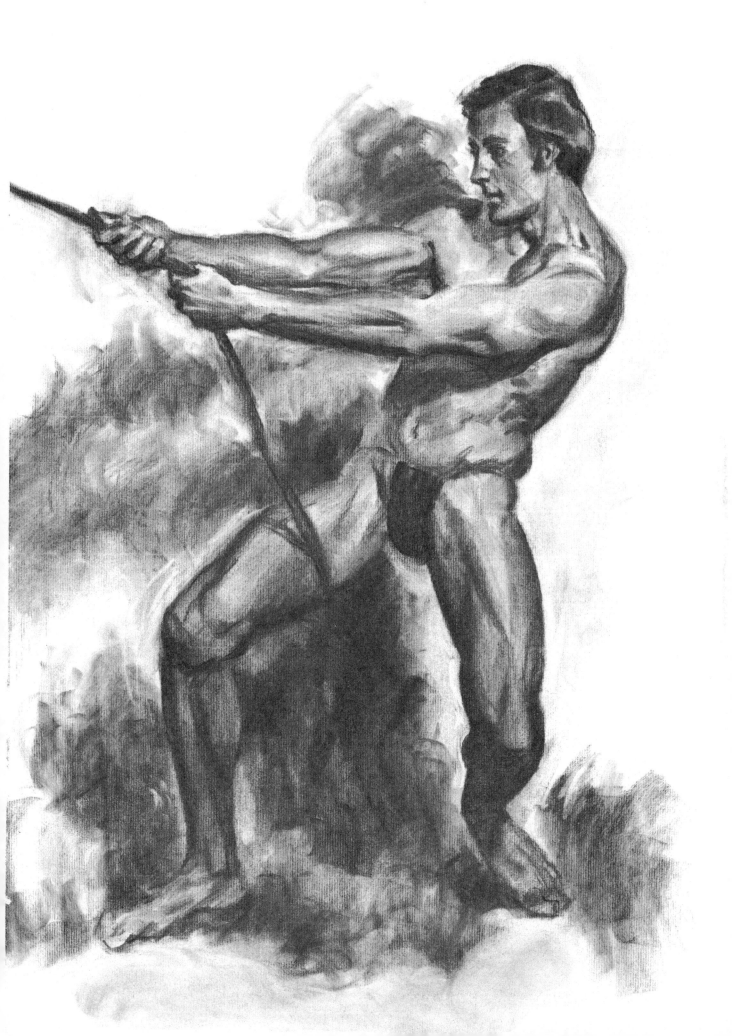

PROJECT 23

DRAWING THE FACE,
HEAD, AND HANDS

It never fails. Before the first week is ended in a life class, a novice will ask, "How do you draw a face?" I'm always torn between giving a two hour monologue on how it can be done, or telling them I have a previous engagement. People who've been drawing for a while soon realize there's no easy answer to such a question — if you're going to draw without recipes.

Usually, the face of the model is right before you, but you don't trust your own eyes. You probably want a simple formula; there are many. A lot of books have various step-by-step instructions for drawing a face. I balk at giving a prescription. The nearest I'll come to it is to explain the placement of facial details.

PLACEMENT OF FACIAL DETAILS

I use the egg again as a model for the head. Mark it with a circle around its center both horizontally and vertically. The horizontal circle will represent the line of the eyes. The vertical line is the dividing line of the face along the nose. Every theory varies and especially here. The front of the face in this way is divided into four equal spaces, starting from an imaginary hairline, to the browline, to the end of the nose, to the mouth, and to the chin. The ears are positioned behind another line drawn vertically around the side. The depth of the ear is from the eyeline down as far as the tip of the noseline. Rotating the egg in any manner, you'll notice the influence of perspective.

The head, however, is more sophisticated than that. The head, "egg," shape has an additional structure — that of the jaw and mouth. (See Figure A, next page.) There's also more modeling to do. For instance, the sides of the head are somewhat flat. The highest point of the head is back of center. There are two scooped out places for the eye sockets, with the eyeballs countering this form by protruding a little. The top of the two eye sockets form the brow. From that point the nose starts to angle out and widens as it drops. The nose has four sides: the front sloping ridge, the two side planes merging with the cheeks, and the bottom plane. The wings of the nose are attachments on the sides. The valley of the septum above the lips divides the two planes which cover the upper teeth and slant back to the cheeks. The top lip forms the bow which seems to be in two sections divided at the top dip. The lower lip is thicker, has a long front rolling shape, and two discernible side panels.

There's an angling back to about halfway between the lower lip and the chin. The side view on page 131 demonstrates a series of setbacks from the nose down. From the front view, an alignment of the face based on an "X" placed sideways can be observed at almost any perspective of the head. Two common lines run from each eyebrow and cross the bridge of the nose. These imaginary lines extend from the inner (thicker) part of the eyebrow to the *inner* curve of the opposite eyeball when the eye is closed, or the *outer* curve of the opposite eyeball when the eye is open (Figure B, Page 131).

The difficulty in giving this kind of instruction is knowing where the dividing line exists between an idealized formula and a worthwhile proportion key. Nature hasn't made faces conform to an exact pattern. In the final analysis, these points are just a means of calling attention to what you've seen or reinforcing what you should be able to see.

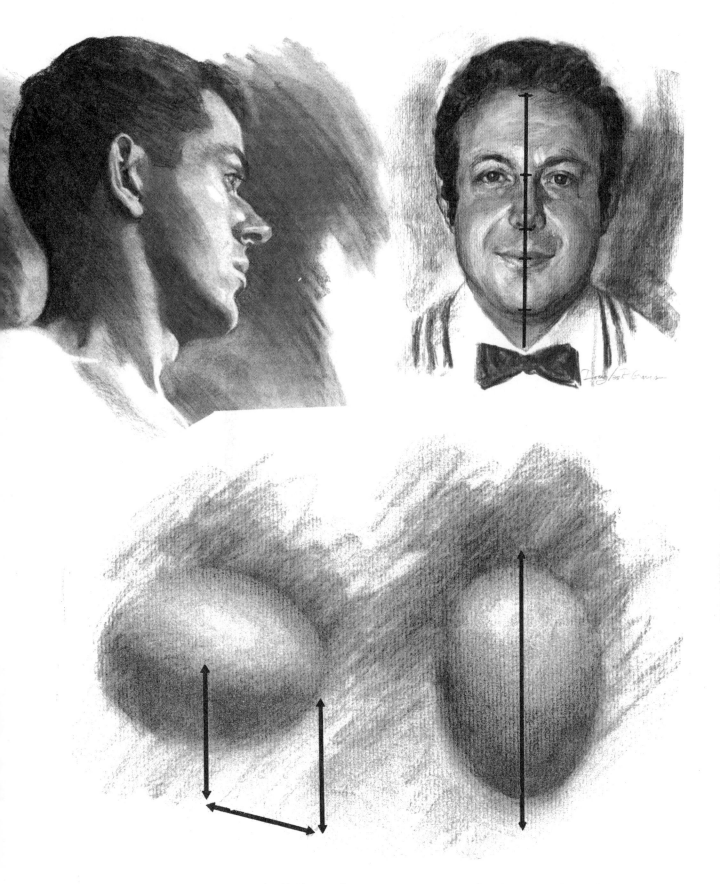

Figure A *(Left) The egg illustrates a way to perceive the side view of a human head. In a level position, it would represent the upper part of the head. The arrows show the shape of the jaw attached underneath. (Right) Standing upright on the small end the egg in this position represents the approximate shape of the head from the front view. The arrow shows the center line of the face.*

Locating facial features can be more precise by using these simple geometric forms. The inverted triangle at the top has its outer points at the pupils, while the bottom point is at a place directly under the nose. From that point two alignment lines angle down through the upper points of the bow shape of the upper lip. These lines coincide with the outer corners of the lower lip.

Figure A *Demonstrated here are the usual steps back from the nose down to the chin.*

Figure B *One of the problems in drawing a face is establishing the proportions between the eye and eyebrow as well as showing the curve of the eyeball in relationship to the larger curve of the head. One way to visualize the curve of the eyeballs is to picture a sideways X with its center at a point over the nose. In the head with the eyes closed (left) the inner (thicker) part of the eyebrow is on the same line as the* inner *curve of the eyeball (and thus, the eyelid) of the opposite eye. When the eyes are wide open (right) the inner part of the eyebrow is on the same line as the* outer *curve of the eyeball of the opposite eye.*

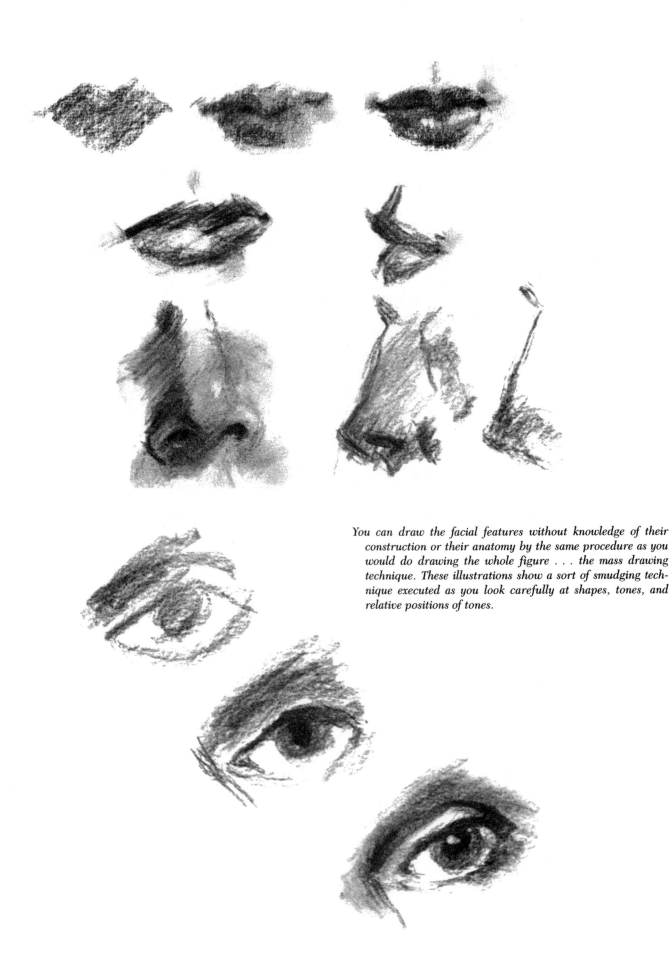

You can draw the facial features without knowledge of their construction or their anatomy by the same procedure as you would do drawing the whole figure . . . the mass drawing technique. These illustrations show a sort of smudging technique executed as you look carefully at shapes, tones, and relative positions of tones.

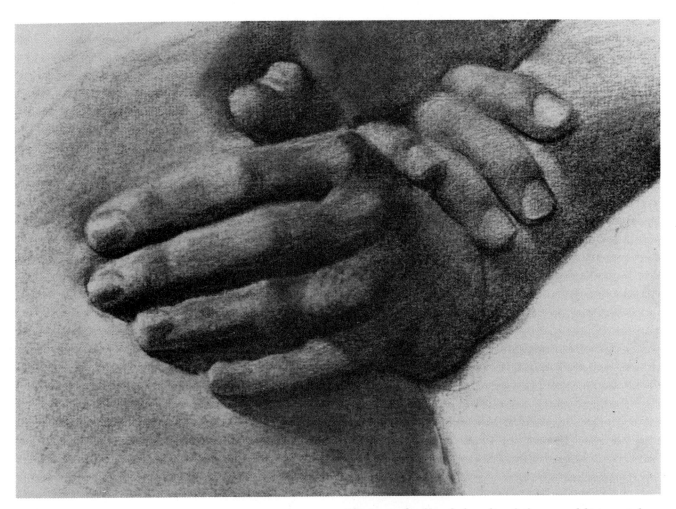

This is a study of hands done directly from a model in an art class. The model was standing, the hidden arm was around her back clasping the wrist of the prominent hand. It is remotely possible to construct this pose by thinking *about it*—but what a chore! By strict observation, fitting all the pieces of the mosaic together, it evolves into a cohesive picture of hands in this position. (There is a brief description of a hand's construction in Project 4.)

Here is a sketch I couldn't have done without many hours spent drawing directly from models. This lady is a cruise director for a major cruise line. I sketched her and about fifty passengers in charcoal in return for a complimentary cruise for my wife and myself. What a payoff!

Developing the genre of charcoal drawing can lead to extra bonuses, such as portrait sketches. It's so much easier than pencil sketches because of its flexibility in correcting. This was a forty-five-minute sketch done for a preliminary study leading to an oil portrait.

Sfumato, from the Italian meaning softened or evaporated like smoke, is often used in describing a drawing having that soft appearance created by fine shading. Charcoal lends itself to achieving this effect. Except for a few linear suggestions in the hair, this drawing is rendered this way.

PROJECT 24

DIFFERENT MODES OF
CHARCOAL RENDERING

In some of the earlier projects we worked on different kinds of paper to learn that subtle new effects are produced. In this project I would like to demonstrate additional ways to produce some unique effects. You will add to your inventory of materials different kinds of supports such as museum-type foam-core board, acrylic gesso, and rubber-cement thinner.

I coat these supports, either the foam-core board or heavy cardboard, such as that which comes off the back of sketch pads (much cheaper than illustration board), with acrylic gesso. I usually give them two coats because I like a rougher texture. Sometimes I brush it on very heavily, leaving a myriad of brush strokes. Use a cheap 1″ or 2″ housepainter's brush and give the backsides a coat to pre-

vent too much warping.

I use the rubber-cement thinner in the process of doing the drawing which will be explained in the steps of the demonstration. There are different solvents you can use, but I find this thinner doesn't have too strong an odor and evaporates very quickly. One caveat: Be sure your room is well ventilated. I also use the powdered charcoal that was once available in cans. If you can't find that, you can make your own by scraping sticks of compressed charcoal with a knife. It will only take on the average one or two tablespoons of this material for each drawing. You can also powder vine charcoal for this procedure but it will be a little more delicate because it isn't as black or fine-grained.

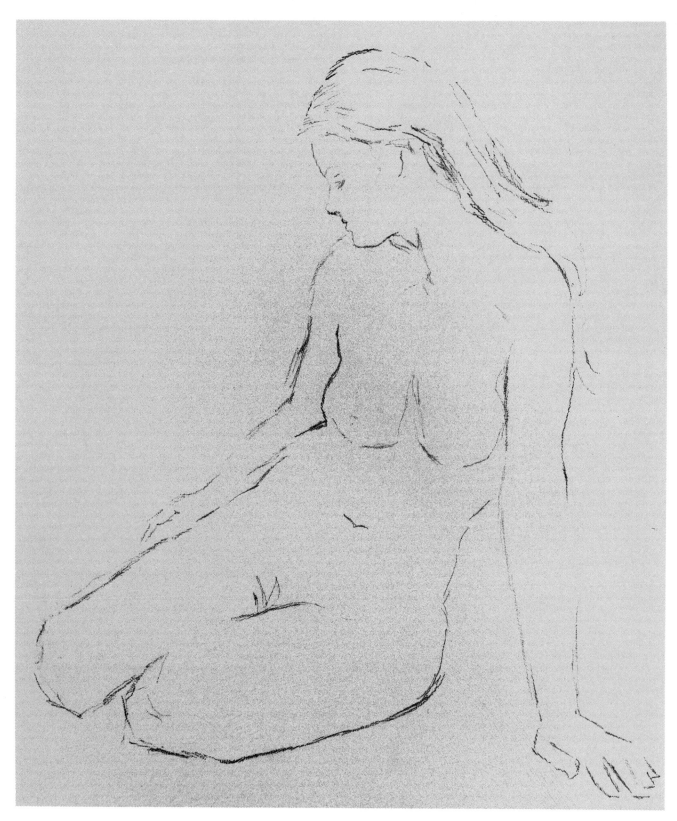

Step 1: *I carefully draw the figure on a foam-core board prepared with two coats of acrylic gesso. Using a charcoal pencil I sketch a very light indication of the boundaries of the figure just to know where the background is going to be.*

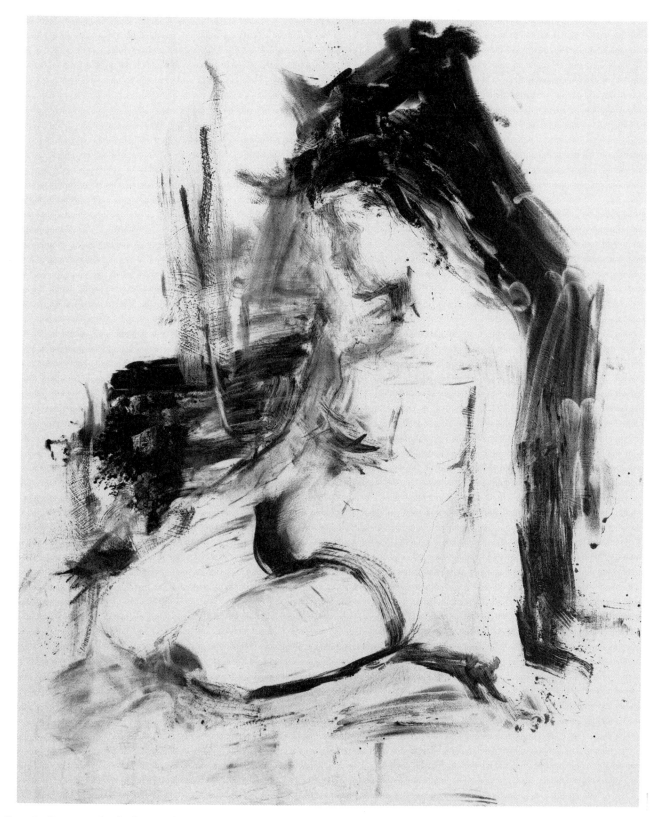

Step 2: *To put in the background, I have the foam-core board lying flat on a table. I pour enough rubber-cement thinner to cover the entire area I will be working in. I sprinkle small amounts of powdered charcoal in a manner to form the design and pattern I want. In this case, a greater amount goes above and down the right side of the figure. A dark area on the left above her arm and leg will need a generous amount (less than a tablespoon full). I just pick it up in my fingers and, after I sprinkle it on, I smear some of it around using either my fingers or a bristle brush. This is the fun and freedom time. You should have some sort of preconceived idea first, as I did when I spotlighted the figure and massed the darks on the light side to the right. The dark on the left above balances that. I counteracted that directional thrust with a couple of up-and-down strokes above left center.*

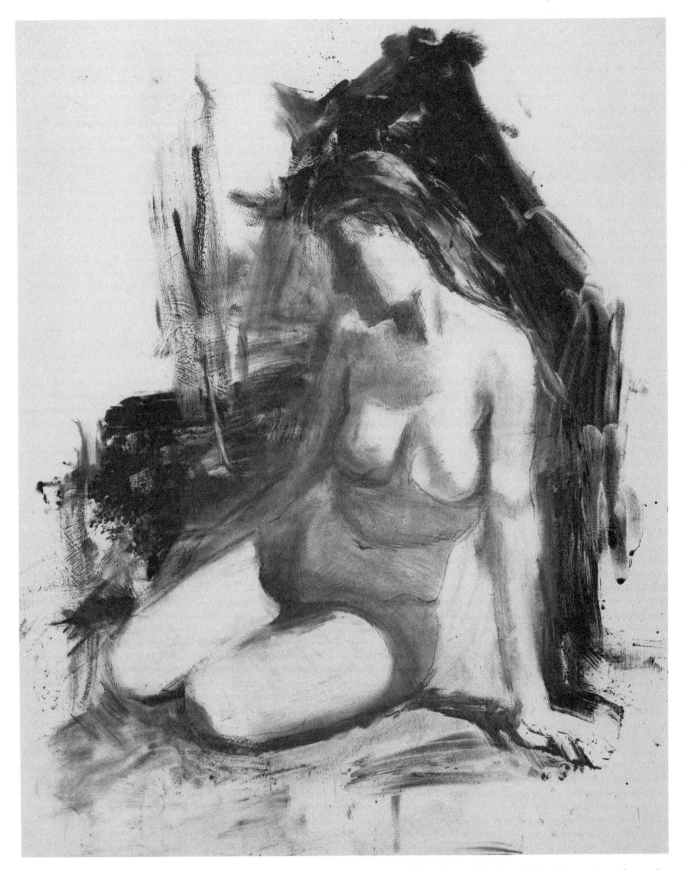

Step 3: *By blending with a bit of the charcoal powder or by shading with a vine charcoal stick, I shade in the light middle tones on her body and face. You can rub it with your fingers or blend it with a piece of foam rubber or even brush it to get the subtle effects you desire.*

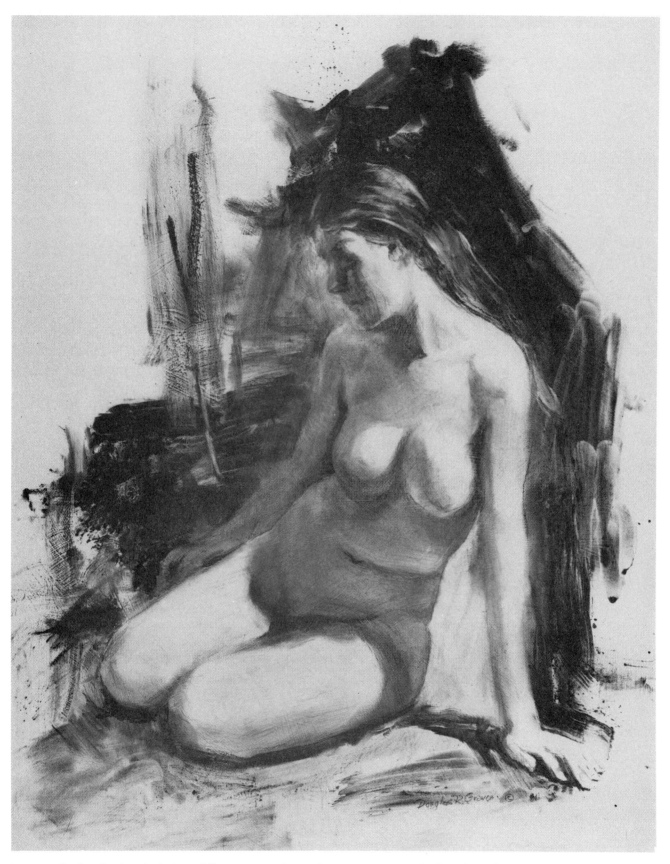

Step 4: *I further develop the light middle tones over the whole body to achieve a roundness, but there's an absence of tones in the lightest area because of the blinding light on the figure, so a lot of the areas will be pure white. The shape of the light half tones on her body and the details of the face tell most of the story. However, I don't do too much detailing in the face and on the hands as this is just a short demonstration of another rendering technique.*

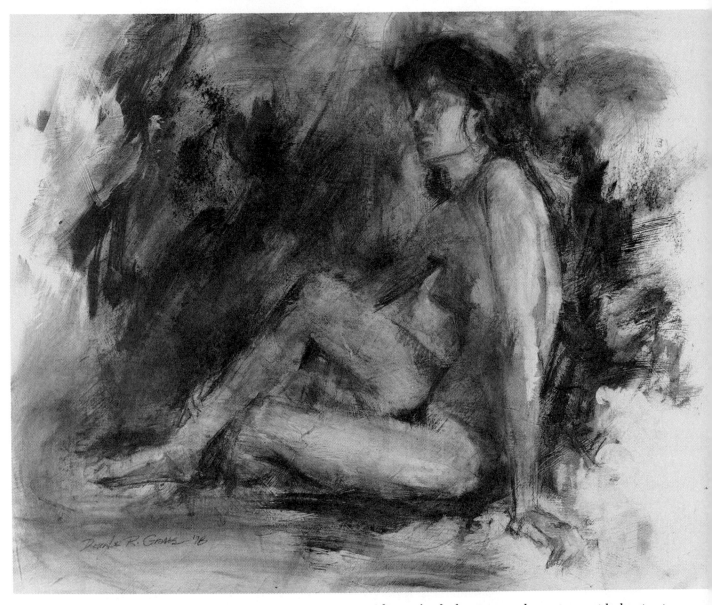

After you've had training and experience with drawing in an academic manner you feel the urge to be a little more "free-wheeling." Using a cardboard from an old 18″ × 24″ sketch pad that was prepared with two coats of acrylic gesso, I started with a very sketchy indication of the figure. Then I just let the figure emerge, alternating vigorous broad strokes, and smearing it in places with my fingers. Contours appeared here and there; if not, an edge would be lost or softly blended, by strokes of the charcoal stick. Painterly effects were done by sprinkling powdered charcoal carefully in spots that were brushed over with a bristle brush dipped in rubber-cement thinner.

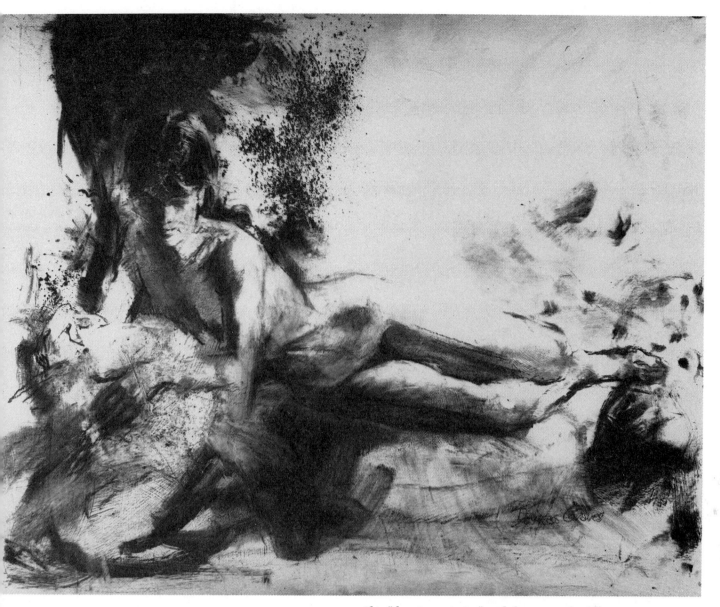

This "drawing painting" and the one on the following page are done with the same materials and with the same freedom but they will show that a great variety of effects can be obtained by varying the amount of charcoal used or by fixing the drawing. (Incidentally, such drawings need a heavier coat of fixative.) Over the fixative you can paint in areas with the white gesso again and work some more with the charcoal. The drawing on the next page was reworked in places like the face, hand, and arm with a small brush and gesso.

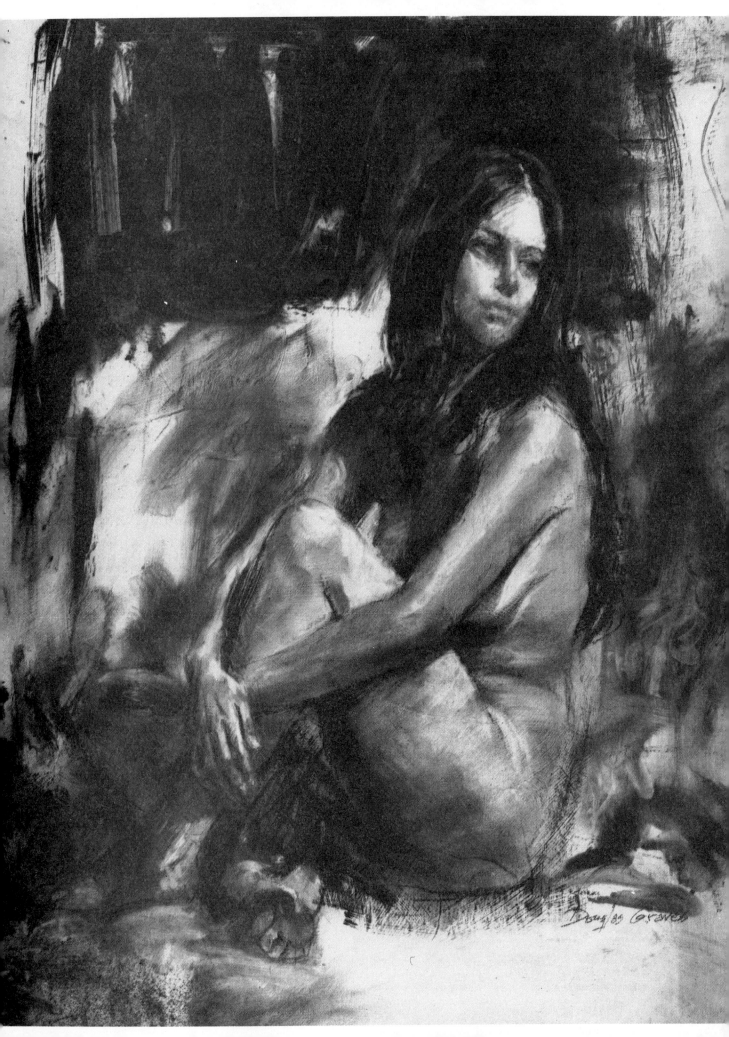

PROJECT 25

COMPOSING A FIGURE ON A PAGE

In my charcoal drawings you've seen many different kinds of poses. With or without backgrounds, they present a small problem of placement. Usually you can sense about where a figure should be. But if an arm or leg shoots out, you should always make use of that. These appendages can be regarded as balance levers to the main mass of weight. By now you've gotten so that you don't center every figure to the right or left on the paper, because this can sometimes endanger the proportion of limbs. If you are able to see the complete figure as a unit, as a geometric shape like a triangle or pyramid, set the figure up so that the total shape seems to balance well on the page.

Later as you use a background with varied or broken shapes, they must be considered along with the figure in compositional planning. A large shadow off to one side might well be a balancing factor in an off-balance pose. Shadows are handy things to have; you can do so much with them. But whatever you do, don't make black, solid, hard-edged shadows. A shadow gets increasingly softer as it gets farther from the object casting it. The drawing or painting becomes more than a study with the addition of other objects; it becomes a composition. Then you must be concerned with a more complex design problem. This is an entirely new subject and there are many books on it.

One device I favor very much is the viewer. With two small adjustable mat corners clipped together you can form a window to sight through. It can be adjusted to the proportion of your paper and can help you compose your subject.

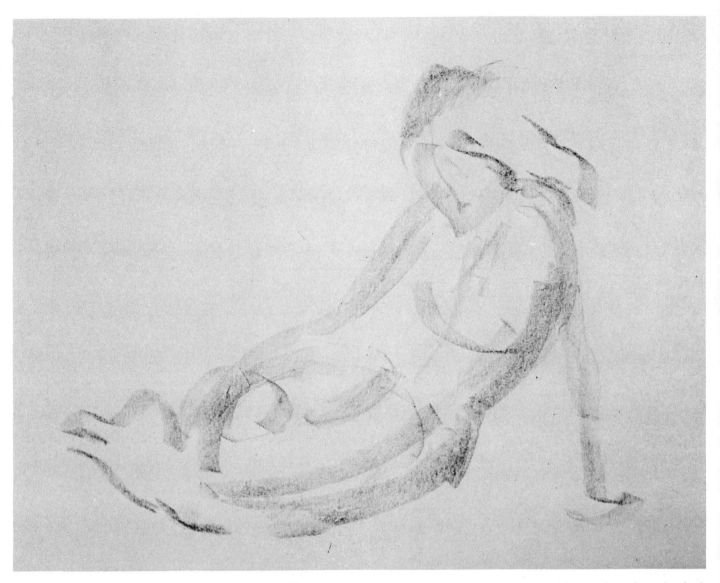

Step 1: *With swift strokes using the side of the charcoal, I'm reaching here for both spontaneity and accuracy. I use compressed charcoal and choose white bond paper which responds to the charcoal beautifully. You can see that there's a sweep of strokes in a bean-like shape which forms the torso and thighs. This shape is balanced on the center, left, and right and is put lower on the page because the head must be placed on top of it. The projection of the feet and one hand out at the sides is about equal and minimal so they don't alter the balance.*

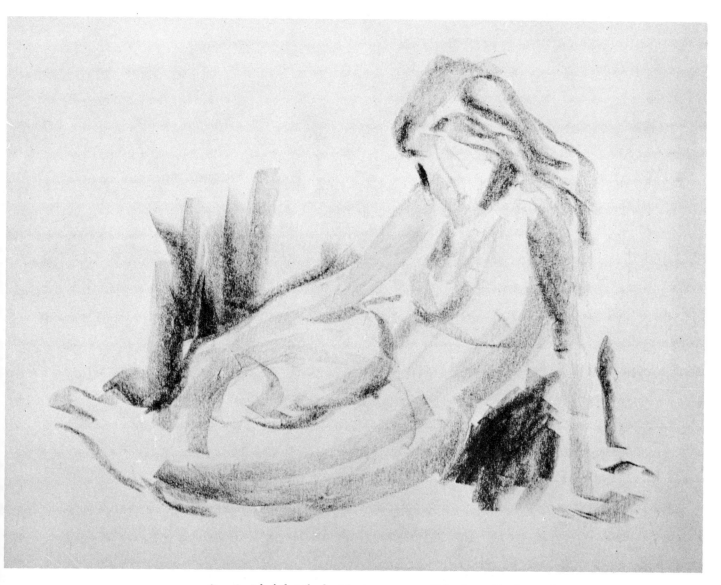

Step 2: *I feel that the best keying spots would be the two background areas and a spot on her hair. These are also opportunities to form some of the negative shape contours. Note the one low tone along the arm resting on the thighs. The key tone of the hair begins to locate the shape of the face. Three area middle tones will help estimate other tone values and also begin registering the form of the figure. These are found under the side of the jaw along the stiffened arm, and on the lowest knee. Some swirling tones are put in on the hair to start bringing it down in value.*

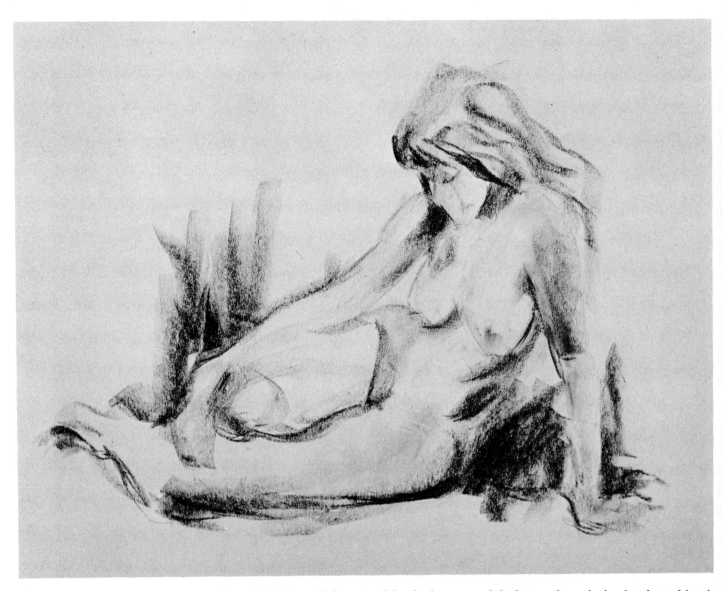

Step 3: *Some darks are used for the front part of the hair to shape the head. A hint of facial features is drawn, but I refrain from being too definite there yet. A dark spot suggests the hair on the other side of the mouth, and I define that contour. This step is also marked with alignment lines: down the front of the arm, around the breasts, and faintly suggesting the negative shape between her upper arm, hip, and breast. There's also a line of separation between the thighs. Notice that these aren't hard incised lines, but a combination of tone and line. The blend of her left arm is suggested with the approximate final tone. Also the tones around her rib cage are put in. With my finger, I rub some of the gesture tones, on the arms, breasts, and lower thigh. At this point they're halftones but they'll go darker later.*

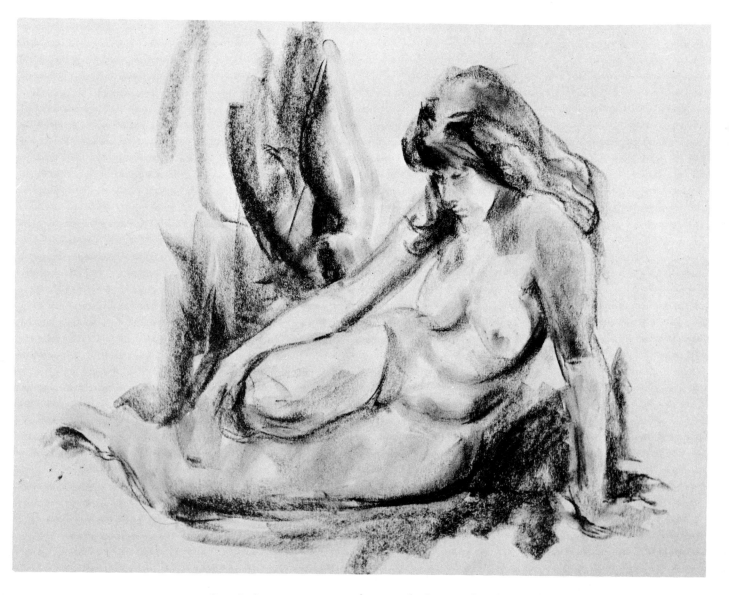

Step 4: *As a counterpoint to the curve the figure makes, I'm going to make a configuration in the background, starting up high left of center, and curving down, going right into the figure. This seems to accentuate the curved nature of the figure position because it's rhythmically in beat; it will eventually be in complete tonal contrast. By adding three varying dark shapes to the hair and with a few sketchy strokes down the back, the head has shape and the effect of light. This will be the effect I ultimately want but darker. By rubbing my finger in the very black spots, I put enough pigment on it to use for halftones over the rest of the body. This is "finger painting."*

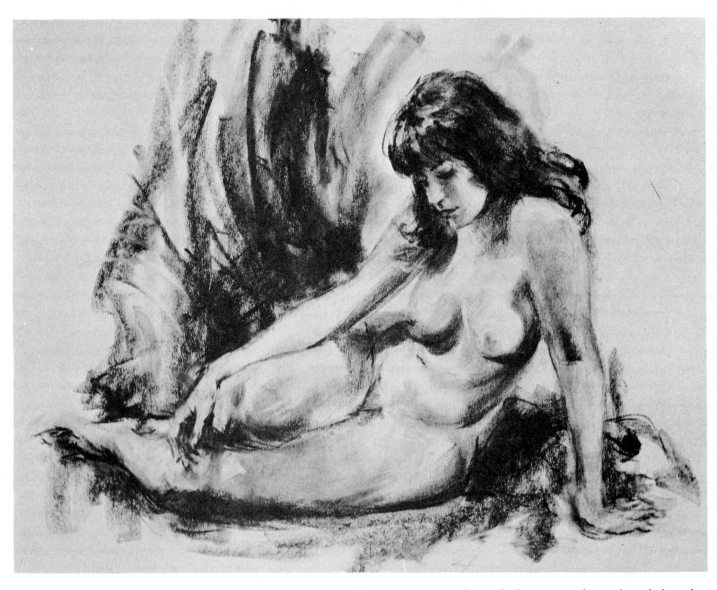

Step 5: *A suggestion of the septum is put in here. The lips contain three values: dark on the upper lip, lighter on the lower lip, and a dark smudge for under the lower lip. Shadows under the breast are put in darker under the arm because nothing reflects light into that area. With a pointed eraser I make hatched strokes in the light areas of the breast, the chest, the abdomen, thighs, arms, and legs. The background is made stronger by adding a third rhythmic detail. With an eraser, I make curves in the other direction (at the left).*

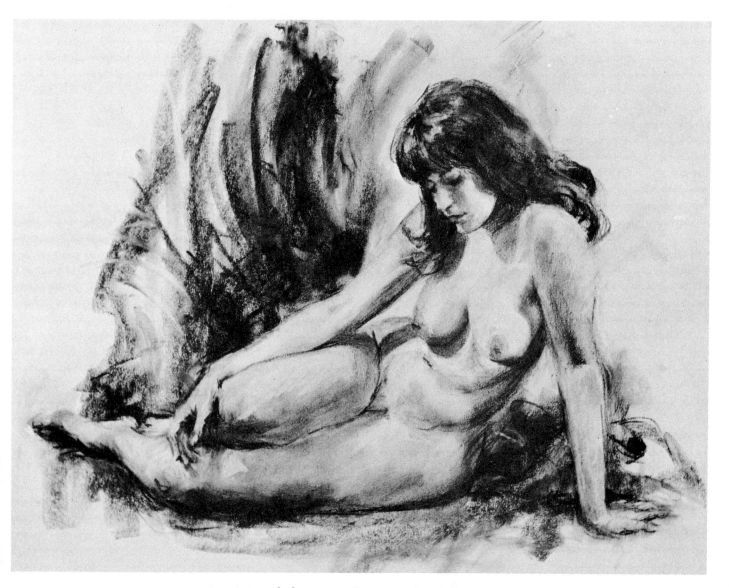

Step 6: *I might have stopped at Step 5, but the drawing was a little rough in spots. The arm she's leaning on is a little broken — that hand doesn't go backward. I straighten the arm by using background darks. The hand goes back because I make the top of it darker than the arm, and the little light going around the wrist also helps. The upper arm isn't quite thick enough above the elbow — so I change it. Her foot goes light at the instep, darker at the base of the toes, then lighter at the toes themselves. One of the big improvements here is putting down halftones to round the form. By dipping my finger in the black areas, I mold those halftones at the shoulder, the arms, and the lower part of the thighs, but it still isn't enough.*

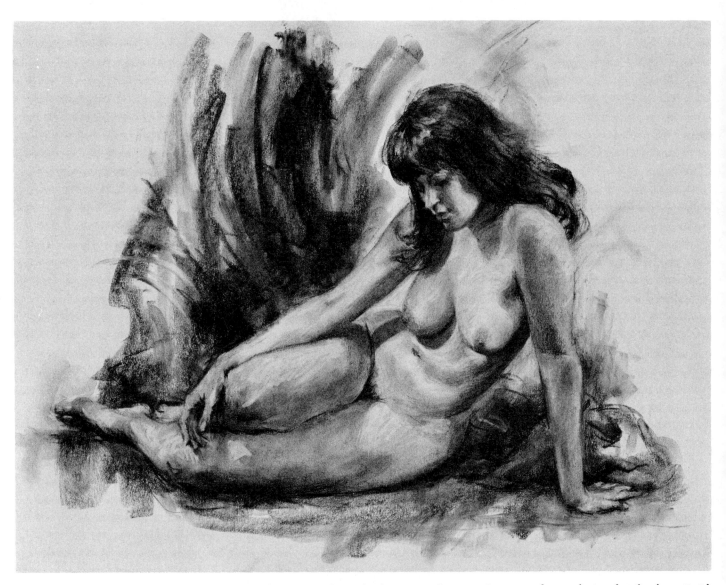

Step 7: *After studying the drawing at this stage, I come to the conclusion that I've been timid about the middle tones. They form a pattern which is necessary for the composition and for a cohesive figure. I go over the whole drawing and knock down those shadows. They're found along the straight arm, the dark tone form of the breast up to the hair, and the shadow on the thighs. I tone down the highlight on the hair because it jumps out too much. One of the objectives of this problem is edges, and careful study will show how much fun I have with the variety of edges here. The hair, of course, is a splendid and natural place for this. One place at the back of the head is smudged with my finger completely into the background. With a few strokes of the eraser, the edge of her upper left arm is lost. Some edges are completely lost on her right arm. These lost edges are dangerous if they change the drawing and the proportions you've established. However, if done with restraint, they can bring a drawing out of the art school, amateur, category.*

PROJECT 26

MASS DRAWING IN FAST ACTION POSES

When drawing the figure in the classroom or workshop, instructors normally like to have models do a series of very short poses in addition to a sustained pose. These little studies or rapidly changing poses are known as quick sketch, calisthenic or gesture drawings, and action poses; they'll throw you into a panic the first time you try them. It's not uncommon to start with a thirty-second pose and then gradually lengthen them to a grand total of five or ten minutes!

WARMING-UP WITH QUICK SKETCHES

The need for this kind of exercise is partly just that — exercise or warm-up. You'll find that keen observation and skill in rendering never reach a status quo. They constantly require honing. The quick sketch helps to keep your drawing skills sharp.

A fast pose also forces you to see in a different manner. You'll look for an instant image in time and space. After an exhausting (and inspiring) session of thirty-second poses, if you critique what you've done, you'd be amazed at how much of the figure you've completed. In a thirty-second pose you can usually complete as much as you can in a five- or ten-minute pose and with a clearer, more definite statement of the whole figure. This kind of sketching forces you to start with the total concept of the figure, gradually reducing the area of vision to find the smaller totals within. You soon discover there isn't time (nor is there any need) to put in the niggly details. The essence of the pose is its attitude or action and a *hint* of the model.

CONTOUR AND GESTURE SKETCHES

A popular book on drawing classifies quick sketches into two categories: the contour sketch and the gesture sketch. In the purest sense the contour drawing is done by letting your eyes slowly, steadily follow the contour of the model as your hand duplicates this path in a proportionate delineation on the paper. It's as if you were actually touching the contour.

The other classification is the gesture drawing, which is more flexible in its application. In a gesture drawing (which is how I've begun all of my demonstrations) you think of the figure in terms of its action lines, thrusts, counter thrusts, internal and surface structure, and placement of generalities.

I feel that the gesture drawing is the most valuable of the two. In most of my tone drawings some type of gesture drawing is used as a base. Therefore, I have no gap to bridge from the layout to the hard core of the tonal part. Using charcoal in this widespread treatment you can, at once, *set* the gesture and create the light and dark forms. If your main project feature, a sustained pose, is to be a tonal one, why not use the mass approach in the warm-up — that is, the quick sketch?

In the demonstration in this project I show you some stages of a quick sketch. Since there aren't many stages to demonstrate, I do a series of three poses. They're all done with a short, square piece of compressed charcoal on a newsprint pad. Series 1 and 2 are thirty-second poses, but Series 3 is a two-minute pose.

MAKING LINES WITH TONAL MEDIA

It always seems expedient to use a line-making instrument such as a pencil or Pentel pen for action poses. Being practically raised on line thinking, you instinctively fall back on this method in a sketching crisis. As awkward as it may feel, it's a tremendous benefit to force yourself — even in a thirty-second pose — to use a material especially meant for tonal masses like charcoal. When you've acquired skill in handling such a medium, explore and integrate a linear style in with the tonal one. You'll have a new bag of creative tools to use. Combinations of line and mass in action drawings can provide unexpected and interesting results.

In the next project I'll discuss line and how you can simulate light and shadow with it. After studying mass drawing, this seems to be the logical climax in learning figure drawing.

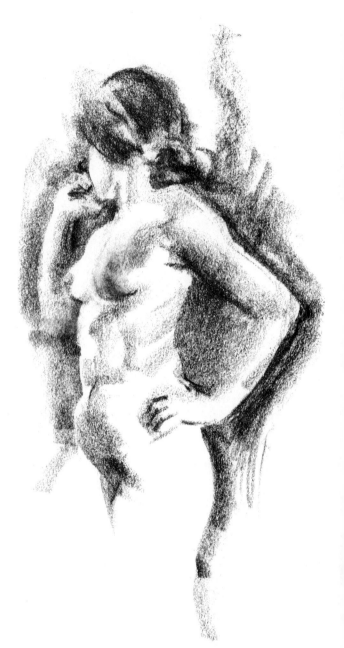

Figure A *These three sketches were made from five-minute poses. Such a pose is just long enough to obtain a representational effect. They were done with Conté in a tonal process.*

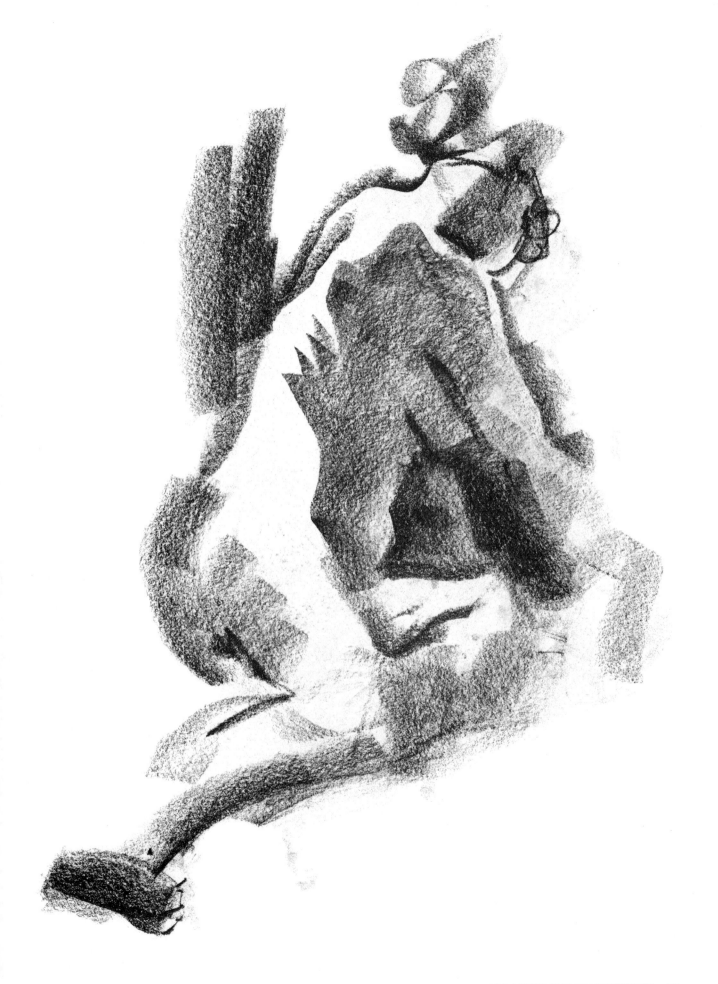

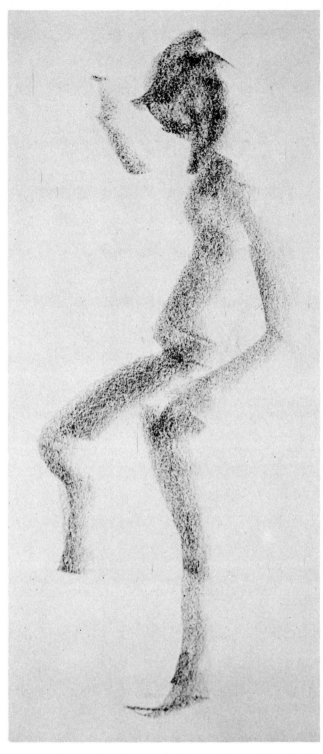

Step 1: *The initial stroke starts with a smudging of the shadow part of the head, quickly descending down the shadow of the body and bent leg. I take two other strokes: one for the upper arm, the other for the lower arm and straight leg.*

Step 2: *Many of the first motions are repeated but with more strength and conviction. I make a pause, a "click," at the neck to establish a key tone. Then, I swing down around the contour of the arm lifting the inner edge of the charcoal. I make a small circle for the nipple. In one stroke I loop under the breast, mark the front contour of the arm, and in one movement shape the back. I sock in the dark shadow of the leg in two passes. The last pass finishes with the under part of the foot.*

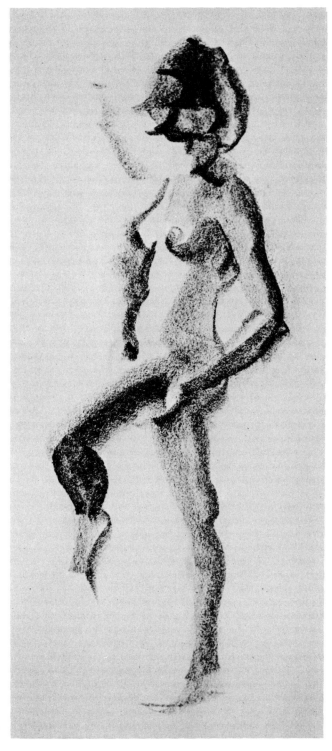 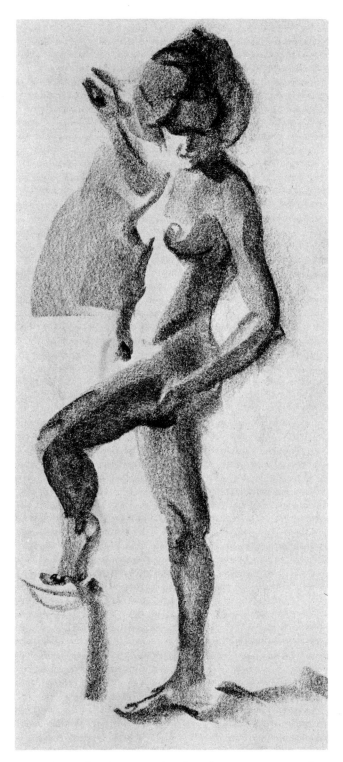

Step 3: *The darkest area, the shadow of the hair, is blackened in and becomes part of the eye and nose line. The front of the body appears brightly lit because of the sweep of the background tone. The back contour of the straighter leg follows the bone and muscle structure.*

Step 4: *Enough accents are placed on the upper arm to explain it. I add a little more tone to the hair and further suggestions of facial features. A tone and a loop on the top of the bent leg show the knee cap. The lower hand is improved some. I give the feet and legs sketchy accents to make them more explicit. Sketching exercises of this kind are valuable for feeling the relative placement of parts.*

Step 1: *In this short pose, instead of starting with an action line, I put down a shadow pattern. The dark stroke is a pivotal point as well as a key tone.*

Step 2: *The circular look to the foreshortened body is shown with a sharp contour tone. The breast emerges to the right of the thigh and is shown by a sweeping, hard-edged tone. The dark angular shape puts shadow under the body and locates the arm. I put in another sweep for the foot.*

Step 3: *A number of things are done here. It's mostly development of the outside shape by pulling the charcoal all around the top side of the figure. I start at the left side and end at the hand. The head is done without lifting the charcoal, in a sort of zigzag series of motions. I deepen the shadow on her thigh and buttocks. Because time is running out, I make the most economical suggestion of the foot and leg.*

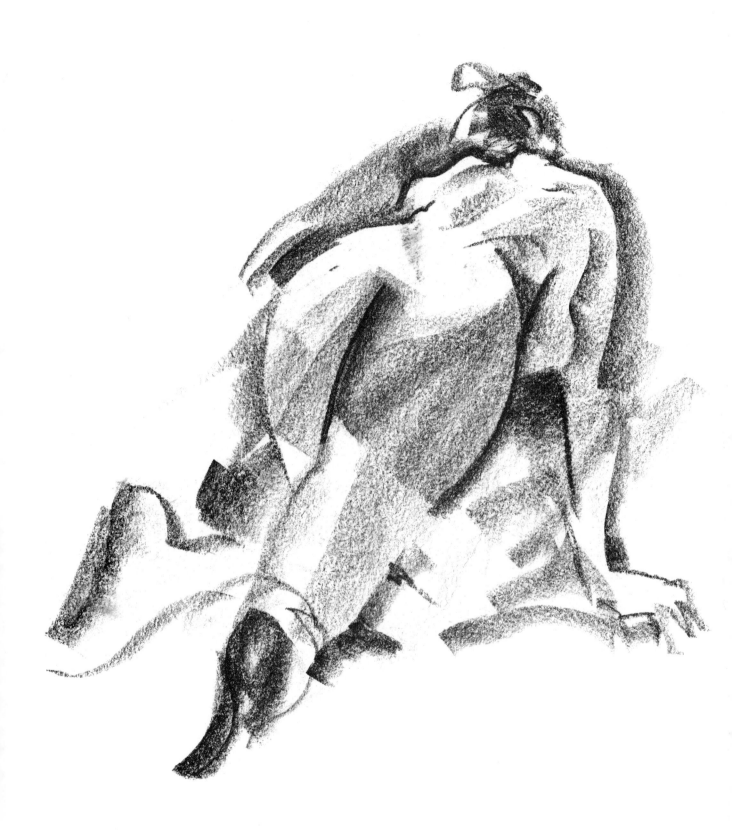

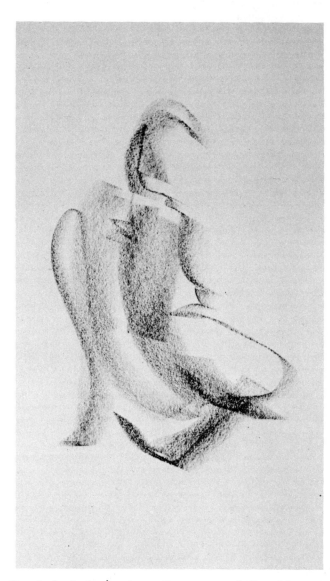 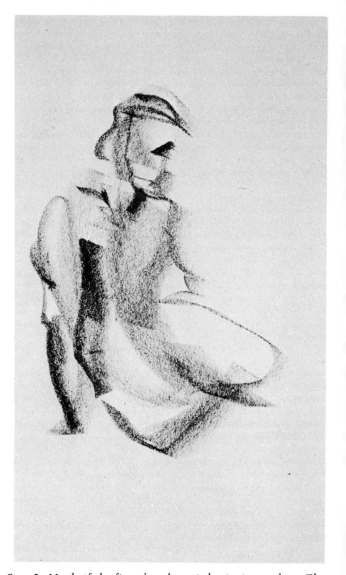

Step 1: *Again, in almost a continuous sweep, I attempt to grasp the feeling of the whole mass and action simultaneously. The calligraphic part shows both contours and inner construction features of the thigh and goes up through the arm and head. These strokes become a very valuable armature. Look for it through the later steps.*

Step 2: *Much of the figure's volume is beginning to show. The dark "V" shape establishes the eye socket. A light tone on the side of the head and one on the mouth area give roundness to the head. A few swift strokes for hair culminate in a line through the center top of the head. A jaw line is added to the previous line and becomes a dark shadow on the throat. That plus a "hook" for the collarbone gives the feeling of the neck. A small sweep shows the contracted triceps. A very heavy stroke shows the inner part of the arm and breaks off to catch part of the thigh.*

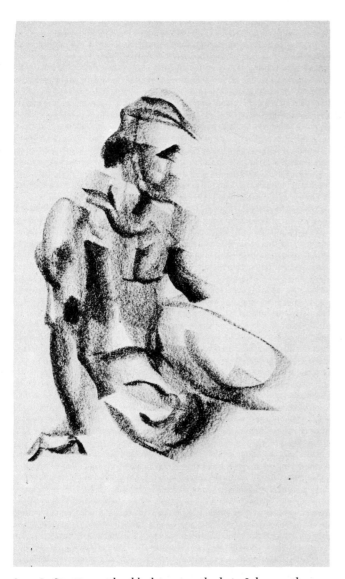

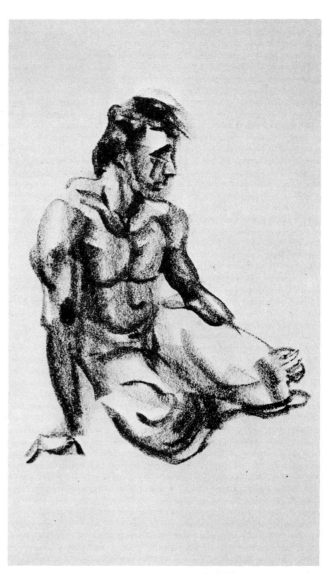

Step 3: *Starting with a black tone on the hair, I deepen the tone of the face side. I note here points of reference such as the collarbone shadow, the breast muscles, the spot under the biceps, the crotch, the thigh muscle, the knee cap, and the hand. A more definite statement of the far underarm is made.*

Step 4: *All throughout this step I come closer to more solidity and roundness. There's more emphasis on light and shadow, notably on the arms and upper body. The addition of more halftones in the shoulder and collarbone region helps create more detail.*

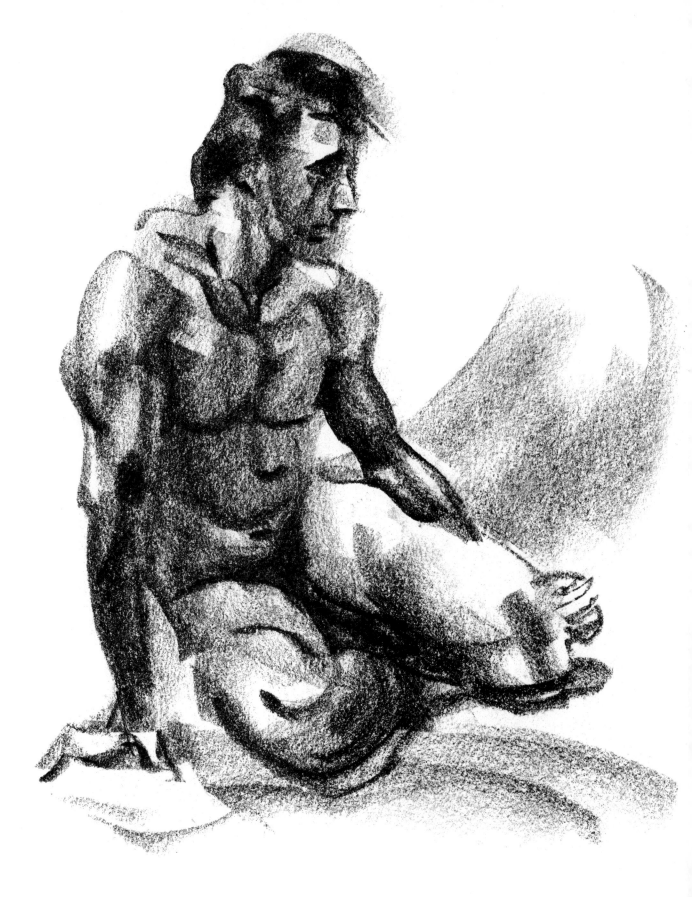

Step 5: *Here I say all I want to with more tones added to the body and legs. The linear indication is left for hands. The top of the shoulder becomes more of a suggestion of those parts rather than an exact contour.*

PROJECT 27

LINE DRAWING:
A BONUS FROM
THE MASS APPROACH

In the early parts of this book, I avoided lines like the plague. However, I only put them aside for a while, so that you could get an unobstructed view of tonal drawings. Now, let's see if studying drawing from a tonal point of view has helped with drawing in line.

EXPRESSING LIGHT AND SHADOW IN LINE

Having learned how the figure can be formed by light and shadow, how can you draw it in line? To simulate dark areas or shadow sides, the linear treatment can be heavy. Where a certain part of the body is heavier or thicker, perhaps a heavier line would work there. A soft or disappearing edge can be expressed by a very thin line or no line. You might have a leg completely in shadow and melting into the shadow on the other leg. Try eliminating the line between them to get that feeling.

Sometimes a very heavy line on the *light* edge of the figure makes that edge seem very bright. Another variation could be the absence of the line on the bright side. Hair is ultra-soft on the edge, so you can't use a hard line to contour it; you must handle this edge with a ragged line, split lines, or broken lines. Lines disappearing behind one another show a part of the body coming in front of another part, foreshortening. A line has to do so much that it can't be just an unvaried, hard contour line.

TONAL DRAWING AS A STEP TO LINE

While using a line to say a lot about the mass of the figure, you're also making it become a graphically beautiful and attractive thing in itself. The lines can cross the figure or zigzag around it. They can find the form and the anatomy of the figure by digging and delving into the volume and mass. (See Figure A.) The line can follow the course of the shadow pattern as in Figure B. In linear sketches such as Figures C and D, Magic Marker and Pentel pen are used, respectively. Lines used in a textural manner can also be employed in a tone drawing. (See Figure E.) See, I don't really hate line as you thought. But a good line drawing must be based on an understanding of tonal mass and light and shadow effects. Working in a tonal mode is the fastest and easiest way to start becoming facile with line. Although doing a line drawing hasn't been your goal, working in a tonal approach can help you to use line intelligently — it's a bonus!

Figure A *A gesture drawing can have lines that ramble freely to explore the constructive features and provide an interesting texture.*

Figure B *Much of today's popular illustration stems from this kind of shadow outlining. It's a description of the planes of the body in flat patterns.*

Figures C and D *Here are additional poses for our gallery. In the broad spectrum of quick sketching, you can use many media to express yourself. Figure C (Above) is a bold, punctuated linear sketch done with a Magic Marker. Figure D (Right) has the contrast of light and shadow as well as a feeling of control. This sketch is executed with a Pentel pen.*

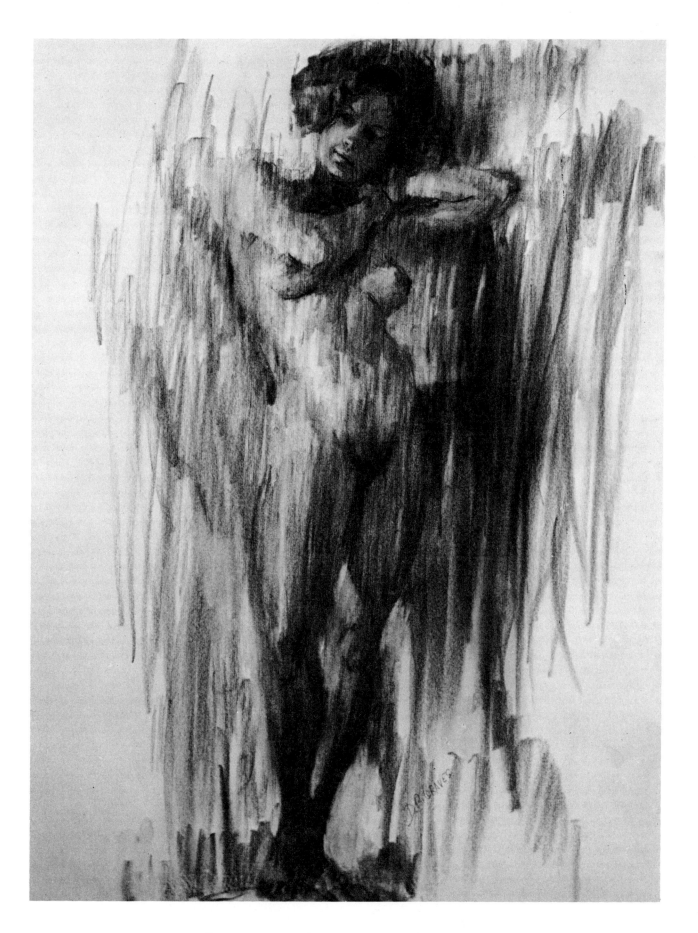

Figure E *Keeping the strokes of the charcoal in a directional and almost linear form, you can build these lines into a three-dimensional portrayal of the figure.*

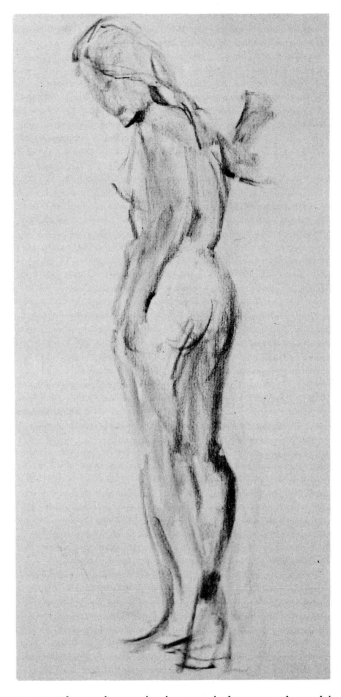 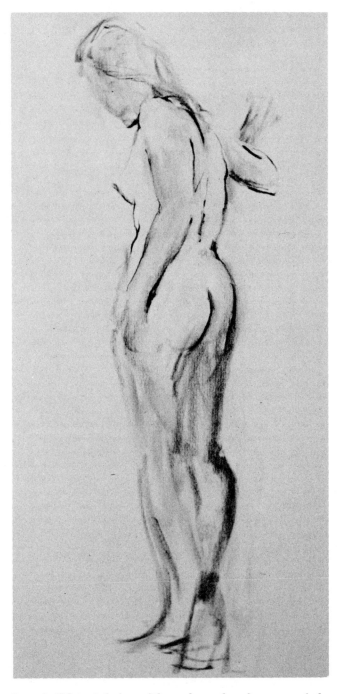

Step 1: *This is a low eye level view — looking up at the model on the stand. For me, this is the most comfortable way to start a studied line drawing. I have plenty of time to do this. There's some feeling of delineation in the beginning, yet it's smudgy enough so that I can maneuver. Notice I do move the leg.*

Step 2: *When I feel confident about the placement of the drawing on the page, I commit myself to places for lines. Having left some feeling of the tones, I start making the line say something about the amount of light and shadow at the chin and near the wrist. With heavier lines, I show thickness of area on the buttocks and the shoulder blades. Thickness is also shown by the passing of contours behind one another; the chest passes behind the hip.*

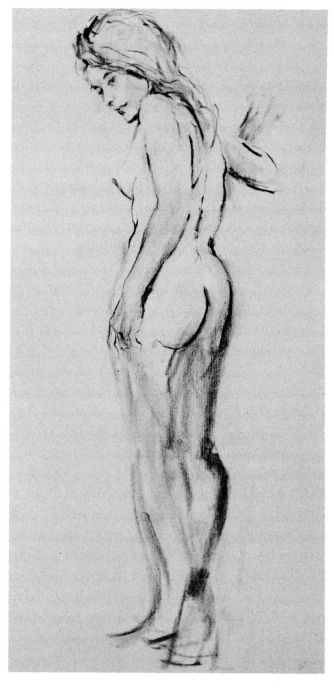

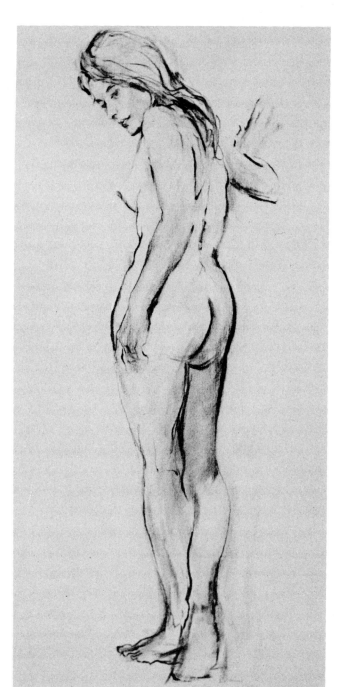

Step 3: *It only takes a hint of a line to tell some of the story. Actually, the problem becomes one of where to stop. Facial features and hair are delineated here. Also I start some detail on the hand.*

Step 4: *I add more lines to the hair, and begin some detail on the feet. The linear style in the legs is begun here. I make too strong a line around the hips. It doesn't say what I want it to.*

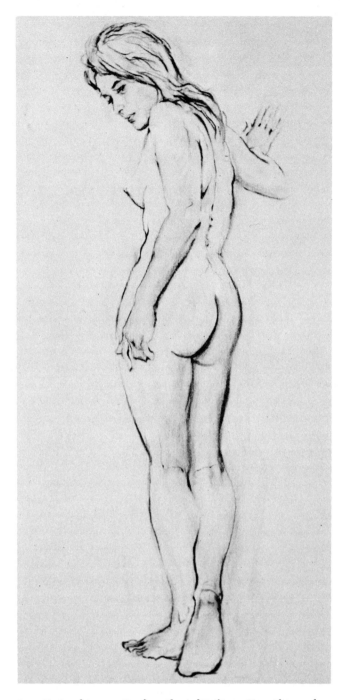

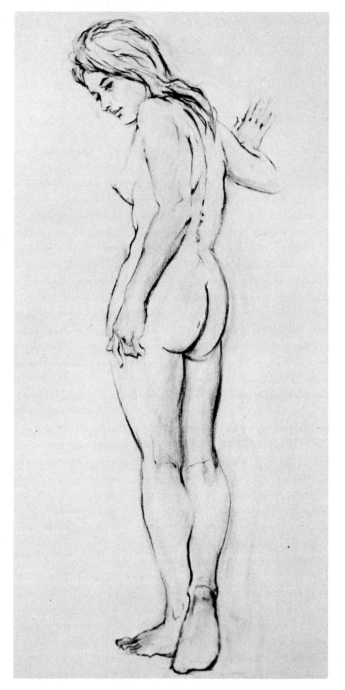

Step 5: *In this step I soften those hip lines. Now those edges seem to turn away as they should. Notice where the calves of the legs press together; by losing that line, they melt together. The upper hand is lightly drawn to keep it in the distance. As I work in the lines, I gradually rub out the tone to see if the line can hold its own and do the job.*

Step 6: *Why can't we make up our minds? I decide to make her smile a little. I also slim her down in the buttocks. I take away the heavy line under her chin.*

Step 7: *After much contemplation, I decide that the line in many places is too delicate to hold the figure together — so I go over most of it. Since I'm not using too many tones, I work out the hair in linear strands, being careful not to create a hard edge around the head. At this point, I shade in light tones with lines at the heavier, darker places.*

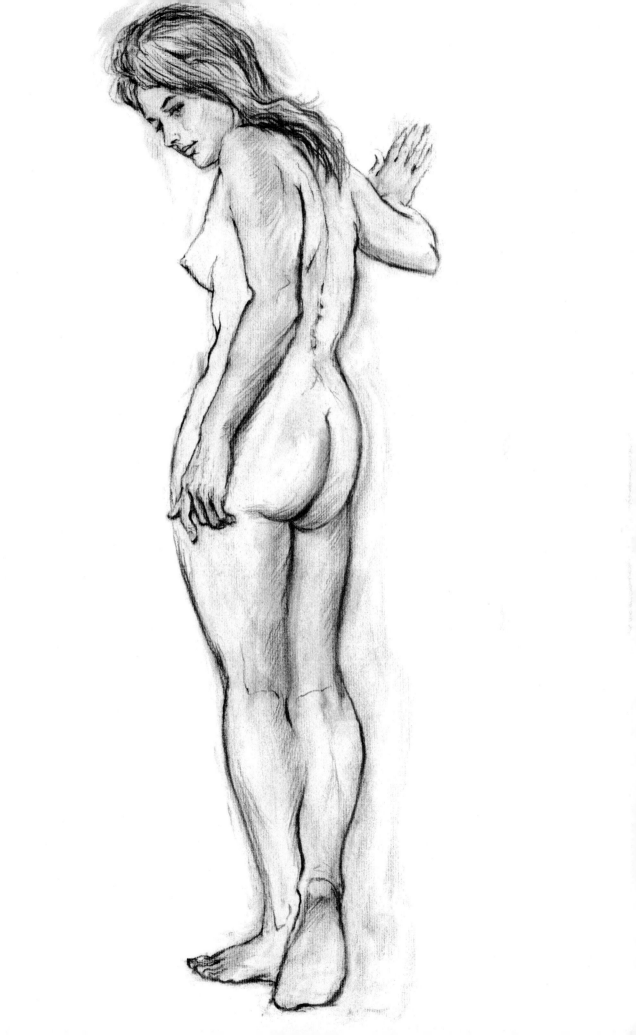

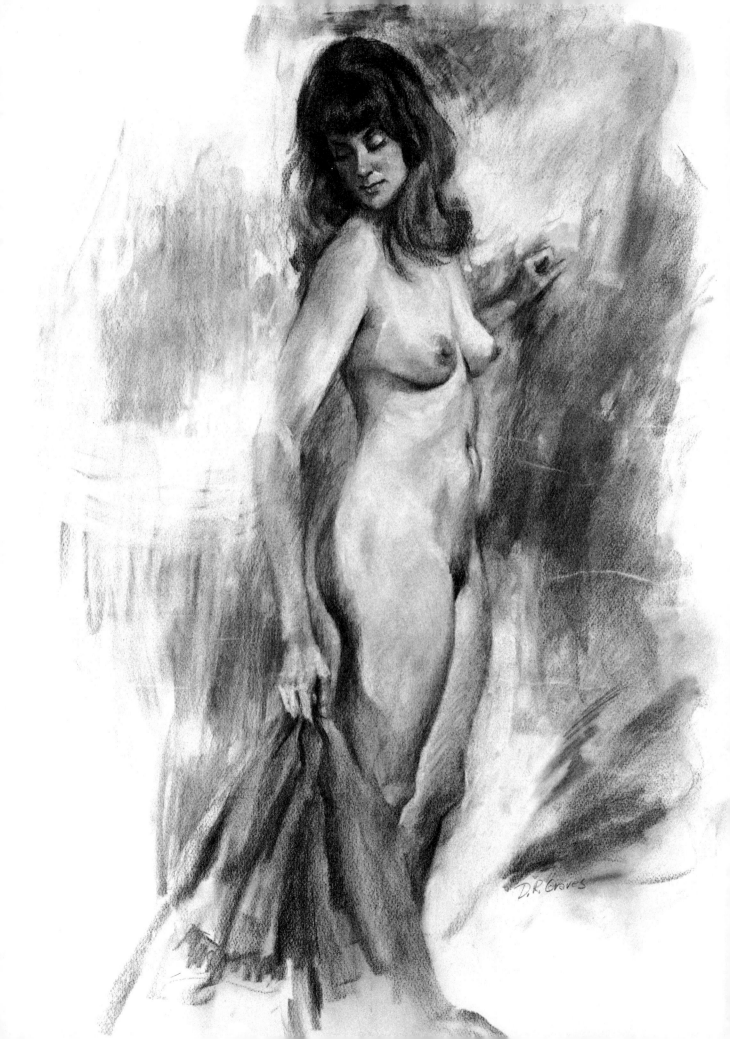

A
FINAL
WORD

Although this book must end, a conclusion is never reached in art. The labor of the artist goes on and on. The shimmering goal of that one perfect drawing is always dangling before you. You'll never give up the quest for it, nor should you, despite self-doubt, pessimism in others, or bad times. At best, the path throughout an art career is a convoluted one. There is no *right* path to take. Your own emotional involvement provides both the path and the obstacle in it. In addition to surmounting some mechanical problems, art instruction should give you aid in overcoming these psychological and emotional barriers.

Throughout this book I've hoped to speed you down your own path by increasing your powers of observation. By learning to see objects — especially the human form — in their totality, as large masses of tone, you can gain a freedom from concern for detail often fostered in the person who begins drawing in line. Charcoal is the perfect medium for this type of broad and free exploration. The human body is the ideal subject on which to practice this tonal approach. Nature's most subtle tonal values, shapes, and shadows are all there in the human figure.

Ultimately you'll want to paint. This desire has also motivated much of the direct instruction in this book and in my classroom. I'm strongly convinced of the natural carryover of mass or tonal drawing to painting. You'll find that you can apply to painting the exact lessons on tone and values that I've given you here. Developing some facility for handling tonal values will help you with the next problems of color and composition. Then, you'll be well on your way to painting and further down your path.

INDEX